KU-748-051

Recording Britain

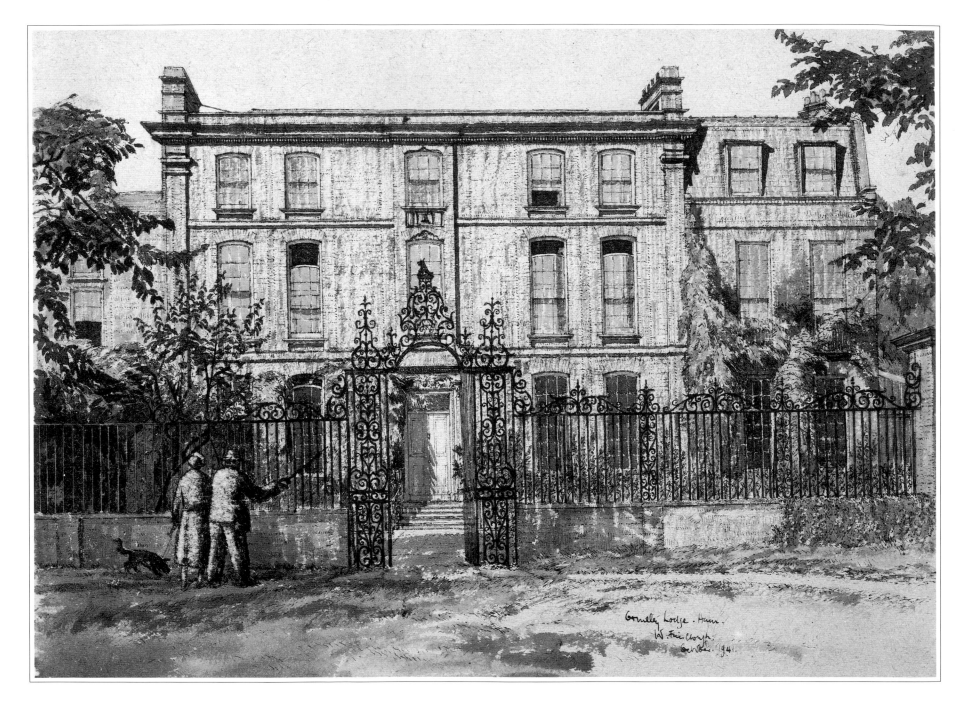

Wilfred Fairclough (b.1907)
ORMELEY LODGE, HAM COMMON, SURREY, 1941

Recording Britain

A Pictorial Domesday of Pre-War Britain

DAVID MELLOR • GILL SAUNDERS • PATRICK WRIGHT

DAVID & CHARLES
Newton Abbot London
in association with the Victoria and Albert Museum

FRONTISPIECE
Wilfred Fairclough (b.1907)
ORMELEY LODGE, HAM COMMON, SURREY, 1941

*Fairclough made a comprehensive study of the
many seventeenth- and eighteenth-century
houses in Ham and Petersham. Ormeley Lodge
is one of the finest, enhanced by the exquisite
wrought-iron gatepiers, gates and railings.
Their quality is such that they have been saved,
by listing, from the fate of so much wrought-
ironwork elsewhere (see pages 30, 130-31)*

Published to coincide with the exhibition held
by the Victoria and Albert Museum, London,
from 1 August to 18 November 1990 and
subsequently touring provincial centres
around Britain.

British Library Cataloguing in Publication Data
Recording Britain: a pictorial Domesday of pre-war
Britain.
 1. Great Britain, 1936-45
 I. Mellor, David II. Saunders, Gill
 III. Wright, Patrick
 941.084

 ISBN 0-7153-9798-2

© Victoria and Albert Museum

All rights reserved. No part of this publication may be
reproduced, stored in a retrieval system, or transmitted,
in any form or by any means, electronic, mechanical,
phyotocopying, recording or otherwise, without the
prior permission of David & Charles Publishers plc

Typeset and designed by John Youé
on a Macintosh system
Printed in Singapore by C.S.Graphics Pte Ltd
for David & Charles Publishers plc
Brunel House Newton Abbot Devon

ACKNOWLEDGEMENTS

My contributions to this book would not have been
possible without the advice and support of friends
and colleagues in the Victoria & Albert Museum. I
must in particular thank Lionel Lambourne for
his initial encouragement; Stephen Astley for
sharing his encyclopaedic knowledge of architec-
ture; Chris Titterington for his guidance on the
history of topographical watercolour; Moira Thun-
der who organised the photography with effi-
ciency and despatch to meet a tight schedule, and
Philip Spruyt de Bay who took the excellent pho-
tographs; Anne Buddle and Helena Gillis who
organised the retrieval of the pictures from the
borrowing institutions; Peggy Hughes, Frances
Rankine and Emily King who typed the manu-
script with unfailing patience and good humour;
and my husband Jon Buckley for his invaluable
assistance with my research on site around the
country.

Gill Saunders
January 1990

The authors would like to thank Dr Sadie Ward of
the CPRE, James Gibbs, archivist at the Royal
Society of Watercolours, Clive Tate, Brian Webb,
Ian and Emma Beck, and Felicity Palmer for their
assistance, and those contributing artists who
shared their reminiscences of the project: Phyllis
Dimond, Mildred Eldridge, Wilfred Fairclough,
Phyllis Ginger, Charles Knight, John Piper, Michael
Rothenstein, Kenneth Rowntree and Olive Smith.

Note on 'Recording Britain'
It has not always been possible to give full or
precise dates for the artists involved with 'Record-
ing Britain'. In some cases the artists were ama-
teurs and thus unrecorded; in others, it seems they
lapsed into obscurity, or perhaps changed career,
and have not been traced.

The name 'Recording Britain' is a misnomer,
for the project covered only England and Wales; a
separate scheme was established in Scotland. Even
then the record was by no means comprehensive;
thirty-two English and four Welsh counties were
fairly well represented, but some counties were
left out altogether owing to insuperable wartime
difficulties. The selection here aims to be repre-
sentative of the balance of the collection as a
whole, whilst allowing for the fact that some of the
watercolours have deteriorated over fifty years and
are now unsuitable for reproduction.

Contents

ACKNOWLEDGEMENTS 4

INTRODUCTION,
by Gill Saunders 7

'Recording Britain':
 A HISTORY AND OUTLINE, by David Mellor 9

REVIVAL OR RUIN?
The 'Recording Britain' Scheme Fifty Years After,
by Patrick Wright 25

THE PLATES:
Bedfordshire 38
Berkshire 40
Buckinghamshire 42
Caernarvonshire 50
Cornwall 55
Denbighshire 59
Derbyshire 60
Dorset 64

Essex 67
Glamorgan 72
Gloucestershire 73
Hampshire 86
Kent 87
Lancashire 97
London 102
Merionethshire 118
Middlesex 119
Norfolk 120
Northamptonshire 122
Oxfordshire 127
Somerset 130
Staffordshire 133
Suffolk 138
Surrey 145
Sussex 148
Worcestershire 156
Yorkshire 159

INDEX 160

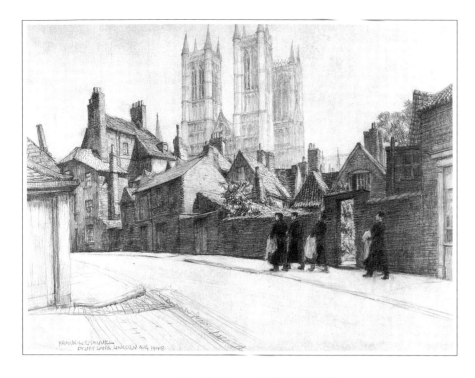

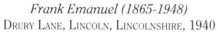

Frank Emanuel (1865-1948)
DRURY LANE, LINCOLN, LINCOLNSHIRE, 1940

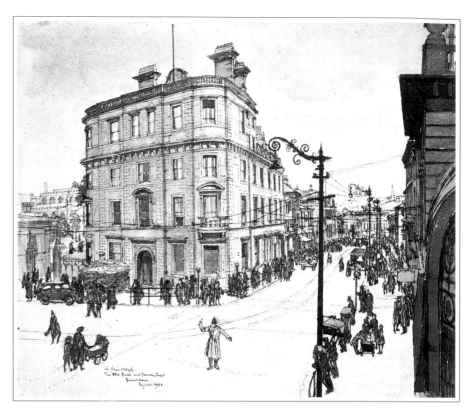

Wilfred Fairclough (b. 1907)
THE 'OLD BULL' AND DARWEN STREET, BLACKBURN,
LANCASHIRE, 1940

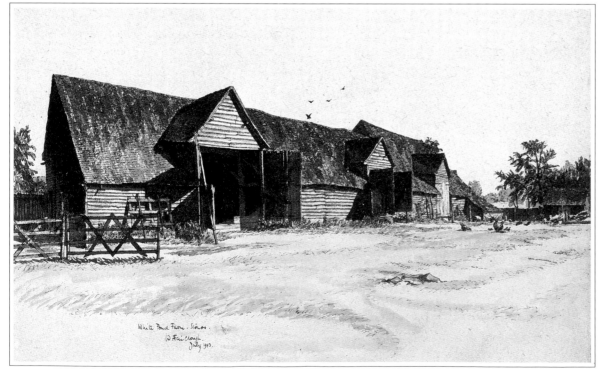

These three drawings demonstrate the diversity encompassed by the 'Recording Britain' brief. In the two studies by Fairclough we have the physical evidence of contrasting economies, rural and industrial; and in the Lincoln picture, an unconventional view of a familiar subject. In their commissions for the project both Fairclough and Frank Emanuel worked exclusively in monochrome – blue ink for the former, pencil for the latter

Wilfred Fairclough (b. 1907)
WHITE POND FARM, STONOR, OXFORDSHIRE, 1943

Introduction

GILL SAUNDERS

In 1940 the Ministry of Labour, in association with the Pilgrim Trust, launched a scheme to employ artists in making a record of the changing face of Britain. The artists commissioned were those who 'could not be concerned with a record of war and were going through bad times'. The 'Recording Britain' scheme thus had its origins primarily in practical and philanthropic considerations, but it developed to address a complex spectrum of anxieties.

T.E. Fennemore, as Secretary of the Central Institute of Art and Design, had recommended, in 1939, that 'artists should be appointed to make drawings, paintings and prints at the war fronts, in factories, workshops, shipyards and on the land, and of the changed life of the towns and villages, thus making a permanent record of life during the war which would be a memorial to the national effort, and of particular local value'. Separate schemes sent artists to the various fronts and into the munitions factories and dockyards; 'Recording Britain' focused on the home front. The result was less a record of change than a tribute to continuity, a celebration of 'Englishness' (Scotland was not covered and Wales was represented by only seventy-six pictures, substantially less than London), of tradition, of the nation's cultural heritage as embodied in historic buildings and familiar landscapes, rural industries and prehistoric monuments. Through most of its fifty-year history the collection of 1,549 watercolours has

been separated and regarded as being of purely local interest; only now has it become possible to see its greater significance.

Though the immediate catalyst for 'Recording Britain' was the wartime threat of bomb damage, it had its roots in wider anxieties about the pace and nature of change, and the future of what we now define as 'the heritage'. Herbert Read, writing about the aims of the scheme, sets out very clearly the underlying ethos, explaining too, why paintings and drawings were preferred to photographs:

Photography can do much, but it cannot give us the colour and atmosphere of a scene, the intangible *genius loci*. It is this intangible element which is so easily destroyed by the irresistible encroachment of what we call civilisation: schemes of development, the growth of industry, and the building of reservoirs and aerodromes; by motor roads and – for the present – by bombs. . . Better than the wordy rhetoric of journalists or politicians, it shows us exactly what we are fighting for – a green and pleasant land, a landscape whose features have been moulded in liberty, whose every winding lane and irregular building is an expression of our national character. We are defending our very possession of these memorials; but when we have secured them from an external enemy, the existence of these drawings may serve to remind us that the real fight – the fight against

all commercial vandalism and insensitive neglect – goes on all the time. There will be little point in saving England from the Nazis if we then deliver it over to the jerry-builders and the development corporations. [1]

As a defence against indiscriminate progress and unaesthetic development, 'Recording Britain' belonged to a predominantly middle-class intellectual milieu for whom the economic benefits of development were outweighed by the loss of beauty and amenity. It was a piece of the conservationist movement that began with the Commons Preservation Society (1865) and the Society for the Protection of Ancient Buildings (1877) and continued with the establishment of the National Trust (1895), the Ramblers Association (1935) and the Council for the Preservation (now, tellingly, Protection) of Rural England (1926). The evidence mustered by 'Recording Britain' undoubtedly gave added impetus to political changes aimed at regulating development: the most important of these was the Town and Country Planning Act of 1947, a comprehensive and radical array of measures to safeguard the environmental needs of communities by controlling changes in land use. This enlightened legislation, protecting not only designated 'green belts' and National Parks, but all open spaces and communities, however apparently unprepossessing they might be, is still in force today. It is, though, increasingly under pressure from

demands for new housing and for tourism and leisure developments.

'Recording Britain' accurately reflects the spirit of the age. At its core is the enduring myth of idyllic and redemptive rural life, a myth given new force at a time of national threat and insecurity. Supported by a powerful tradition of cultural Romanticism, the English village was projected as the ideal community in opposition to the city. Where the city was characterised as chaotic, dislocated, anonymous, the village represented security, intimacy, harmony and continuity. The har-monious grouping and 'natural' growth of the village were the visual counterparts of these social virtues. In 'Recording Britain' the city, and indus-trialisation, are marginalised or shown defeated and in decline. Even in London, by concentrating on single buildings, the impression given is one of linked villages rather than of a commercial and industrial metropolis.

However, it would be wrong to suggest that the bucolic view of country life is predominant. Many of the artists confront the evidence of change and decay and chart the decline of rural communities in images of redundant churches, farmhouses which have lost their purpose together with their land, encroaching urbanisation, obsolete crafts and customs, and the benign neglect in a country churchyard.

The countryside of the 1940s was still worked in self-sustaining and traditional ways, and natives outnumbered the urban incomers, despite the haemorrhaging of the young to the towns and cities. Today we are in danger of creating a coun-tryside which, aside from the agri-business farms, is no more than a vast theme park, a heritage trail linking dormitory villages and enclaves of second homes, dead communities which have lost their native populations together with their purpose, their self-sufficiency along with their services. But the case is not hopeless: a new 'green' awareness and a vociferous countryside lobby may yet reverse the more damaging trends; it is heartening to note that well over half of the 'Recording Britain' sub-jects remain substantially unchanged today.

FOOTNOTES AND REFERENCES

1 Quoted in *This Land is Our Land: Aspects of Agricul-ture in English Art* (exhibition catalogue, Mall Galleries, London, 1989).

Byland was the least known of the great Cistercian abbeys of Yorkshire. Rothenstein's sketch shows how these dramatic ruins were domesticated, built around by later generations (the new buildings often cannibalising the old). The dominant image in this picture is in fact an absence: the fragmentary round window, an emblem of perfection destroyed. As such, it stands for the decline of the Church as a central focus in society, and generally for the triumph of nature over human endeavour. The ruined abbey was the archetypal Romantic motif, an invitation to reflect on mortality

Michael Rothenstein (b. 1908)
BYLAND ABBEY, YORKSHIRE, 1940

'Recording Britain':
A History and Outline

DAVID MELLOR

1 The Establishment of the Scheme

I need not tell you what terrible distress the war is causing among artists. . . the situation is so serious that I have been wondering if it would not be desirable for the Government to take some action. . . I have in mind something like the federal scheme for artists carried out in America during the last five years, though ours would no doubt have to be on a less ambitious scale. . . [it] would have a wonderful effect on English art in general.[1]

So wrote Sir Kenneth Clark to Humbert Wolfe, an official at the Ministry of Labour, exactly one month after the declaration of war in 1939. 'Recording Britain' – developed in the last few months of 1939, primarily as an unemployment relief scheme for artists – would carry a type of American priority from the time of its conception. From Clark's first model for the scheme to its financing by an initial grant from the Pilgrim Trust, the fund 'to promote [Britain's] future well-being'[2] provided by the American millionaire Edward Harkness, this apparently most British of projects had American provenance and foundations. When, ten years later, the four-volume collection *Recording Britain* was published, a third of all sales were to the United States.[3]

'Recording Britain' was, we might say, a hybrid of American philanthropy and expertise,[4] combined with British governmental and cultural institutions and pressure groups. It was certainly a hybrid in so far as its committee, formed in December 1939, owed allegiance to the Pilgrim Trust and the Central Institute for Art and Design (CIAD), housed in the National Gallery, as well as the Ministry of Labour. As a form of indirect state sponsorship for art it belongs to that transitional moment in British culture in the early 1940s before the Treasury took on more fully the responsibility of funding the arts.[5]

It was from inside the Committee for the Employment of Artists in Wartime, itself part of the Ministry of Labour and National Service, that a plan to record 'vanishing' or 'changing' aspects of Britain first emerged in the late autumn of 1939. As early as February 1939, Clark had been asked by the Ministry of Labour for his opinion about the position of artists under the new state powers of national service that had been announced to the public the previous month.[6] The Central Register of artists was administered by the CIAD, although many painters chose not to register. But the powers of the state over the individual were enlarged enormously when war did arrive. The Council for the Preservation of Rural England (the CPRE) – one of the bodies advising 'Recording Britain' – noted in 1940 that the National Service and the Emergency Powers Acts of 1939-40 gave the state 'absolute control over all persons and property'.[7] The melancholy metaphor of a 'vanishing' Britain

had a relevance beyond the CPRE's fears for the dereliction and despoliation of the landscape, as a wider allegory of the passing of the liberal order and its characteristic monuments and objects.

Clark's immediate strategy was to save from 'vanishing' the very artists themselves, protégés like Kenneth Rowntree and John Piper – and to save their media and the traditional genres in which they worked. But it would require some transformation in role and status. Clark foresaw that these artists, saved 'from starvation',[8] would be utilised in the British national service, being paid according to the model of the uniform salary system of the US Federal Arts Project, thus removing them from previous commercial values of art production.[9] Remuneration for 'Recording Britain' artists 'shall have no relation to the normal market value of the artist's time or work, but. . . shall be of the nature of a uniform living wage', proposed the Committee for the Employment of Artists in Wartime.[10] What was being predicted was a new national mandate for the artist ,who was to be enrolled into a centralised corporate system, presided over by the CIAD. But it was not to work out in quite this way.

On 3 December 1939 Clark drove from Bangor to Harlech to meet Tom Jones, Lloyd George's old secretary, a masterful operator behind the scenes of the Establishment, and, since 1930, the Secretary of the Pilgrim Trust. Clark took with him an outline of a 'Scheme for Recording Changing

Aspects of England', with which to win the support of the Pilgrim Trust and to secure a grant of £4,500 to save 'the whole tradition of English art'.[11] This would 'absorb 25 to 30 of our best landscape painters . . . at £5 per week for a 6 month period . . . trusting the artist to work steadily'.[12] Clark did not succeed in convincing Tom Jones entirely and when the Pilgrim Trust met on 14 December the Trustees voted only £2,500;[13] the ambitious spread of the project thus had to be curtailed.

The initial programme of subjects to be recorded by the project was part of the package which Clark negotiated with Tom Jones. Clark envisaged four categories:

A. Fine tracts of landscape which are likely to be spoiled by building developments. . . B. Towns and villages where old buildings are about to be pulled down. . . C. Parish Churches – many of these are in a bad state of repair and will fall down or be ruined by restoration. . . D. Country Houses and their Parks – these will be largely abandoned after the war and will either fall into disrepair or be converted into lunatic sanataria. . .[14]

The iconography of decline and fall was written large in this choice of categories, and the perception of the passing of the old order was a widely held one.[15] A socially catastrophic sense of ending is evident in the programme's assumptions: 'These should be records showing the elegance and dignity of country houses *in their last phase,* but should have a sociological as well as artistic value.'[16]

2 Administering the Scheme: Arnold Palmer

That the 'Recording Britain' project did not become over-centralised, corporatist and bureaucratic was due partly to the curtailed scale of the scheme after the Pilgrim Trust's disappointing response to Clark's bid. That it was instead characterised by a flexible method of operation was almost entirely due to the person appointed as its secretary on 21 December 1939. The genial Arnold Palmer was fifty-four when he volunteered his help *gratis* to Clark, who replied: 'I believe that there will be a great deal which you can do better than anyone else'.[1] Clark's confidence was borne out by Palmer's organisational skills, which had been developed during his administration at the Carnegie Institute in London of British artists' entries to the large annual painting competition at Pittsburgh, USA – a job he had done since the mid-1920s. 'Very possibly you have access to all the American information you need', he told Clark, 'but the department I represent is non-commercial (Carnegie's will laid that down), disinterested and eclectic. . .'[2] What Palmer exemplified was a very rare type: a gifted cultural agent in the twilight of Empire, possessed of the virtues of public service and an outstanding ability to manage artists sympathetically.[3]

Mistrustful of Clark's ambitions in gathering many areas of British art under his sway,[4] Palmer's preferences were in a more modest key. Certainly, in comparison with Clark, his taste in contemporary British art was relatively conservative – he admired and owned works by Camden Town Group painters and was a partisan of the Royal Watercolour Society, affiliations which distinguished him entirely from Clark's support for that English Neo-Romantic *avant-garde* of Moore, Sutherland and Piper. Palmer's cultural orientation is reflective of other structures in British art, more 'centrist' ones of longer duration, formulated thirty years before he took on 'Recording Britain'.

Palmer's frame of mind was essentially Georgian – that is, it belonged to the moment of Rupert Brooke and the Georgian poets and artists of 1910-20. Together with R.A. Scott-James, Palmer had edited and directed *The New Weekly* from 1913, guided by the cultural politics of radical Liberalism. In so far as Palmer moulded 'Recording Brit-ain', the art produced was a repetition of that liberal Georgian landscape vision of England mapped by E.M. Forster in *Howards End* (1910). The distinctively Georgian cultural project of cataloguing countryside motifs[5] in an anti-sublime mode was recreated in the drawings for 'Recording Britain'. Conventional opinion in the form of a *Times* editorial in June 1942 explicitly linked the drawings in the second 'Recording Britain' exhibition at the National Gallery to the Georgian structure of feeling. In this editorial the imagined spectator is overcome by a rush of lyrical rapture prompted by the topographic drawings on show: '. . . one's heart-strings tugged to wish oneself far enough from Trafalgar Square and cry with Rupert Brooke, ". . . would that I were in Grantchester, in Grantchester" '.[6] Here the editorial writer's citation of *The Old Vicarage, Grantchester* (1912) stands as the epitome of the sentiment attached to a specified building, such as Howards End, viewed and understood within the dense connotations of war, as the home ground of the British poet (or artist) and, most of all, as a sign of national identity in time of stress.[7]

Palmer possessed his own version of the idyllic country house, his own Old Vicarage, Grantchester: The Grange at Yattendon in Berkshire, where 'Recording Britain' artists like Wilfred Fairclough would visit and stay.[8] During the first half of the 1940s Palmer would go up by train from Reading to his long office in the basement of the National Gallery in London once a week.[9] The National Gallery in wartime resembled an anarchic, but grand, country house, Clark's personal kingdom, romantically filled with eccentric and erratic individuals: for example, the dealer Lilian Browse, who ran her own private gallery from a room she had begged for 'research', and the Head Keeper, a British Israelite, who was intent on converting the Welsh nation.[10] Into this milieu Palmer casually turned up for his weekly meetings with his artists and the small committee, dressed

Arnold Palmer, 1940s

elegantly as the country gentleman paying a visit to his club in town.

A man of the turf, Palmer also appreciated the seasonal nature of producing topographical drawings *en plein air*. Reporting to the Pilgrim Trust on the progress that had been made in the period between the end of November 1940 and April 1941, he wrote hoping for 'a renewal of their grant to cover the season just opening'.[11] Clark had originally argued for six-month periods of commissioning artists since 'a shorter period would not allow for the changing seasons; e.g. a three month period which began in January would

not make it possible to record summer land-scapes'.[12] But with the disappointingly low initial grant from the Pilgrim Trust, the three-month period for commissions became a reality, with some artists being offered £72 – certainly not a 'living wage' – for the production of twenty-four paintings made over that time. Others were on the same standard rate of £3 per drawing, but were contracted for only four weeks at a time.

Clark may have presented too grim a picture of 'starving' and unemployed artists in October 1939, because of the temporary closure of so many teaching institutions immediately after the outbreak of the war.[13] By the time the first contracts were sent out for the beginning of the first 'season' in April 1940, artists like Charles Knight and Wilfred Fairclough, two of the first to be commissioned, were back in art school teaching and the task of 'Recording Britain' became a part-time job. The length of time for the artists to complete a drawing varied: Fairclough found himself skimping and hurrying a drawing and resolved to devote 'a full day's work and perhaps back in the morning' to it,[14] while Kenneth Rowntree reckoned two days' full work on a drawing like *Tan-yr-Allt*.[15]

'A light touch'[16] in commissioning enabled Palmer to elicit casual piece work or promise to see drawings made on spec. After thirty-four full meetings of the committee in 1940, its first year of existence,

> . . . the scheme was running smoothly and the three members. . . were in such harmony that full meetings became rare. . . Committee meetings tended to be, in fact, informal talks between the Secretary and any available member; but the scheme appeared to suffer not at all.[17]

Palmer's informalism and ease was crucial, gently imprinting 'Recording Britain' with the outlines of a liberal amateur's idyll of culture.

3 The CPRE, Charles Knight and the Practice of a Watercolour Tradition

In September 1939, the first month of the war, the village of Ditchling became the focus of a national outcry against unregulated speculative housing development in the countryside. The foot of the South Downs between Ditchling and Keymer was to be comprehensively built over. *The Times* and other national newspapers took up the issue [1] which aroused local resistance:

> . . . residents, strongly supported by H.Q. and Sussex representatives of the CPRE, have been working for the reservation of as much open space and as much of the property as possible. . . and to ensure the preservation of the character of Ditchling village.[2]

Frank Pick, supremo of the London Passenger Transport Board and perhaps the most conspicuous of the decade's corporatist art patrons, was not only a member of the Committee for the Employment of Artists in Wartime, but was also an executive of the CPRE. He first raised the need 'to get in touch with the CPRE to help recording "Changing Britain" ' [3] a few weeks after the Ditchling campaign began. When Clark came to draft his outline of the 'Scheme for Recording Changing Aspects of England' for Tom Jones and the Pilgrim Trust, the potential threat to Ditchling was clearly a priority in his mind. It stood as the illustration for the first example of 'Subject[s] to be Recorded':

> Fine tracts of landscape which are likely to be spoilt by building developments. . . The CPRE must have records of the numerous letters written protesting against building developments on the Downs. . .[4]

The policy of the CPRE in wartime, as in peace, centred upon the conservation of agricultural

resources and the 'social environment of the rural population'.[5] The CPRE's recurrent language of threat, using the metaphors of contamination, bodily injury and monstrousness caused by the agency of developers – as in the title of Clough Williams-Ellis's pre-war book *Britain and the Beast* (1937) – would, eventually, be incorporated into Palmer's writing and publicity for 'Recording Britain'. But, at the beginning of 1940, 'resistance of invasion of agricultural areas'[6] by developers *and* the armed forces of the Crown was paramount for the CPRE.

In the first months of 1940 Palmer's new committee requested 'lists of places suitable for painting and drawing in the "Record of Disappearing Britain" scheme'[7] from the CPRE. Sixteen county and local authority branches complied, including Dorset, Essex, Northamptonshire and the Sussex Rural Amenity Council. Sites in these counties were then recorded in the first 'season', May – October 1940. By July 1941 similar listings had been assembled by Derbyshire, Glocestershire, Lancashire, Worcestershire, Bedfordshire and Kent CPRE county branches. Palmer was also 'in touch with our representatives in Hampshire and several other counties. Will Britain's beauty', asked the writer apocalyptically for the CPRE's *Progress Report*, 'be restored or obliterated?'[8]

The watercolourist Charles Knight had settled in a smallholding on Beacon Road under the Downs in Ditchling in 1934. Born close by in Hove, he became a leader of the village's Handworkers Guild and, following rural vernacular forms, he designed inn signs for Sussex pubs.[9] His affiliations with the local resistance to planned housing development were underlined by his recollection that he 'didn't need the CPRE's advice. . . because I lived there!'[10] – that is, as part of the community he was only too aware of the potential disfigurement of the face of the village. It is in this context that we should read his watercolours of *Anne of Cleves' House, Ditchling* (see also page 153). In April 1940 he was chosen by the 'Recording Britain' committee to document the area for a three-month period. Palmer later paid him this compliment: '[Charles Knight]. . . launched the collection with an intensive semi-continuous group of drawings such as no other contributor, except Mr Fairclough in Surrey, ever again provided'.[11] The autonomy of artists to choose their own sites within the broad directions of the scheme is demonstrated by Palmer's acceptance of Knight's suggestion that, as well as documenting Ditchling, he should also record in successive sections the 25-mile long Southdown Underhill Road from Milton Street to Edburton.[12]

The artists working for the 'Recording Britain' scheme pursued jobs and skills that were closely linked to topography: Fairclough, with fellow project artist S.R. Badmin, was recruited into making highly detailed models of the French and German countryside for the RAF at Medmenham, meanwhile continuing his drawings for 'Recording Britain' after 1942. Similarly, before the war, Knight had been employed as a cartographer. As he worked systematically across Sussex in the early summer of 1940 the adjacent local roads became busy and then congested with troops; the British Expeditionary Force had been evacuated from France and another kind of invasion, in this

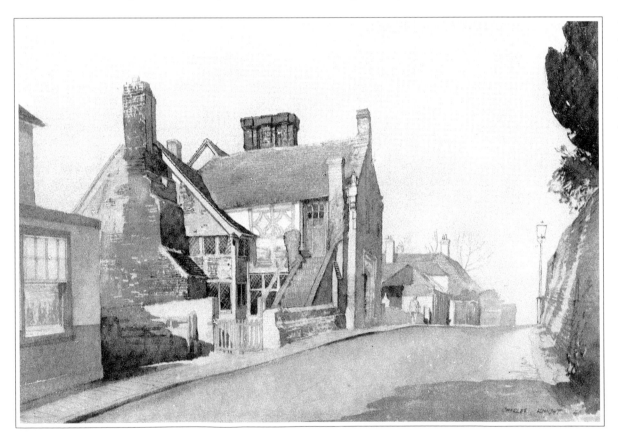

Charles Knight (b. 1901)
ANNE OF CLEVES' HOUSE, DITCHLING, SUSSEX

Russell Flint, the President of the Royal Society of Painters in Watercolours at the time of 'Recording Britain', was also a key member of the small committee administering the project. While he was best known for his figure subjects, his few (nine) donations to the scheme prove him to have been a gifted landscape painter

case by the Nazis, constituted the threat to Sussex soil. Making his exact mapping transcriptions of the landscape, Knight was now seen as a potential spy rather than as a champion of village integrity.[13]

Knight's drawings of the locality made in 1940 became defensive instruments against a further attempt at development in Ditchling, when the Ministry of Works and East Sussex County Council planned to build a by-pass through part of the village in 1954. At the official enquiry, Counsel for the villagers produced, 'as his trump card',[14] one of Knight's drawings of just the place to be affected:

> . . . he then observed they [the Ministry of Works] proposed to do precisely what the war had failed to achieve. . . destroy the beauty of Ditchling! The fact that American money had been used to put on record this view did not go unnoticed in the court. . . [15]

Such a narrative, as retold in the *Annual of the Old Water-Colour Society's Club,* rehearses that contemporary theme so often articulated in the Ealing comedies of the late Forties and early Fifties, of a successful indigenous community resistance to the baleful forces of social modernisation.[16] The fact that an American element of

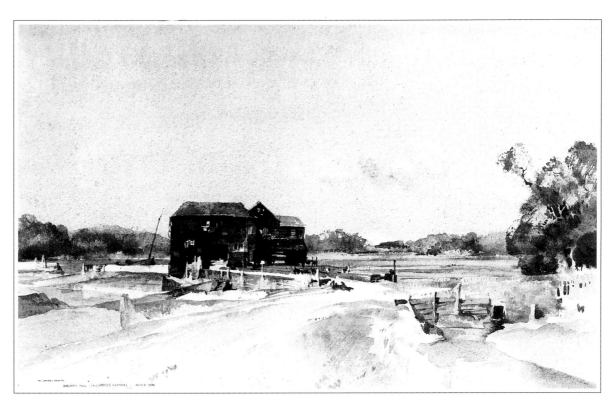

Sir William Russell Flint (1880-1969)
BIRDHAM MILL, CHICHESTER CHANNEL, SUSSEX, 1938

involvement, in the form of sponsorship and possible spectatorship, was present, echoed opinion around the CPRE promotional film *England.* Shown with commercial feature films during 1939, it depicted '. . . the bucolic peace of the Downs. . . [and] the threat to the very places where peace and recreation can be found. . . '[17] But, it was reported, film critics invited to the press showing recommended that it should be remade so that 'America would grasp it'.[18] The making of representations of Britain that were targeted at American viewers and sponsors was an inescapable part of the visual imagination.

Like other 'Recording Britain' artists such as Thomas Hennell, Charles Knight was an upholder and conserver of craft skills in a double sense: first, in belonging to a rural community which valued the perpetuation of crafts and, second, as a watercolourist who attended to his medium as a craft.

Watercolour, as a medium, was read as possessing a formative native history, an essential Britishness. The first exhibition of the scheme in July 1941 at the National Gallery prompted Herbert Read to welcome 'Recording Britain' as an artist's relief scheme like the American Federal Arts Project, although unlike it in that the medium in which the works were produced were not gigantic murals or large canvases.

The happy solution, for which Sir Kenneth Clark must be given credit, was to employ our artists in a modest craft for which, among the nations of the world, they have shown a supreme ability – the topographical watercolour drawing. From the early eighteenth century... the English artist has been peripetetic...brother of the fisherman and the naturalist. But he was disappearing.[19]

Herbert Read's 'disappearing' watercolourist – zealously preserved by Russell Flint's efforts as President of the RWS, of which Knight was a member – was now flourishing under 'Recording Britain'. Nothing less than a crusading restoration was being enacted, a re-establishment of English origins – so, at least, considered *Country Life* on the occasion of the final National Gallery show of the scheme in the summer of 1943: 'The Pilgrim Trust's enlightened undertaking has, in fact, re-established this great national art, in which England is first and foremost yet which, perhaps because of its very nativeness, is too often overlooked.'[20] Unseen, disappearing and vanishing – these terms framed a rhetoric for the 'threatened' object, the artist himself [21] who was mystically joined to the sacramental body of Britain through the Ministry of Labour's project, and revitalised: 'To praise watercolour is for me to praise England and to be forever indebted to those painters who have shown me. . . how beautiful our land is.'[22] This was the ideology of the Royal Watercolour Society in the epoch of William Russell Flint's presidency, here voiced by E.T. Holding in 1940. Holding succeeded in combining the overcoming of Nazism by democracy with the possibly ascendant craft of watercolour topography, in a rapture of cultural nationalism: 'The triumph of a righteous cause and the practice of watercolour painting may seem to have little or nothing in common. But this is not so.'[23]

As a regular attender of its exclusive pre-war exhibitions and an enthusiastic patron of its members,[24] Palmer's preference for the RWS surfaced most dramatically in his biography of Russell Flint, which he wrote during his period as Secretary of the committee. At the close of *More Than Just Shadows* (1943), Palmer presents Russell Flint charitably procuring commissions with 'Recording Britain' for RWS members in his capacity as a committee member, extending 'his sympathy for artists down on their luck'.[25] A look

at the roll of contributing artists to 'Recording Britain' reveals a good number of associate or full members of the RWS – among them the elderly A.S. Hartrick and Walter Bayes, as well as the younger mid-generation artists Vincent Lines, Charles Knight, Mildred Eldridge and Thomas Hennell. In a surprising tactic designed to further revivify the RWS, Palmer and Flint proposed for associateship painters like Kenneth Rowntree whose styles were basically Modernist derived. Rowntree was voted in at the time of the last 'Recording Britain' show in 1943, but after a few meetings he lapsed, feeling that 'it was a bit stuffy'.[26] It was the last throw of 'an ancient body',[27] an institution which, because of the historical and cultural circumstances of the war, appeared to be capable of creating a return across a hundred and fifty years to the golden age of British topography.

This 'return' was a definite strand in British art in the first half of the twentieth century. Augustus John and the painter counterparts to the Georgian poets of around 1912 favoured 'old English' watercolours of the Girtin and Cotman period. Just as Blake and Samuel Palmer were revived in the 1910s and 1920s, so were watercolours of the very early nineteenth century. Wilfred Fairclough first encountered Turner's watercolours when he left art school in the mid-Twenties, through a small collection of drawings circulated by the Victoria and Albert Museum to Blackburn, and he utilised Turner's technique of drawing in cobalt blue ink for his records of buildings in the period 1940-42.[28] It was around the same point in the mid-Twenties that Charles Knight began to study Cotman's drawings, spurred on by a *Studio* special issue on the artist. He copied Cotman in Norwich, and now recalls, '. . .it was the fashion to imitate the Norwich School'.[29] When, in 1943, *Country Life* declared, 'Charles Knight is an unsurpassed technician in the Cotman manner',[30] it indicated a model of British art where 'Old English' watercolour techniques had a currency irrespective of

historical moment. Yet Knight's 'imitations'[31] were different from the products of another antiquarian revivalist of the same generation, John Piper. When Piper began his research into and pastiches of the Picturesque tradition – Cotman included – in the late Thirties and early Forties,[32] he re-theorised the Picturesque within Modernist paradigms of play with frames, and 'expressive' paint surfaces. Nevertheless, assimilation to tradition, a realigned British cultural tradition, beckoned to him, too.

4 John Piper: Authority and the House of Windsor

Perhaps the most celebrated 'Recording Britain' drawings – indeed perhaps the most celebrated British drawings from the Forties altogether – were not formally commissioned for the scheme at all, but were made for HM The Queen. They concluded the June 1942 London exhibition and were immediately enrolled into a national tradition, while their author was fêted. In his suite of Windsor Castle drawings, Piper deconstructed the elements of antiquarian topography yet still managed to evoke the resonances of previous watercolour representations by 'the Georgian, Paul Sandby'.[1] Piper benefitted from the aura of royal prestige surrounding his task of 'Recording Windsor for the Queen'.[2] That he could work successfully in both antiquarian and Modernist registers at once, with a 'contemporary vision combined, mysteriously, with the spatial dignity of Cotman',[3] gratified his fellow 'Recording Britain' artist, Michael Rothenstein. The drawings were triumphantly hung on the end wall of the last main room in the National Gallery exhibition and through their size and Neo-Romantic bravura they were grandly 'out of tune'[4] with the intimacy of the other drawings in the show. It was the moment of full recognition for Piper, a turning point in his career. On 24 June the national dailies' critics

were unanimous in identifying them as the exhibition's keynote pictures, both theatrical and Gothic.[5] With the drawings Piper addressed the topic of the grand country house which Clark had identified as about to disappear in his original programme for 'Recording Britain'; yet the pictures, while amply displaying that apocalyptic tenor, were construed as images of the stormy renewal of an old order rather than documents of its collapse.

The following day *The Times* editorial singled out Piper by virtue of the royal commission which had its origin in the Queen's visit to the first 'Recording Britain' show with Sir Kenneth Clark the previous year. The general point which recurred in press comment upon the Windsor drawings was their demonstration of the renovated and modern outlook of the monarchy itself:

Her Majesty is known as a discriminating collector of contemporary pictures and it was a happy thought on her part to commission from a modern artist his own individual renderings of one of the classic subjects of English topographical art.

The knot of tradition and modernity was bound tightly around the royal warrant and sanction for a Neo-Romantic topography. The hallowed site spoke the proper name of the royal family itself; Piper had painted not just the castle but the prime symbol of Britain – the House of Windsor. The possibility of another 'return' arose, a return to royal patronage of art.

This would be, in Raymond Mortimer's *New Statesman* comment at the end of the first week of this exhibition, an exemplary rebuke to the 'proud philistinism' of 'our governing class'.[7] And a link to royal patronage was secured by 'Recording Britain' over the following few years: Vincent Lines, one of the young draughtsman disciples, with Thomas Hennell, of A.S. Hartrick, painted eight

watercolours for the Queen in 1943-4 of the line of elms before and after felling on the Long Walk in the grounds of the castle.[8] (The threat to trees from wartime felling figured high in the CPRE's roster of anxieties.) Following this his name was put forward as possible drawing and painting tutor to Princess Margaret; Lines was unable to accept the post but in his stead Charles Knight filled the role until 1946.[9] Piper's triumph as a new topographer was entwined with the fairy-tale narrative of the British monarchy: the successful June exhibition of 'Recording Britain' was also represented as a fairy-tale rescue and transformation of topography from neglect. Eric Newton in *The Listener* significantly offered a royal allegory: 'And now at last Prince Charming (disguised as a Government Department) has led this poor Cinderella of topography forward into the light once more and set her on a nice throne.'[10]

A new school, a new topography, hailed in Piper's name at the second 'Recording Britain' exhibition, was fully enthroned by the critical responses to the third and final show. We might trace a genealogy from Nash's teaching at the Royal College of Art in the mid-Twenties, when the stylistic fathers, Ravilious and Bawden, emerged, to the moment of Piper's call to (British) order in his 1937 essay 'Lost: A Valuable Object',[11] and his rededication to landscape; through, finally, to the appearance of Kenneth Rowntree and Barbara Jones within the 'Recording Britain' scheme. The formal values of linear *claritas*, the priority which Nash had announced in Unit One, were shifted by Rowntree and Jones from abstract or surreal Nashian 'places' to specific, often dilapidated, topographic sites, in the course of the scheme. Hard and definite (as against Piper's transparent and ambiguously decorated, theatricalised planes), Rowntree and Jones kept a fascinated distance on the signs of the past, forming what virtually amounts to a kind of crisp 'Magic Realist' style. A strain of *neue sachlichkeit* melancholy

codes their itemising of a disused, disjointed Britain. In this respect Ravilious was their true point of departure: the Ravilious whom Piper admired, making thin lithograph versions of crafted Victorian shop frontages where 'there is the suggestion that you are looking in at a series of gay old-fashioned parties from a matter-of-fact street in the present'.[12] This motif of bitter-sweet nostalgia and alienated topography was found in the work of Rowntree and Jones by Curius Crowe in 1943:

. . . where the early watercolourists were drawn to scenes of departed Roman or Mediaeval grandeur, these young artists tend to react to the grotesque or pathetic contrast between the intention and present use of a place or nostalgically to some scene of traditional but not necessarily elegant peace.[13]

That sense of distance, uncanniness and dislocation attending the modernist observer of antiquarian sites might possibly be related to the displacing 'motor-touring' travelling habits of the 'new topographers' in their travels. While A.S. Hartrick in 1939 admitted that, to see good examples of stained glass in parish churches, 'With a car much ground can be covered; but the ideal way. . . is to go on foot. The destination then acquires romance and may become a haven of solitude.'[14] If Hartrick's spartan follower, Thomas Hennell, insisted on moving long distances to draw subjects for 'Recording Britain' on his bicycle, the 'new topographers' travelled in high-performance motor-cars: Piper used his Lancia to visit parish churches and Rowntree had an Alvis two-seater 'Doctor's Special'.[15] However, the church could be experienced as a sanctuary and sovereign remedy for modern existential terrors: this was a crucial principle for the significant group of Christian artists working for 'Recording Britain'. Thomas Hennell, for example, was a lay preacher for the Church of England. We cannot

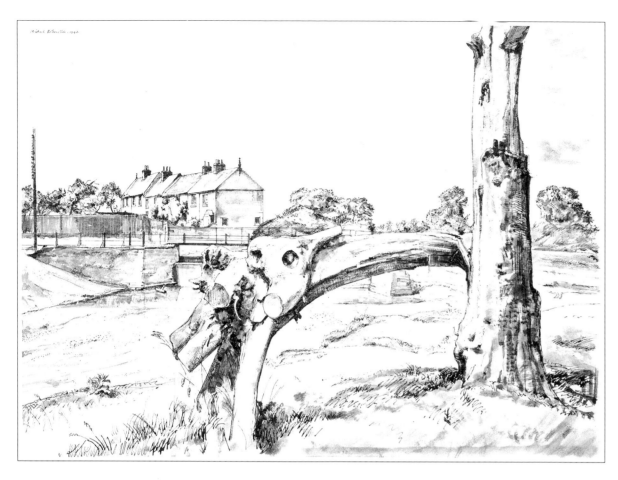

Michael Rothenstein (b. 1908)
SUNNY TERRACE, NORBY, THIRSK, YORKSHIRE, 1940

Combining distant views of buildings – churches, manor houses or, as in this case, a terrace of houses – with close-ups of uncanny objects, Rothenstein lent a surrealist aspect to his landscapes. Here, a lightning-blasted tree, itself an unlucky portent, is transformed into an alien monster which bars the way to the everyday. Rothenstein's drawing exemplifies the way in which artists working for 'Recording Britain' could represent the idea of a threatened countryside

Church and king, queen and castle formed the buttresses of Piper's imaginary system of authority during the period of 'Recording Britain'.

5 Kenneth Rowntree; Writing, Religion and the Category of 'Popular Art'

If Arnold Palmer was the gate-keeper to 'Recording Britain' for RWS members, together with William Russell Flint, then Sir Kenneth Clark still maintained his own patrician patronage by bringing forward nominee artists such as Piper, Graham Bell and Kenneth Rowntree. Clark asked Rowntree for his curriculum vitae in November 1939,[1] but they had become friends earlier that year. There had been a commission for a jacket design for a book written by Clark's wife, Jane; more importantly, Rowntree was asked by Clark to paint a picture of his favourite neighbourhood pub in Hampstead:[2] he was earmarked as a topographer. Rowntree entered the scheme in its first 'season'; in his native Yorkshire and in Derbyshire, he represented the sporadic environmental interruptions of road markings, telegraph poles, ladders, scaffoldings and profane environmental clutter, as a modernised overlay around sites like *Castle, Sherif Hutton* or *Guisborough Priory,* (page 159). This was a Nashian tactic which he shared with Michael Rothenstein whose views onto ruined abbeys and cottages were invariably fore-

adequately analyse Piper and Rowntree's representations of churches and chapels without the contextual framework of their own religious beliefs. Similarly, Mildred Eldridge's drawings of upland Welsh chapels, such as *Addoldy-y-Bedyddwyr, Glyndyfrdwy,*[16] or *Baptism in the River Ceiriog (*page 59),[17] should be understood in the context of her marriage to the Rev R.S. Thomas of the Church of Wales and poet of an austere Christianity in the bleak, peasant, 'desert of Wales'.[18] In 1937 Piper annexed the (Welsh) Non-Conformist chapel as a distinctive part of his personal iconography. This came at the very moment that he embraced topography as a genre that would

effect his salvation from abstraction.[19] In 1939 Piper was received into the Church of England, a decision motivated in part by his rejection of modernism and his need to cleave to craft and *métier* certainties in a gesture of cultural conservatism. Piper's biographer Anthony West describes a trajectory whereby, in 1939, he

ceased to aspire to be an artist in the Bohemian sense of the word and became a craftsman, resolved, without any priggishness, to live out his days, humble before God and his craft, fulfilling his Christian duty to make full use of the talents he had been endowed with. . .[20]

grounded with his versions of Nash's *Monster Field* or formalised gardening paraphernalia.[3] Rowntree's flat and segmented drawings became sharper and more precise in recording derelict churches and chapels in Essex; his first two 'seasons' were 'a great self-education in water-colour'.[4]

Following his Quaker beliefs, Rowntree registered as a conscientious objector to conscription for military national service. Commissioned by Clark and the Ministry of Information for the War Artists Advisory Committee (WAAC), the other artists' employment measure of late 1939, Rowntree ran into continual harassment by military authorities because of his pacifism and his perceived risk to security.[5] The problems Rowntree encountered sketching dock installations did not attend his drawing of the interior and exterior of churches. Driving to them during the week, he would remain for two days or more, silent, 'absolutely solitary'.[6] At Tilty and at the Black Chapel in Essex, he represented the interiors as elating and intimate places – more as surrogate Quaker meeting-houses – where he experienced an uncanny company; they were 'the most exciting places I'd been in, with a feeling of being with people',[7] despite their emptiness. There was, he found, a quietist comfort in line with Quakerism in this vacant gathering; the comfort lay in his admiration for the signs, words and monuments of the interior that mediated between him and the dead. Nazi invasion was imminent; the current, July 1940, issue of the *Architectural Review* had an article by Geoffrey Grigson citing Thomas Hardy's vision of a church as 'a meeting place of the dead, the living and the unborn'.[8]

Rowntree's project at *Little Saling, Church of SS Peter and Paul, Essex* (page 171) resembles Walker Evans' 'records of an age before imminent collapse',[9] those stern meditations on the sparse furniture and decorations of sharecroppers' dwellings in southern USA that were known in Britain

through copies of his *American Photographs* (1938).[10] Like Evans, Rowntree orchestrated domestic objects in his stylistic vein of Magic Realism for apocalyptic times. At *SS Peter and Paul* the profile of an enamel milk jug is rhymed by Rowntree with the cursive carving of the pew end and the painted consecration cross on the wall behind. Antiquarian detail is raised in these drawings to a post-Cézannian formal strength unknown in the rest of the 'Recording Britain' scheme. They are modestly crafted drawings, their planes fitting together in an allegory of community and craft which Rowntree found crystallised in the seatings and box pews made by local carpenters at Whitby. He recalls the threat of invasion and bombing compounding their dereliction – 'Parish Churches . . . many of these will either fall down or be ruined . . .' went Clark's first programme for the scheme[11] – which compelled him to inventorise urgently the churches and chapels where 'the interiors looked tired and I wanted to get them down quickly',[12] before the blow fell.

Rowntree's chief device for his pictorial versions of Quaker quietism was to make the written word reverberate through his drawings for the scheme. His concentration on written texts in his church and chapel pictures is in contrast to Piper's Anglican preference for custom and decoration. Compare, for example, Piper's *Tombstones, Hinton in the Hedges* (page 122),[13] their baroque cartouches left blank and emptied out of inscriptions, with Rowntree's Evans-ish *The Livermore Tombs, Barnston* (page 68),[14] where the early Victorian epitaphs are minutely and exactly represented. This acute lettered naturalism was frequently criticised by reviewers: '. . . sometimes he seems carried away by a quaintly worded notice board or nice old lettering into reproducing it as a picture. This is surely to follow surrealism dangerously near to bathos.'[15] Unable to bear witness or to testify verbally as a Quaker, we might say that Rowntree found these words as *objets*, or rather

textes trouvés, and wrote them out again. The ecclesiastical writing of man and God is set up in *Whitby Parish Church* with the Ten Commandments, the Tablets of the Law. Here Rowntree reflectively noted another motto: 'But be ye doers of the word and not hearers only deceiving your own selves'. He indeed emerged as a 'doer of the word', but in a quietist way, through self-inscription, as a pictorial writer of the word. He focused on simple textual injunctions: for example, the gilded 'Praise the Lord' at Little Saling. In his drawings of non-church subjects he used lettering in a cubist play with the identity of objects – for example, in his painting of the bathroom of the inn at Ashopton where the letters spelling out bathmat are inverted and reversed, making a minimal sermon from the banal domestic text. 'I have come to realise' he said recently, 'that words are what my work is all about.'[16]

Rowntree's projection of Quaker order found its best monument in his drawing *Interior of the Friends Meeting House at Great Bardfield,* where the calm spaces of frontal planes open at a central door through which are revealed rows of wooden pigeon-holes for docketing letters. The themes of writing, quietism and Quaker thought are, literally, inked out, framed and then reframed within this self-referring picture. Exceptionally, parts of one or two of his 'Recording Britain' drawings resemble a clean page of writing paper, or a book, with white zones awaiting instructions, the word in troubled times. In *Underbank Farm, Woodlands, Ashdale* (page 63) Rowntree leaves a blank white board, where (he writes on the verso of the drawing) 'the water of the Ladybower Dam will reach'; thus the deluge, the apocalypse of the countryside envisaged by the CPRE, met with Rowntree's own place of writing, which was empty for once.

'As for Mr Rowntree, who is stiff and harsh . . . he will also have his admirers',[17] wrote Maurice Collis in 1942, when Rowntree's drawing of Shelley's

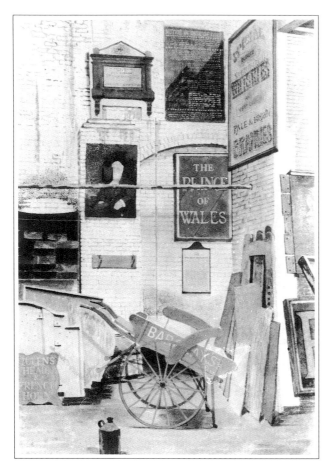

Kenneth Rowntree (b. 1915)
THE SIGNWRITER'S SHOP, SOUTHWARK

house at Portmadoc, *Tan-yr-Allt,* was used as the poster for the 'Recording Britain' show at the National Gallery. The 'stiff' style of Rowntree had many connotations at this time; Collis was identifying it with the *faux naïf. Tan-yr-Allt,* made up as a painting, with its flush Regency surface planes, the crisp and flattened, almost heraldic detail, acted well as a poster. It was painted in a mode which answered to Thomas Hennell's call for a probity in technique based on commercial craft techniques which were almost lost. Hennell had in mind the flat suavities of the coach-building painters: 'Never was painting done more soundly and permanently than by these tradesmen',[18] he

wrote in *British Craftsmen.* We could trace this line of reasoning back to the 'Old English' painters of around 1900, such as James Pryde and William Nicholson who looked to a Tory tradition of inn signs and sporting prints. This strain in iconography (rather than technique) – a vernacular tradition in art and design, of which Charles Knight in his Ditchling Handworkers Guild enclave was still a part – was being comprehensively re-examined by another of the 'new topographers', Barbara Jones. In his initial plans for employing artists, based on the US Federal Arts Project, Clark had noted that '400 artists are employed on the preparation of an index of American design forming a pictorial record of American decorative arts from 1620 to 1900'.[19] There can be no doubt that Clark saw that one of the aims of 'Recording Britain' might lie in such a direction, to assemble, however piecemeal, fragments of a British vernacular decorative art.

It is under such a rubric that we might understand drawings such as Walter Bayes's *Naval Relics, Millbank,*[20] with its colossal folk effigies of ships' figureheads or Barbara Jones's masterpiece of uncanny merry-go-round figures, *Savages Yard, King's Lynn* (page 121).[21] The *Architectural Review* had used the world of the folk-decorated merry-go-round as a site of authenticity and tradition over and against the depthless modernism of the New York World Fair in 1939: 'The world of yesterday, richly gilt, boisterous, rather than uncontrolled, prances past the newer, taut simplicity of the world of tomorrow. . . a somewhat vague utopia'.[22]

Other projects to revalue the pre-modernist tradition in design culture were being pursued by artists in 'Recording Britain'. Enid Marx, who drew Victorian shop signs for the scheme in St John's Wood, seems to have been an earlier and more consistent retriever of the vernacular than Barbara Jones. Marx's pioneering study *English Popular and Traditional Art* (1946) appeared in

the same series, 'Britain in Pictures' (edited by the Georgian journalist, W.J. Turner),[23] as Hennell's *British Craftsmen.* The same paradigm of a vernacular culture was explored by Olive Cook, a 'Recording Britain' artist who also worked at the National Gallery. Olive Cook and Edwin Smith's contributions to the annual *Saturday Book,* beginning in 1941-2, mapped British design and popular taste[24] in terms of etched pub glass, Victorian religious mottoes, Edwardian shop windows and dilapidated windmills. This lexicon is suggestive of the sub-group taste which prevailed among Enid Marx, Barbara Jones, Olive Cook and Edwin Smith. They particularly favoured Louis Meier's antique shop in Cecil Court and the second-hand booksellers of the Farringdon Road,[25] but the pursuit of the vernacular was competitive; if one of the group saw something piquant in a junk-shop, 'you couldn't tell Barbara [Jones] or she'd be there ahead of you'.[26] Rowntree enters this world with his watercolour *The Signwriter's Shop, Southwark.*[27] This drawing resembles the English marriage of Ben Shahn and Giorgio de Chirico. A cart, pale red and lettered, stands in front of a courtyard full of inn signs that are displayed like paintings stored in a museum basement. Like Barbara Jones's *Savage's Yard,* it is an image of the abandoned remnants of a popular culture which is now being read as found modernist art, of *written* signs that are stacked like canvases, signs detached by Rowntree from the culture of the London pub, with other destinations and ends.

6 The Context, Uses and Public of the 'Recording Britain' Exhibitions and Tours

'Recording Britain' was not unique as a national scheme to document landscape and historical buildings in the first half of the 1940s. Other agendas looking to the future of the land and its architecture, where the antiquarian priority was not uppermost, were set by parallel organisations

and exhibitions. Nevertheless, the imperatives of post-war planning and reconstruction needed an historical framework and this was the function of Ralph Tubbs's systematic exhibition about past British building types, called 'The Englishman Builds'. It was held at the National Gallery in October 1942, three months after the second 'Recording Britain' show: 'the National Gallery shows the evolution of this most national art from the castles and churches of the Normans. . . and indicates lines on which they may fulfil the needs of the coming age'.[1] An entire section was devoted to Great Coxwell Barn as a vernacular structure where 'the medieval builders made fine architecture when building for their everyday needs'.[2] Such functionalist discourse was implicit at every point in this and the other parallel exhibitions; photographic blow-ups and modernist display techniques adapted from German and Soviet Twenties designs were used in contrast to the framed watercolours in a traditional hang for 'Recording Britain'. The prominence of the Great Coxwell Barn in the Tubbs exhibition seems to have prompted Palmer and Piper to record the tithe barn for the third and final 'Recording Britain' show in 1943, giving that 'colour and character' which Kenneth Clark felt made watercolour drawings rather than photography 'essential', in his outline for the scheme in 1939.[3] Topographic records, Clark believed, 'cannot be rendered by photography',[4] yet the populist responses to the revival by 'Recording Britain' of the endangered watercolourist were disbelieving on this score.

At Slough Library in September 1942 a small selection of drawings from the scheme, dubbed 'Beautiful Britain' and toured by the Council for the Encouragement of Music and the Arts (CEMA), ran into scathing local criticism. The columnist 'Sweep' castigated the project: 'If cranks like to paint that way. . . that is their affair. Far better had they enlisted an army of photographers to do the job.'[5] 'Sweep' probably knew very well that just

such an enterprise had been underway for more than a year with the National Buildings Record (NBR). The Pilgrim Trust had given a grant of £2,000 in 1941 and again in the following year to help fund, with additional Rockefeller money, a vast record of English architecture. The same factors of fear of dereliction and harm from war that fuelled the formation of 'Recording Britain' helped to establish the NBR. Clark was, unsurprisingly, the prime mover once again. As the Blitz began in the autumn of 1940 he urged, through the Ministry of Information, a Record of Historic Buildings.[6] His efforts 'to make a record of all meritorious buildings'[7] resulted in discussions with John Summerson who became Deputy Director of the NBR in February 1941 under the chairmanship of the Master of the Rolls. In the period of the Blitz, with the probability of invasion creating a national emergency, 'the need for a speedy record dictated the almost exclusive use of the camera', a writer for the Pilgrim Trust reported, looking back from 1943.[8] By the time 'Recording Britain' had commissioned and purchased 727 drawings in the summer of 1942, the NBR 'had in its care 130,000 photographs and to this number several thousand a month are being added. . . The whole of Georgian Exeter has been dealt with a few weeks before the Nazi visitation'.[9] The scope of the NBR, like that of 'Recording Britain', was inclusive, plural; it encompassed 'not only cathedrals and colleges but non-conformist chapels and vernacular and industrial buildings where these have any claim to value in the light of art and history'.[10] The NBR's role as the systematic shadow of 'Recording Britain' was made plain in June 1944 when parts of its immense photographic documentation were exhibited at the National Gallery.[11]

Divided up into several small exhibitions called 'British Chronicle' and 'Beautiful Britain', 'Recording Britain' was enlisted in 1942 into collectivist and populist cultural initiatives as part of the

British Institute for Adult Education's (BIAE) 'Art for the People' tours. The paintings of the scheme, previously seen only at the National Gallery, were now returned to the provincial heartlands from which they came. These touring shows were under the directorship of Bill Williams and funded by CEMA, which in its turn was sponsored partly by the Pilgrim Trust until 1943. County by county, the exhibitions proliferated at a grassroots level of institutions. For instance, in Lincolnshire in 1942, the Lindsay Rural Community Council, with the support of the YMCA and BIAE local offices, showed 'Art on a Rural Tour' at six venues. The following year three exhibition units – one of children's art, one entitled 'Living in the Country' based on the Scott Report on land as a national asset, and one 'Recording Britain' unit entitled 'British Chronicle' – were circulated through the county's grammar schools.[12] Education committees, the Workers' Educational Association (which Williams had headed), and the local county library, all tended to be to the fore in each county in securing and administering the shows.

These were often presented in terms of *kitsch* versions of fictions about the countryside. In Bristol in October 1942, an exhibition by 'Recording Britain' entitled 'Lovely Britain' was announced as covering 'the delightful old-world cottages of villages',[13] while in Derby the press release indicated the targeting of 'all lovers of pastoral beauty. . . art lovers. . . and last but not least. . . the ordinary man and woman, because it records their homely surroundings and peaceful occupations'.[14] The form of address to the 'ordinary man and woman', that abiding myth of the collectivist imagination in Forties Britain, was strengthened in the exhibitions themselves since guides from the BIAE would escort visitors around the shows and direct their viewing; these attendants were 'quite ready to talk informally . . . to try to help visitors, to persuade them that modern art is not merely a leg-pull and to show them what to look for'.[15] (It was the

presence at a 'Beautiful Britain' exhibition of one such 'propagandising' guide-lecturer that had enraged the journalist 'Sweep' in Slough Library.)

The Pilgrim Trust was clearly worried about the potential collectivist uses to which the pictures might be put. In 1942, at the height of the populist drive by CEMA to circulate 'Recording Britain' beyond the capital and outside conventional settings for art exhibitions, Tom Jones, the Trust's Secretary, refused permission for the pictures to be shown in what was becoming the regular provincial city site location for BIAE/CEMA shows, the mass canteen facilities known as British Restaurants. Clark, furious, defined the argument for wider access to the drawings through the British Restaurants: 'it provides the only practical means of bringing pictures to the people, especially workers, who would never have the leisure to see them . . . thousands every day instead of the hundreds who visit libraries and similar institutions'.[16] Not only were the Pilgrim Trust unwilling to carry through CEMA's populist logic in exhibiting the records, but they also barred the way, despite many requests, for relatively inexpensive books of illustrations to be made from the drawings. Philip James, the Deputy Secretary of CEMA, had suggested in March 1942 that Penguin could publish a paperback selling at about 1s with a print run of 50,000. The Trustees decided that they would reserve the rights of publication until a quality format could be agreed upon.[17] It was not until October 1944 that what proved to be a protracted publication programme, spread over five years, was embarked on with the Oxford University Press. The 'beautifully produced volumes',[18] costing £5 guineas for each set of four, had sold 8,253 copies by 1950.[19]

As it was, the provincial 'Recording Britain' exhibition tours had functioned on an extensive enough scale. Fitting into place as part of city festivals sponsored by CEMA in the summers of 1942 and 1943, they had often been consciously designed as part of a package of compensatory holiday experiences for war workers who were being encouraged not to take vacations. This piece of Ministry of Information(MoI)/CEMA manipulation was distributed at national and provincial level by the press. The *News Chronicle* revealed the drift of this in its review of the National Gallery show of June 1942, 'Queen's Pictures at National Gallery':

Miss Mona Moore's East Anglian paintings have a lyric atmosphere that is almost a substitute for a holiday in Norwich. . . Hooper's Ham and Petersham discovers Georgian architectural delights that compensate a Surrey man for staying at home.[20]

Through June and July of 1942 and again in 1943 the propaganda slogans for domestic consumption – 'Holiday-at-Home' and 'The Stay-at-Homes' – became ubiquitous in the media. The exhibitions by 'Recording Britain' were aligned with these campaigns. A recurring phrase, presumably from a CEMA press release, found its way into the coverage of provincial shows: by attending the 'Beautiful Britain'/'British Chronicle' show, 'the visitor will be able to enjoy many of the beautiful scenes of our country with the minimum of travel'.[21] The continuing campaign to persuade the population not to use the railways to travel came up as a constraint which CEMA's exhibitions would make void:

Before the war, the beauties of southern England were one of the great joys for holidaymakers, it was the custom for a large section of the population to roam in their cars . . . Today when every station is placarded with the slogan, 'Is Your Journey Really Necessary?' and when holidays are short, such pleasures are past. CEMA, has however, stepped in to fill the breach and has sent . . . as a record of the beauties of southern England an exhibition of pictures by contemporary artists who should attract every holiday maker in spirit.[22]

The Manchester *Evening Chronicle* led with the headline 'The "Stay-at-Homes" Ask for Drama, Music and Art'.[23] This governmental management of leisure and fantasy in which 'Recording Britain' was only one special attraction, was not, it should be said, covert; on the contrary, the linkage between the persuasion of the population and the role the exhibition had to play was made transparent in a kind of hectic celebration of propaganda. The same *Evening Chronicle,* for example, reported that:

The government's campaign for workers to spend their 'holidays-at-home' is meeting with great success. All over Britain, villages, towns and cities are competing with each other to make their programmes more attractive. Nationwide plans are being made by CEMA in co-operation with the government . . . The Recording Britain series have been loaned for exhibition throughout the county.[24]

Found in such statements was an enthusiasm for a collectivist, peculiarly English form of city and village festivals; events that drew upon the pool of pastoral iconography which had been accessed by 'Recording Britain'.

7 The End of the Scheme: the Brewers, 'The Londoner's England' and the publication of Recording Britain

The last year of 'Recording Britain' was 1943; on 5 January 1944 *The Times* carried an article headed 'End of War-Time Scheme for Artists'. The period of national emergency had ended with the close of 1942 and the reassertion of Allied military might at Stalingrad and El Alamein. The fears of whole-

THE
LONDONER'S
ENGLAND

CONTEMPORARY WATER-COLOURS AND DRAWINGS OF
LONDON AND THE HOME COUNTIES REPRODUCED 'BY
COLOUR AND MONOCHROME LITHOGRAPHY & BY HALF-
TONE: ASSEMBLED & EDITED WITH DESCRIPTIVE TEXT
BY ALAN BOTT

AVALON PRESS & WILLIAM COLLINS

Title page, The Londoner's England, *1947*

sale dereliction and destruction on British soil had not been realised. And while CEMA waxed in power – to the point where it emerged as the Arts Council of Great Britain in the summer of 1945 – 'Recording Britain' dwindled; the counties had been, for the most part, surveyed and drawn, and most crucially, emergency relief measures to employ artists were no longer necessary. But it was not the end at all. The Ministry of Labour Committee for the Employment of Artists in Wartime had foreseen in 1939 that 'should it ['Recording Britain'] meet with success . . . we have little doubt that other benefactors will be forthcoming to enable the work to be continued'.[1] And so they were. When Kenneth Rowntree painted *The Signwriter's Shop, Southwark* late in 1944, after a V-rocket

attack, he was no longer working for 'Recording Britain' but for a consortium of brewers who were funding an extension of the original scheme.

The big brewers had been inclined, like the petrol companies, towards topography for publicity.[2] The members of the Brewers Society were particularly well integrated with traditional British power élites, especially the Conservative Party, and during the war they had collaborated with the MoI by volunteering their advertisements and poster spaces for government publicity through their regular advertising agent, Sir William Crawford. In the early spring of 1944 'Recording Britain' began a privatised afterlife after the end of Pilgrim Trust funding. The CIAD formally announced from the National Gallery that four large brewery firms, Messrs Barclays, Courage, Watney Combe and Reid, and Whitbread were now financing a project to be called 'The Londoner's England'. 'Artists will be commissioned to make watercolours and other drawings of scenes in London and the surrounding counties which are within the Londoner's daily reach.'[3]

The project's rationale was entirely shifted by this geographical reduction in scope. Despite the normative aspect of the topographics of 'Recording Britain' and its mandate during the national emergency from 1940 to 1943, there still remained an arcadian or idyllic dimension to the drawings that was never entirely regulated. In his exposition of Neo-Romantic ideology in 1942, Alex Comfort wrote about the role of the artist in the national emergency, confronting '. . . the collapse of urban centralism'.[4] Thus, while the original project had engaged with this cultural dispersal by virtue of its sites across most of the counties of England and its exhibitions in places outside London, the big four brewers' project recentred itself from within a metropolitan and Home Counties perspective. The committee of Flint, Jowett, Clark and Palmer was retained in the privatisation, and finance flowed in. Palmer had managed without a telephone be-

RECORDING BRITAIN

VOLUME IV

Wiltshire · Somerset
Cornwall · Devon · Dorset · Hampshire
Sussex · Kent

EDITED, WITH NOTES, BY
Arnold Palmer

Geoffrey Cumberlege
OXFORD UNIVERSITY PRESS
in association with
THE PILGRIM TRUST
1949

Title page, Recording Britain *Vol IV, 1949*

fore in his office; a line was now installed in April to cope with the running of the new scheme.[5] And while the old flat rate of payment had been £3 per drawing, £65 was mentioned as a fee by the brewers' consortium. Clark was reportedly astounded and dubious: 'This', he is alleged to have said, 'is the kind of money to make artists swell-headed'.[6] As a compromise the artists were offered 15 guineas per piece of work. Funds now slopped around unused and Palmer would regularly telephone artists like Wilfred Fairclough on duty at RAF Medmenham to tell him that there was money to spend if only he could make some drawings.[7]

Just as Clark had his programme for 'Recording Britain' – an agonised iconography of doomed types of building or tracts of 'threatened' country-

side – so the big brewers had theirs. The CIAD announcement contained the simple point that the finished pictures were to be displayed in inns and hotels. There was a hidden assumption of unproblematic illustration amounting to an insinuating advertisement for the brewers' world. The artists were nudged towards brewing-related motifs – hence Rowntree's *Signwriter's Shop*, with its plethora of inn signs. 'A pub, as a subject, would be agreeable', was the instruction given to artists.[8] Even the contemporary Forties photographic advertisements for the brewers in the series 'This England' used topography in a less nakedly promotional manner. A high proportion of the drawings that were published in 1947 in Alan Bott's selection The *Londoner's England* included town- or village-scapes that contained within the picture tell-tale pub signs. Bott's introduction to the book defensively rejected the likely charge of the brewers' undue influence over the project:

There is not, and never has been, a bargain for any subsidy for the book, direct or indirect. Because they are public spirited, I presume that Messrs Whitbread, Messrs Watney, Combe, Reid, Messrs Courage and Messrs Barclay, Perkins brew good beers . . . If there are public houses among the plates in this book, it is only because pubs are a cherished part of London life . . . If there are likewise one or two breweries, it is because these breweries were notable details of the composition.[9]

The pub had undoubtedly been a key component of the new vernacular topography of 'Recording Britain'; we should recall that Rowntree's career had begun with Clark's commission to draw his neighbourhood Hampstead pub. Piper had made the pub an element of his Neo-Picturesque writings in the late Thirties and early Forties, especially in his essay of 1940, 'Fully Licensed',[10] while in the same year Edward Ardizzone illus-

trated Maurice Gorham's book *The Local*. The new topographers, during the period of cultural and national emergency from 1940 to 1943, with which 'Recording Britain' coincided, believed that pubs 'represent[ed] . . . a vernacular tradition for whose disappearance the country would be much poorer'.[11] With the 'Londoner's England' project they ran into the promotional use of a 'beer and skittles' iconography which redefined those vernacular connotations in the big brewers' interests.

Palmer set out, with the scheme wound up, to prepare his text for the volumes of 'Recording Britain' which the Oxford University Press were to publish. From 1945 to 1948, into the depths of post-war austerity, he made long journeys across the Britain to which he had dispatched his artists. Apart from being prevented by a blizzard from reaching Malvern in the hard winter of 1947,[12] he visited all but one of the 450 or so sites that were illustrated in the OUP set. Going out by train and then hired car or taxi, Palmer discovered a ramshackle country. It was a spectacle that depressed him[13] and one that finds its way into the book, not just at the level of Palmer's witty jeremiads, but also in the muted sadness of the reproductions, design and bindings. The elaborately etched off-set half-tone blocks and the duotone processes used by the printers lent 'a certain demure brown sameness'.[14] The bright, vulgar colour of vernacular decoration and paintings of merry-go-rounds and canal boats that Jones and Rowntree had sought out as a sort of restorative derived from *art forain*, while visible in their original drawings, was neutralised in the context of the book. Metaphors of the pale, the dull and the misfitted occur in the first reviews, which found Volume 1 'curiously disappointing'.[15] The social context of austerity – which in British painting in the second half of the Forties led to a craving for the uncensored colours of the Mediterranean – gave a representation, of a pale British culture, 'without lustre', yet intact, however ramshackle. Here was the wan face of the

land, recorded by Clark and Palmer's reparative strategy, which had come through and survived the apocalypse.[16] It was this meaning that lay behind the gesture of the Prime Minister, Clement Attlee, when he dispatched a copy of the first volume of *Recording Britain* to representatives of twelve nations of Europe in December 1946, – a gift signifying 'Britishness'.[17]

FOOTNOTES AND REFERENCES

1 The Establishment of the Scheme

1 Sir Kenneth Clark to Humbert Wolfe, 3 October 1939, National Gallery Archives.

2 From John Buchan's preamble to the Trust Deed of 1930, cf *The Pilgrim Trust*, nd, p3.

3 2,899 sets were exported to the USA out of the total of 8,253 sets sold.

4 Arnold Palmer, Secretary to the 'Recording Britain' Committee, worked for the London end of another US charity, the Carnegie Institute.

5 For opinions and debates on state patronage of the arts, see Raymond Mortimer 'CEMA' *New Statesman*, 3 October 1942, pp219-20: 'Should Britain have a Ministry for the Fine Arts'?, *The Studio*, February 1943, pp51-6.

6 Humbert Wolfe to Sir Kenneth Clark, 25 February 1939, National Gallery Archives.

7 *CPRE Annual Report, 1939-40, p7.*

8 See Sir Kenneth Clark to Humbert Wolfe, October 1939, *op cit*.

9 See 'Appendix on FAP', 26 October 1939, National Gallery Archives.

10 2nd Interim Report, 21 December 1939, National Gallery Archives.

11 'Scheme for Recording Changing Aspects of England', Pilgrim Trust Archives.

12 *Ibid.*

13 This contrasts with the experience of another 'Recording Britain' committee member, the President of the Royal Watercolour Society (RWS), who managed to raise £4,000 by telephone from the Pilgrim Trust to pay

for the RWS' premises' rent a few years later, of Sir William Russell Flint 'From Pall Mall to Conduit Street', *Annual of the Old Watercolour Society Club,* Vol XXX (1953), pp13-17, p17.

14 'Scheme for Recording Changing Aspects of England', Pilgrim Trust Archive.

15 Eg, see the work of Bill Brandt in wartime discussed in D. Mellor 'Brandt's Phantasms', *Bill Brandt/Behind the Camera,* 1985, p89.

16 'Scheme for Recording Changing Aspects of England', my italicisation.

2 Administering the Scheme: Arnold Palmer

1 Sir Kenneth Clark to Arnold Palmer, 24 October 1939, National Gallery Archives.

2 Arnold Palmer to Sir Kenneth Clark, 23 October 1939.

3 This generous trait was spontaneously mentioned to the author by all interviewed surviving painters for the scheme.

4 Interview with Felicity Palmer, January 1990.

5 For an account of the Georgian pastoral 'catalogue poem', see Robert V. Ross *The Georgian Revolt,* 1967, p251.

6 'Editorial', *The Times,* 25 June 1942.

7 Sir William Russell Flint, a 'Recording Britain' committee member together with Clark and Jowett, was a noted admirer of Brooke's poetry, of R. Lewis and K. S. Gardner *William Russell Flint,* 1988, p19.

8 And in the case of Fairclough draw the front elevation of The Grange in cobalt blue for Palmer's collection.

9 Felicity Palmer, *op cit.*

10 Author's interview with Olive Smith, January 1990.

11 Pilgrim Trust Sub-Committee Report, 22 April 1941, Pilgrim Trust Archives.

12 'Scheme for Recording Changing Aspects of England', *op cit.*

13 However, for others like John Piper, real hardship was being encountered. Author's interview with John Piper, January 1987.

14 Author's interview, Wilfred Fairclough, January 1990.

15 Author's interview, Kenneth Rowntree, January 1990.

16 Olive Smith, *ibid.*

17 AP, undated note, probably *c*1946, Pilgrim Trust Archives.

3 The CPRE, Charles Knight and the Practice of a Watercolour Tradition

1 CPRE *Wartime Progress Report and Annual Report,* 1939, p15.

2 *Ibid.*

3 Meeting of the Committee for the Employment of Artists in Wartime, 1 November 1939, National Gallery Archives.

4 'Scheme for Recording Changing Aspects of England', Pilgrim Trust Archives.

5 CPRE *Wartime Progress Report. . . , ibid,* p6.

6 *Ibid,*

7 *Ibid,* p21.

8 CPRE *Wartime Progress Report,* July 1940-July 1941, p13.

9 See R. T. Hodges-Paul, 'Charles Knight', *Annual of the Old Watercolour Society Club,* Vol XXXVI, 1961, pp43-57.

10 Charles Knight, interview with the author, January 1990.

11 *Recording Brittain,* Vol IV, p145, 1949.

12 Charles Knight, *ibid;* see also Palmer's remarks on one of these views, *ibid,* p174.

13 Charles Knight, *ibid.*

14 R.T. Hodges-Paul, *op cit,* p51.

15 *Ibid.*

16 For a rural example, see *The Titfield Thunderbolt* (1953), and as an urban one, *Passport to Pimlico* (1949).

17 CPRE *Monthly Report,* February/March 1939, pp25-6.

18 *Ibid.*

19 Herbert Read 'English Watercolours and Continental Oils', *The Listener,* 24 July 1941, pp121-2.

20 Curius Crowe, *op cit.* p418.

21 Eg, '. . . his [the watercolourist's] survival is important', 'Landscape and Topography' *Country Life,* 3 July 1942, p36.

22 E. T. Holding, 'In Praise of Watercolour', *Annual of the Old WaterColour Society Club* [AOWSC], Vol XVII, 1940, pp63-7.

23 *Ibid,* p66.

24 His affectionate involvement with the RWS was mentioned by almost all those survivors or relatives the author interviewed, particularly Olive Smith, Wilfred Fairclough, Charles Knight and Felicity Palmer.

25 A. Palmer, *More than Just Shadows,* 1943, p22.

26 Kenneth Rowntree, interview with the author, January 1990.

27 A. Palmer, *op cit,* p19.

28 Wilfred Fairclough, interview with the author, January 1990.

29 Charles Knight, *op cit.*

30 Curius Crowe, *op cit,* p419.

31 Charles Knight, *op cit.*

32 See Piper's essays for the *Architectural Review* during this period, especially 'John Sell Cotman', *Architectural Review,* July 1942, pp9-12, as an artist revived on account of cultural realignments after the fall of Fry and Bell's formalism in the Thirties.

4 John Piper: Authority and the House of Windsor

1 'Recording Windsor for the Queen', *The Sketch,* 1 July 1942, p17.

2 *Ibid.*

3 M. Rothenstein, 'Art Front', *World Review,* August 1942.

4 M. Collis 'Art', *Time and Tide,* 4 July 1942.

5 See *The Times,* 24 June 1942, comparing them with designs for *Macbeth* and T. W. Earp in *The Telegraph,* 24 June 1942.

6 'Editorial', *The Times,* 25 June 1942.

7 Raymond Mortimer, 'Recording Britain', *New Statesman,* 27 June 1942.

8 See M. Macleod, *Drawn from Nature,* 1979, p29.

9 R. T. Hodges-Paul, *op cit,* p56.

10 Eric Newton 'Recording Britain', *The Listener,* 2 July 1942, p7.

11 Ed Mfynwy Piper, *The Painter's Object,* 1937.

12 J. Piper, 'Lithographs by Eric Ravilious of Shop Fronts', *Signature* No5, March 1937, p48.

13 Curius Crowe, *op cit,* p418.

14 A. S. Hartrick, *A Painter's Pilgrimage Through the Years,* 1939, p242.

15 Kenneth Rowntree, interview with the author, January 1990.

16 *Recording Britain,* Vol III, p101, 1948.

17 *Ibid*, p103.

18 Mildred Eldridge, letter to the author, 2 Feb 1990.

19 See *John Piper*, Tate Gallery Catalogue, no33, 1983. John Betjeman remarked Piper's incorporation of the chapel in 'Non Conformist Architecture', *Architectural Review*, December 1940, pp161-74.

20 A. West, *John Piper*, 1979, p92.

5 Kenneth Rowntree: Writing, Religion and the Category of 'Popular Art'

1 Dated 4 November, National Gallery Archives.

2 Kenneth Rowntree, interview with the author, January 1990.

3 See, for example, Rothenstein's *Byland Abbey from the West, Recording Britain*, Vol II, 1947, p189.

4 Kenneth Rowntree, *op cit*.

5 See Kenneth Rowntree's WAAC file, Imperial War Museum.

6 Kenneth Rowntree, *op cit*.

7 *Ibid*.

8 Geoffrey Grigson, 'Architecture and Thomas Hardy', *Architectural Review*, July 1940, p2.

9 Lincoln Kirstein 'American Photographs', *American Photographs*, New York, 1938.

10 See Geoffrey Gorer, 'American Photographs', *The Listener*, 8 December 1938, pXV.

11 'Scheme for Recording Changing Aspects of England', Pilgrim Trust Archive.

12 Kenneth Rowntree, *op cit*.

13 *Recording Britain*, Vol II, 1947, p111.

14 *Ibid*, p12.

15 Curius Crowe, *op cit*, p419.

16 Kenneth Rowntree, *op cit*. See also John Milner 'Contagious Vision', *Kenneth Rowntree*, Laing Art Gallery catalogue, 1976.

17 Maurice Collis 'Art', *Time and Tide*, 4 July 1942.

18 Thomas Hennell, *British Craftsmen*, 1943, p18.

19 The Employment of Artists During the War Period, 26 October 1939, Appendix A.

20 *Recording Britain*, Vol I, 1946, p26.

21 *Recording Britain*, Vol IV, 1949, p163.

22 *The Architectural Review*, August 1939, p35.

23 W. J. Turner may be regarded as the godfather of Neo-Romantic illustration, skipping the generations to give opportunities to Craxton and others at the publishers, Frederick Muller.

24 Eg, 'Manners and Customs of the English', *Saturday Book* No 4, October 1944, pp7-64.

25 Olive Cook, interview with the author, January 1990.

26 *Ibid*.

27 Ed Alan Bott, *The Londoner's England*, 1947, pl 36.

6 The Context, Uses and Public of the 'Recording Britain' Exhibitions and Tours

1 'New Buildings', *Tribune*, 6 October 1942.

2 'The Englishman Builds', *The Builder*, 30 October 1942, p367.

3 Kenneth Clark 'Scheme for Recording Changing Aspects of England', Pilgrim Trust Archives.

4 *Ibid*.

5 'Odds and Ends', *Slough Observer*, 18 September 1942.

6 See Home Planning Committee meeting, 16 October 1940, Mass Observation Archive, University of Sussex.

7 *Ibid*, 20 November 1940.

8 Pilgrim Trust *Annual Report*, 1943.

9 John Summerson 'Bombed Buildings', *New Statesman*, 22 August 1942, p126. For a useful account of the history of the NBR, see Stephen Croad 'Architectural Records in The Archives of the Royal Commission on theHistorical Monuments of England', *Transactions of the Ancient Monuments Society, Vol XXX, 1989, pp23-44*.

10 *Ibid*.

11 John Summerson, 'The National Buildings Record', *Country Life*, 2 June 1944, pp943-5.

12 *Lincolnshire Chronicle and Leader*, 17 July 1943.

13 'Lovely Britain/Art Show in the Bristol Musuem', *Western Daily Press*, 12 October 1942.

14 Press release text carried by *Derby Evening Telegraph*, 1 August 1942 and *Derbyshire Advertiser*, 14 August 1942.

15 'Under the Clock', *Northern Dispatch*, 11 Aug 1942.

16 Sir Kenneth Clark to Thomas Jones, 22 July 1942, Pilgrim Trust Archives.

17 Correspondence in Pilgrim Trust Archives.

18 'Listener's Book Chronicle', *The Listener*, 8 November 1949, p415.

19 Geoffrey Cumberlege to Lord Kilmaine, 23 March 1950, Pilgrim Trust Archive.

20 *News Chronicle*, 26 June 1942.

21 See, for example, 'Recording Britain Show at Ryde', *Isle of Wight Times*, 8 July 1943.

22 *Ibid*.

23 *Manchester Evening Chronicle*, 25 June 1942.

24 *Ibid*.

7 The End of the Scheme: the Brewers, The Londoner's England and the Publication of Recording Britain

1 2nd Interim Report, Committee for the Employment of Artists in Wartime, 21 December 1939, 25 (c), National Gallery Archives.

2 See Jack Beddington's initiative over topographical advertisements for Shell from the mid-1930s.

3 'The Londoner's England in Wartime', *The Times*, 15 July 1944.

4 Alex Comfort, *Art and Social Responsibility*, 1946, p13.

5 Letter of request from T. A. Fennemore, CIAD, 17 April 1944.

6 Wilfred Fairclough, interview with the author, January 1990.

7 *Ibid*.

8 *Ibid*.

9 Alan Bott, 'Something About London', *The Londoner's England*, 1947, pp5-14, pp9-10.

10 J. Piper, 'Fully Licensed', *The Architectural Review*, March 1940, pp87-100.

11 Anthony West, review of John Gorman, *The Local, The Architectectural Review*, March 1940, p110.

12 Arnold Palmer to Geoffrey Cumberledge, Good Friday 1971, Felicity Palmer Collection.

13 Felicity Palmer, interview with the author, Jan 1990.

14 Stephen Bone 'Visions of England', *New Statesman*, 24 September 1949, pp338-9.

15 'Listener's Book Review Chronicle', *The Listener*, 28 November 1946, p763.

16 *Ibid*.

17 'Restoring Allied Libraries', *The Times*, 7 Dec 1946.

Revival or Ruin?

The 'Recording Britain' Scheme Fifty Years After

PATRICK WRIGHT

1 A Great Arch Disappears

In February 1942, the English painter Julian Trevelyan was despatched to the Middle East to investigate some new forms of camouflage which had been contrived by British forces in the desert. After what he described in his diary as 'three days of the most turgid perparations, innoculations, and valedictions', he went out and got drunk with his wife and then allowed himself to be 'engulfed in the portals of Euston station'.[1]

That last manoeuvre would be difficult to carry off now. There are no portals at Euston station today, but in Trevelyan's time there was a vast Doric Arch, a triumphant Propylaeum, no less, which had long been known as 'The Gateway to the North'. The Arch was built in the 1830s as part of the station designed by Philip Hardwick for the London & Birmingham Railway Company. As Nikolaus Pevsner wrote in the early Fifties, Hardwick 'went all out for the sublime' in his design. Recognising the railway to be 'something as grandiose of its kind as anything the Greeks ever had accomplished', he opted for 'the highest rhetoric available' and in the 1830s that meant Doric.[2] The Arch was painted for the 'Recording Britain' scheme by Barbara Jones in 1943 (see page 112), a year or so after Trevelyan made his reluctant plunge. She showed an Arch that had already seen better days: here it was, as Arnold Palmer wrote in 1946, 'caged ... cluttered up and scribbled over' but still recognisable as 'the most imaginative adventure in stone essayed by any English railway company'.[3]

Like the many other porticos, gateways and arches that were recorded for the scheme, Hardwick's obstructed 'Gateway to the North' may have seemed emblematic of the access Hitler must never be allowed. Nevertheless, Jones's portrayal is of a distinctly unheroic kind. Over in Germany, Albert Speer was reviving classical architecture to express the triumphant power and ambition of Fascism, but in Jones's London, the Doric Arch stood merely as a shabby and soot-blackened relic, plainly out of kilter with present times. Indeed, Jones treated it as something of a folly: a building designed to exceed the limited utilitarian purpose for which it had been built, and which it had since gone on to lose almost entirely. Designed as an imposing entrance, the gate bears a sign revealing that it is only in use as an exit. As disorientated as a rural sign-post that has been turned in order to confuse invading troops, it serves only as a convenient roost for a couple of obscure pigeons and a cloth-capped man who shows no indication of going anywhere at all. There is a definite sense of obsolescence about the picture, but there is an understated patriotism too. Like a number of other artists involved in the 'Recording Britain' scheme, Jones chose to indicate the presence of war through a tiny and hardly perceptible detail in an otherwise unchanged scene (in this case, a detail that was too small even to show up when the image was printed for publication in 1946): a news stand by the Arch displays a poster advertising 'War Latest'.

Jones's Euston Arch shared in the general insecurity of the nation at war, but like so many of the buildings and landscapes recorded in the scheme, it was also threatened in another sense. Indeed, the Arch had been acquainted with destructive explosions long before the bombers of the Luftwaffe began their night raids on London. When, in the early 1880s, its western lodge was condemned, it was found to be too strong to pull down and the demolition contractors had to use dynamite to complete the job. By the Forties, it was rumoured that the railway company had often called in tenders for the removal of the Doric Arch and, indeed, that it had only survived this long because it was so solidly built that the cost of demolition turned out to be prohibitive.

The Euston Arch survived the war, but it eventually succumbed to this other, more domestic threat as 1961 gave way to 1962. Euston station was to be rebuilt as part of the London-Midlands electrification drive, and the hopelessly impractical Doric Propylaeum was not allowed to stand in the way of modernisation even though a vigorous campaign was mounted in its defence. The Conservative MP Sir Frank Markham asked in the House of Commons whether the Doric Arch could not be removed and re-erected elsewhere, but Sir Keith Joseph, as Secretary of State, declared that

it was not within his power to make a grant covering the costs of this operation. The Royal Fine Art Commission advised Macmillan's Ministry of Housing and Local Government that the Euston Arch should be preserved. To begin with, the government felt no obligation to take the conservationist argument seriously. Indeed, on 22 July 1960, *The Times* reported that there had been 'some ministerial laughter' in the Commons when a Labour MP protested against the 'careless vandalism' going on under Macmillan's government and described Euston station and its Arch as 'wonderful monuments to the railway age which should not disappear entirely'.

A year or so later the government had refined its response. It still gave no real quarter to the conservationists, but it had learned to pay lip service to some of their arguments and to cut out the sniggers altogether. On 12 July 1961 Mr Marples, the Minister of Transport, announced in the Commons that though 'all possible ways of preserving the historic buildings in situ have been considered' and while 'the possibility of moving the Doric Arch to another part of the site has also been examined', it had been decided – not, by this time, without regret – that the Arch must go.

Letters began to appear in *The Times*. One recalled how the sight of Euston station in a mist had long been rated as 'one of the most impressive . . . in London', adding that Aubrey Beardsley had once remarked that Euston station made it quite unnecessary for Londoners to visit Egypt. On 15 July John Gloag, President of the Society of Architectural Historians, wrote in to remark that 'the government's decision to destroy the Doric portico of Euston station will deprive London of a noble monument'. Hardwick's Arch was 'an example of the genius of early nineteenth century architects for working in the classic idiom, which was then a living and inspiring tradition'. He ended with a rhetorical question: 'Would any European country allow such a land-mark of archi-tectural history to be removed on economic or any other grounds, without some attempt to raise the money for its preservation or re-erection?'

Eventually Harold Macmillan himself felt obliged to made a statement. Having been approached by a deputation from the Royal Academy on 24 October 1961, he wrote to Sir Charles Wheeler, President of the Royal Academy, declaring that while he 'was impressed by the architectural and historic importance which you and your friends attached to the portico', he did not imagine that any of the delegation 'would consider that the reconstruction of the station should be abandoned so that the portico might remain on its present site'. Since the only existing alternative was 'to put it in the middle of a traffic roundabout', Macmillan stuck by his minister and insisted that the Arch would have to go. In November, the Society for the Protection of Ancient Buildings joined forces with the Victorian Society and the Georgian Group to issue a joint statement remarking that, while nothing further could be done to prevent the English people from losing their finest triumphal gateway, it was certainly time to express redoubled concern 'about the threat to other great architectural monuments in the custody of the Ministry of Transport'. In the end it was only the demolition man who tried to make amends. By 7 March 1962 the deed had been done, and *The Times* reported that Mr Frank Valori, Managing Director of the guilty firm, was to present a silver replica of the Doric Arch to the Victorian Society. Lord Esher, then President of the Victorian Society, received the gift, saying that he 'felt as if someone had murdered his wife and then presented him with her bust by Epstein'. There was some small consolation to be found in the fact that Mr Valori was 'a benevolent executioner who, as a man of taste with a respect for fine architecture, had undertaken the demolition without pleasure'.

The memory of that demolition has lingered on through the Seventies and Eighties. Indeed, the Euston Arch haunts the present like a Shakespearean ghost that appears sporadically to point an accusing finger at people who would prefer to forget. John Betjeman invoked it in the Seventies, citing the demolition as a dismal but decisive moment in the rise of modern conservationism.[4] Gavin Stamp still rages about it at the beginning of the Nineties, blaming the destruction on the 'cynical indifference' of Harold Macmillan – a man whom Stamp likens to Ceaucescu, the fallen Romanian dictator whose abhorrent policy of 'systematisation' of historic towns and villages is well known.[5] The destruction of that inconvenient Doric Arch is remembered in equally polemical fashion by a more exalted figure. In 1989 Saatchi and Saatchi designed three posters to advertise the Victoria and Albert Museum's exhibition of Prince Charles's architectural 'Vision of Britain'. One of them includes the Euston Arch in a list of 'splendid buildings' which were 'demolished to make way for ugly modern buildings' in the Fifties and early Sixties. By now the menace of war which motivated Barbara Jones's picture is entirely forgotten. The danger which threatened and finally overcame the Euston Arch is associated entirely with the post-war peace: a peace which all three of these campaigners – Betjeman, Stamp and Prince Charles – have denounced, in their various ways, as more damaging to the face of Britain than German bombs ever were.

2 The National Heritage is Not What it Was

It has been intriguing to visit the V & A as the paintings and drawings from the 'Recording Britain' scheme have come back in. Posted out to the various counties at the end of the war, they have been recalled from council chambers, municipal offices, libraries and also, judging by the dusty but unfaded look of many of them, from obscure vaults all round the country. They come together to reassemble a record that has been unappreciated

and largely forgotten for nearly fifty years. The four illustrated books published shortly after the war by Oxford University Press as a summation of the project have also known dust and decline. The rarely cited volumes have tended to gather on the long-stay shelves of the nation's second-hand book shops – struggling to hold their price at the threshold beyond which a book becomes plain junk.

Not all of these pictures can survive the passing of that animating sense of emergency which reached out during the war to endow every feature of the national landscape with urgent significance. As the selection reproduced in this book shows, there are some works of evocative and transforming brilliance, but it has to be said that there are a great many others that look drained and exhausted; indeed, they seem to emerge from obscurity only to die before one's eyes. Faced with the typical late-twentieth-century art critic, these images would probably not stand a chance. They would be chastised for their stylistic timidity, their sentimentality, their unredeemed amateurism and, no doubt, for the southern bias of the scheme to which they contribute. (As Arnold Palmer was rash enough to say of Kent, 'In time of war the whole kingdom is apt to feel a special affection and anxiety for the exposed, peninsular county at its south-east corner' [*Recording Britain* Vol IV, p189]). It wouldn't take our unforgiving critic a moment to shovel all these pictures into the same dustbin: surely this is just the dismal art of 'Englishness', that defensive and highly selective sense of nationhood which is especially efflorescent at times of insecurity and crisis.

How else are we to appraise the scheme beyond simply sorting out the gold from the dross? As we look at these images and the threatened heritage they evoke, we should recognise how much has changed in the fifty or so years since they were painted. The 'Recording Britain' scheme offers itself as an inventory of destruction and survival (or at least of imminent doom forestalled): some of

those cherished landscapes and buildings have gone the way of the Euston Arch, while others, including a number that seemed even more obviously threatened, are still with us. But there is another, more far-reaching point that can also be deduced from the post-war history of the Euston Arch: namely, that our conception of the 'heritage' is dynamic – that it changes over time and, indeed, that developments since 1945 have transformed the whole standing of the national heritage in relation to contemporary society. If we are to understand the 'Recording Britain' scheme as it worked in its own time, we need to think our way back through some of these more recent developments.

To begin with we should recognise that the post-war years have been less than kind to the topographical watercolour tradition that contributed so much to 'Recording Britain'. As the art market has boomed around abstractionism and other international currents, landscape painting of the kind represented in the scheme, has been left to the amateur and the obscure recluse. By the Sixties, this landscape tradition was in total retreat. To find it during this period, we must follow a figure like Reynolds Stone, the engraver who went to ground in the early Fifties at the Old Rectory in Litton Cheney, Dorset, where he would receive visits from a wide circle of friends that included conservationists like John Betjeman and James Lees-Milne. Stone was of an old-fashioned Conservative disposition, but he also campaigned against nuclear power and the continuing march of pylons over the national landscape. He clung to his obscurity, apparently believing that he could only maintain his artistic integrity and his continuity with the landscape tradition that he loved at the very margins of national life. Stone rarely left the Old Rectory's seven-acre stretch of wooded and romantically overgrown grounds. His watercolours dwell on trees, ponds, the church tower glimpsed through leaves. Only occasionally would

he venture out into a nearby field to take in a grey stone cottage or two, or to visit another favourite site in Dorset.

Our understanding of what makes up the national heritage has also changed considerably over the same years. Looking back on the 'Recording Britain' scheme from the 1990s, we are as likely to be as much struck by absences as presences. Georgian architecture is well represented, but the relative absence of Victorian buildings indicates the neglect that prompted the formation of the Victorian Society in 1958. Similarly, the 'Recording Britain' scheme does not seem to share our own more recent obsession with the large country house. A number were certainly included, but they tend to be viewed from unexpected angles – through the foliage of their gardens, for example – or recorded only for minor and unregarded features like garden statuary, gatehouses or eyecatchers. Partly, this was a matter of scheme policy: artists were urged to concentrate on buildings and places that were little known and previously overlooked. But the comparative lack of emphasis on these grand buildings should also remind us that while Britain's country houses had long been highly regarded, they were only just coming onto the conservationist agenda at the time of the 'Recording Britain' scheme. As we approach these images, we must try to think our way back through the huge cult that has been built up around the country house since the war. At the time of the 'Recording Britain' scheme, the National Trust was still a tiny organisation which had only just adopted the large country house as an object of concern. In 1942, when James Lees-Milne joined as the Historic Buildings Secretary who was to be responsible for developing the new Country Houses Scheme, the National Trust had six thousand members and a mere six staff.[6] The idea that the survival of the grand private country house depended on public measures of conservation was still distinctly novel.

While conservation has certainly adopted new objects since the war, it has also been much more fully integrated into state policy. In part, the mournful pessimism that pre-war preservationism bequeathed to the scheme can be attributed to the sense of helplessness that followed from the lack of statutory controls: all too often in those days, it was only aesthetics and the customary decencies of class that could be invoked against the threat of development. Since then a whole battery of measures, defective and under increasing erosion as they may be, have been enacted in the name of conservation. The National Trust was made into a statutory body, so that significant buildings and landscape could be bequeathed in lieu of tax for the nation. The Town and Country Planning Acts of 1944 and 1947 introduced the statutory listing of historical buildings, while the National Parks and Access to the Countryside Act of 1949 established the new Nature Conservancy's responsibility for managing nature reserves and designating other areas as Sites of Special Scientific Interest. The National Land Fund, formed by Attlee's Labour government immediately after the war, was subsequently strangled by the Treasury, but it prepared the ground for the National Heritage Memorial Fund which has since replaced it.

Finally, we should recognise that the national heritage, as it has risen to become such a prominent theme in the national culture, has also taken on a new range of metaphorical associations. The conservationists' urgent rhetoric of heritage and danger has always been concerned with particular threats to particular places or sites, but in recent years it has become embroiled in a much wider argument which has tended to reduce the whole post-war history of Britain to a polemical opposition between the traditional nation and the various forms of modernisation that appear to threaten it. A war of the worlds has broken out between old England and the reforming state or, to express it through what are now our most powerful archi-

tectural symbols, between Brideshead and the tower blocks. It is this entirely symptomatic polarisation which has yielded the recent style war between Modernism and Classical Revivalism, fought out with such sound and fury around Prince Charles and his ideas about architecture.

The conservationist argument wasn't always captive to such morbid social polemic as this. Indeed, one only has to look back on pre-war conservationists to realise how different the choices were once considered to be. We might briefly remember the artist and writer Paul Nash who simply refused to choose between a cult of the antique and the commercialised banalities of 'modernistic' style, condemning both as false alternatives sourced in the same 'snobbery and delusion'; and who was similarly disinclined to choose (as we are constantly being asked to today) between the much-lampooned austerities of high Modernism and the proper human comforts of hearth and home. As Nash remarked, while 'Monsieur Corbusier's conception of the house "as a machine to live in" is very well up to a point', it should also be remembered that 'most of us wish to be comfortable whatever machine we are in'.[7] We should also recall A.R. Powys, who was the highly regarded Secretary of the Society for the Protection of Ancient Buildings before the war. Powys was appalled at the idea that traditional and modern architecture should still be divided, as they had been in the nineteenth century, by a 'Battle of the Styles'. As he remarked in an essay called 'Tradition and Modernity', which should be required reading for all present-day classical revivalists:[8]

It is assumed by the 'Traditionalists' that tradition and conformity to tradition are good: and it is probable that building traditions are indeed a good influence on this art. But the 'Traditionalists' make one mistake that is so serious in the adherence to their theory, that it

immediately shows the application of their conclusion to be false. They use the word tradition in a sense that it does not bear. The kind of architecture they admire and desire is not traditional, but one which represents an academic revival. What they admire in buildings is the conscious reproduction of ancient forms reshuffled into new arrangements.

Powys, who had similarly severe things to say about dogmatic Modernism, was both a determined conservationist and a champion of industrial building techniques. Indeed, he argued against the view, then being advanced by 'a very vocal group', that 'no houses can be pleasant unless the methods which were traditional no later than the eighteenth century are revived in their building'. He wanted to see old houses being refurbished rather than demolished, but he also insisted that new building should be carried out in the 'newer mass-made building materials', and that Beauty, contrary to the aesthetic theories of the revivalists, would prove 'quite able to join company' with modern materials and methods.[9] If the arguments of such pre-war conservationists as Nash and Powys can give the lie to the polemical orthodoxies of our time, perhaps the 'Recording Britain' scheme has helpful things to tell us too.

3 Preservationism at War

'Recording Britain' has been called propagandistic, but it is a curious kind of propaganda that seeks to inspire people by showing them pictures of a homeland that has already gone to war against all that is best in itself. The scheme was guided by a sense of pressing emergency. Time was short and there could be no delay. As Arnold Palmer recalled of the decision to bring the scheme's artists into London, 'everything was in acute danger'. Artists were sent out on their bikes to record subjects which had often been selected with the help of the

Edward Walker (1879-?)
MILK STREET, SHREWSBURY, SHROPSHIRE, 1943

county Secretary of the Council for the Preservation of Rural England. The emergency was real enough, but the threat posed by Hitler was also allowed to galvanise an older sense of danger which had been shaped and promoted by preservationists before the war. This is one of the most remarkable characteristics of the scheme. It met the emergency of war by summoning up a pre-war imagery that showed a Britain that was apparently already dying by its' own hand. Arnold Palmer certainly felt ambivalent about this. At the beginning of the first of those four OUP volumes, he tries to distance 'Recording Britain' from the pre-war preservationist despair on which it nevertheless drew so heavily. He quotes from the Victorian writer Sir Walter Besant's description of the Blue Coat School in Westminster ('It is old, it is beautiful. . . it is still most useful – therefore one feels certain that it is doomed'), condemning it as an example of the 'whining note' that is 'too prevalent among topographers' (RB I 6). Nevertheless, the 'Recording Britain' scheme forced its artists in the direction of exactly this kind of melancholy. As for Palmer, one only has to look at the rest of his commentary to see that he could be just as doleful; indeed, he could whine along with the best of them.

Artists were instructed to 'keep an eye open for any characteristic of a district or an era' which was 'endangered by neglect, "local improvements", adaptation, by-passes, and so on'(RB IV 99). As they gave expression to the overriding Nazi menace, they invoked a whole cluster of more domestic dangers. There was urban encroachment: both creeping suburbanisation like that which threatened the Surrey villages of Petersham and Ham, and ribbon development which, while it could be approved in the case of ancient village streets, was deadly in an age of unrestricted modern development. There were the pylons that marched across the most beautiful areas of countryside, and, of course, the older industrialisation that had left little of the once beautiful county of Lancashire that was not 'nineteenth century as well as blackish' (RB III 1). There was the tendency to smarten pubs, and the commercial pressure that was ruining old town houses by forcing them into service as modern shops. Edward Walker drew one such building in Shrewsbury's Milk Street: a fine Queen Anne corner-house which had recently had a twentieth-century shop front forced into it (Arnold Palmer's commentary feared that the damage caused to the ground floor would eventually be used as an excuse to demolish the whole building, thereby 'obliterating the last silent, reproachful, doubt-engendering, admiration-stealing traces' that remained above[RB III 58]). The scheme recorded a considerable number of declining rural churches, victims of religious scepticism and dwindling rural populations, and in its treatment of places like Cambridge, it also came out against 'change masquerading as improvement'. P. Tennyson Green's portrayal of the King's Parade was accompanied by a text which regretted the damage done to the scale of a street now that small houses were usually replaced with something 'a little, or a lot, taller'. Palmer regretted that 'The abominable tendency of buildings to grow higher is already spoiling the proportions of the square' (RB II 94). This is mild in comparison to the revulsion that people would feel twenty years later during the boom in high-rise council housing. (In the early Forties, as readers of Evelyn Waugh's *Brideshead Revisited* may remember, the reviled Modernist buildings that were going up on the site of demolished Georgian houses were associated with luxury private housing). But we are on the path nevertheless – as we might sense when Palmer protests against the 'wildly inappropriate...block of flats' that had recently replaced the eastern end of Brunswick Terrace in Hove (RB IV 172). There were already, as Palmer said of Cambridge, 'signs of the horrid tendency here'.

A number of pictures in the scheme show the threat to Old England coming from the British state itself. Numerous buildings were threatened by road-widening and by-pass schemes, but there were other versions of this story too. Up in Derbyshire in 1940, Mrs Haythornthwaite of the CPRE directed the scheme's artists into the area around Ashopton and Derwent villages, some miles west of Sheffield. The land and villages round here were due to be submerged by the Derwent Valley Water Board, then preparing to create the new Ladybower Reservoir. Kenneth Rowntree pictured the valley as it was just before flooding, showing the white boards which had been placed in meadows to mark the perimeter of the new lake. He painted the Ashopton Inn, a pub which, though popular with

hikers for many years, would be a hundred feet underwater by the time its image found its way into printed circulation. Rowntree lingered over its agreeably unsmartened interior: the benches, the iron table, the darts board, the prize fish mounted prophetically in a glass case on the wall. Mrs Haythornthwaite also warned the 'Recording Britain' scheme that the Medical Officer of Health in Sheffield was insisting that the same standards (heights of room etc) should apply in both town and country, and that as a result all rural buildings over a hundred and fifty years old in the stretch of Derbyshire which had recently been taken over by Sheffield were in 'imminent danger' of demolition. Richard Seddon was promptly despatched to the Porter Valley and Norton area, where he attempted to capture the 'definite local character and charm' of seventeenth- and eighteenth-century stone cottages which, as the commentary insisted, had 'made a good contribution to the life of the nation' despite what the improving bureaucrats and state officials were now inclined to say (RB III 23).

In cherishing the traditional face of the nation against the destructive modern state, the 'Recording Britain' scheme sometimes came into direct collision with the war effort itself. An undisguised conflict broke out in the West Country: recording was 'proceeding in an orderly, a pleasantly quiet, manner', when the government launched an urgent drive for scrap metal. Suddenly all the seventeenth- and eighteenth-century wrought iron gates and railings in the country were endangered, and the city of Bath was especially at risk. The scheme poured its recording artists into this already well-documented place, which would otherwise have been 'almost entirely omitted in favour of less obvious subjects' (RB IV 33). Clifford Ellis was among the artists commissioned to draw 'architectural ironwork which might be removed as scrap-metal', and he contributed his own account of how he had to go into battle with the

Ministry of Works and Planning to get some obviously outstanding ironwork included on the dismally inadequate 'schedule of ironwork to be preserved' (RB IV 38). The Luftwaffe's Baedeker raiders were damaging enough but, as Palmer concluded, England also needed protection from its own government ministries whose 'nose-diving inspectors' proved to be as 'capricious as bombs' (RB IV 42).

On other occasions, 'Recording Britain' came into conflict with Britain's military defenders themselves. As the war developed, large areas of the country were closed to the recorders, and even where access was granted the scheme's cycling artists were frequently mistaken for spies by both the general public and members of the armed forces who were constantly being tipped off about their suspicious-looking presence.[10] Kenneth Rowntree remembers the crunching sound of boots on gravel as vigilant members of the Home Guard came up to catch this apparent fifth columnist in the act. Artists were sometimes equipped with special passes, but these proved more trouble than they were worth: they were unfamiliar and therefore all the more likely to be mistaken for bad forgeries from Berlin. These difficulties were especially intense in coastal areas. The artists sent to record Sussex worked in an atmosphere of 'suspicion and open hostility' (RB IV 145). Charles Knight was among them, and he was constantly interrupted as menacing crowds gathered around him. Knight contrived an innovative method to deal with this problem; he would 'work surreptitiously, making up a drawing out of lots of small notes – even resorting to walking past my subject again and again' (RB IV 164). Such was the trouble in East Suffolk that: 'It was thought wiser and kinder to remove the artists from an area in which, hanging about with their sketch-books and paint-boxes, they were hourly the objects of darker suspicions. . .' (RB II 49).

But if the artists were unjustly accused, it does

appear that the scheme itself was sometimes unsure exactly which side it was on. Certainly, there are times when Palmer's commentary fails to differentiate the German menace from the threat posed by Britain's own army of defence. Essex was considered to be a likely area of invasion, and the recorders were sent in 'before the county was occupied by the British, or the German, Army'. As for Suffolk, the book published in 1947 described this as 'a vulnerable county which is finding some difficulty in getting rid of its protectors' (RB II 50). The poignancy of the destruction that could be caused in the name of defence was nowhere more clearly captured than in Louisa Puller's picture of Church Farm, viewed from across the churchyard in the Suffolk village of Sudbourne. Puller was asked to visit this tract of countryside at a few hours notice in 1942: it 'was being appropriated for the exercise of tanks and other destructive agencies'. She found seven farmhouses already empty, the livestock rounded up at the door for the move, and the whole place about to disappear behind the wire. In 1947 the area was still lost to the outside world and Palmer was touched into a morbid lyricism: 'The bordering roads and hedgerows cascade beneath caterpillar tracks' (RB II 72). Sudbourne was one of those English villages – and there were a good many in the Forties – that had apparently died for Victory.

4 Doing Without the Avant Garde

This sense of imminent danger appears to have placed clear stylistic limits on the 'Recording Britain' scheme which, while it was certainly prepared to be more evocative than the photographic testimony of the National Buildings Record could ever be, nevertheless refused to find any grounds for romance or formal experimentation in the depiction of wartime ruin. The aesthetics of the Blitz were left to 'Neo-Romantic' artists like John Minton and Graham Sutherland, or to less

well-known figures like Wanda Ostrowska, a Polish artist who came to London in 1942 and painted the smouldering wreckage of the City. For Ostrowska the destruction was 'London's Glory', a test triumphantly endured.[11] She saw new figures appearing in the wreckage – a bombed-out warehouse becomes 'The Skull' – and presented the ruins as, to quote from Viola Garvin's commentary on her pictures, 'pediments of solidity' on which the newly steeled spirit of the nation could rest.

The 'Recording Britain' scheme wanted none of this. On the whole, it was also distinctly shy of the modernist experimentation which had done so much to enliven landscape painting in the late Twenties and early Thirties. Some artists in the scheme certainly reveal a sense of abstraction: John Piper's portrayal of the Tithe Barn, Great Coxwell (page 41) (RB I 145) is quickened by a sensitivity to abstract pattern, for example. Nevertheless, we only have to look at the record of Dorset to suspect that there is nothing quite like a war to discourage avant-garde tendencies and reanimate even the most tired of picturesque clichés. When Eve Kirk visited places like Swanage and Weymouth in 1940, she went out of her way to celebrate exactly what artists like Paul Nash had only a few years earlier been struggling so hard to escape. These resorts were not places of monstrous bad taste or 'Seaside Surrealism' as Paul Nash dubbed them. Instead, she showed them as undisturbed pleasure grounds with golden sand, bathing machines and those irksome crowds of people that pre-war artists like Nash had worked so ingeniously to remove from the scene. Admittedly, a certain smudgy suspension of realism still had its uses: in her *View over Weymouth towards Portland* (1940) Kirk rendered the distant ships on the bay with sufficient imprecision to beg the question whether they were warships or the customary pre-war leisure and fishing vessels. The same point applies to Thomas Hennell's watercolour of Lulworth Cove (page 64). He showed this

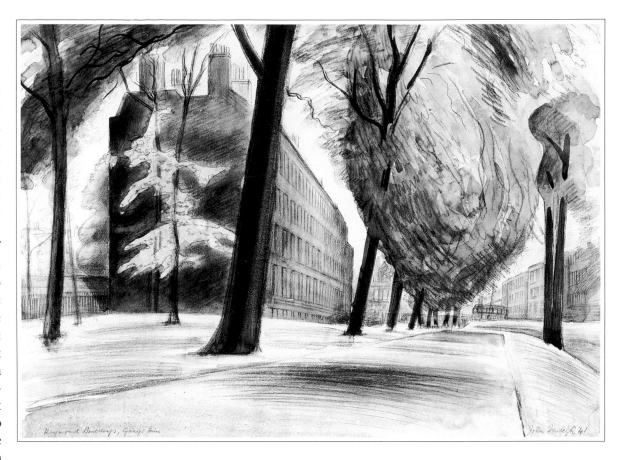

John Farleigh (1900-1965)
RAYMOND BUILDINGS, GRAY'S INN, LONDON, 1941

famous beauty spot from an entirely conventional vantage point that had been used by countless artists since the eighteenth century, but it is unlikely that in 1940 anyone would have complained. The whole surrounding area was in military use. Indeed, the nearby Isle of Purbeck seems to have been one large military encampment; with the exception of a few already very well-known sites, like Corfe Castle, it was entirely off the record, and the permitted glimpse of Lulworth Cove must have seemed all the more reassuring for its familar and time-sanctioned perspective.

One justification for this suppression of experimentation can be found in the wartime writings of John Farleigh, an engraver who contributed three images of London to the scheme in 1941. One of these is an expressionistic treatment of Raymond Buildings in London's Gray's Inn Field: Farleigh throws this formal building off its customary axis, and further disorientates it with the help of a crude wash of looming trees. Judging by his notebooks, the war prompted Farleigh into a brief experimental phase. In autumn 1940, he was writing of the excitement of war, and celebrating its disorientating effect: 'the signposts are gone. They did not exist except as symbols of our suburbanity created for our own comfort and self-deceptions'.[12] When Tottenham Court Road was bombed in December 1940 Farleigh wrote that it had 'lost its vulgarity and achieved beauty and humility'. In February 1941, he wandered down a blitzed Oxford Street, appreciating 'the emptiness of ruin' and remark-

ing that 'there was a loveliness about the whole atmosphere'. He even found a lesson in the fact that the sham Corinthian columns of a bombed department store had survived while the rest of the building was reduced to a heap of rubble: clearly it is important not to cast tawdry design in such permanent form. . . In the early months of 1941 Farleigh was still holding out against the simple-minded realism of the topographical tradition:

I can remember when it was enough that I should see green fields and trees to be filled with the desire to paint. I love them still but do not wish to paint them; for the moment they have no message. At the beginning I thought I could ignore the war; now I know I am drawn into it, or at least my mental vision is dominated by it. The landscape that was once sufficient is past; the towns no longer serve their purpose; the entrails of the houses hang down in festoons; their job is done. The houses that once stood apart in an effort to look different look sadly humbled as they mix indiscriminately in the heaps of rubbish. . .

A year later, in January 1942, he is writing very differently. In a brief article called 'The future of furnishing fabrics' he predicts that the post-war years will bring 'a nostalgia for quiet colour and charm. In the recoil from violence, machines and brutality, graciousness and curves will take the place of angles and straight lines'. As he continues, he gainsays his own earlier enthusiasm for the bizarre revelations of war, and endorses the 'Recording Britain' scheme in a manner that suggests he would have understood why none of his own experimental contributions were selected for inclusion in the books published after the war:

Excitement and distortion will have had their day. We are already losing interest in spectacular ruins and distorted girders. In their ago-

nized and twisted curves, they expressed the grief of so many a year ago. Now their message is of futility and waste.

Look for a moment at the painters! They are moved by a new inspiration and are closer to the people than they have been for years. The war has touched into quickness a new sympathy and many sluggish emotions have been quickened into life.

Records are being made of the life of the people without loss of artistic integrity. Beautiful buildings are being drawn so that something may be saved from the common wreck — something that will be handed on as a guide to future generations of the beauty that will always triumph in the end.

This was the message of the 'Recording Britain' scheme for other commentators too: the war was clearing out a lot of pretension, and encouraging a return to the true figurative traditions of national life. Modernist abstraction was like pylons, industrialism and the state – one more menace standing between the Englishman and the true life to which he belonged. The Conservative ruralist H.J. Massingham would certainly have seen it in this way. In a tribute published just after the war in a posthumous collection of articles by Thomas Hennell, Massingham hailed this important contributor to the scheme as a man who 'appeared sanity embodied against the anarchy of a whole civilisation gone mad'. Massingham evidently approved of the fact that Hennell – said to be an English countryman who 'belonged to Kentish fields' in the same way that Hardy could be said to belong to Wessex – had been commissioned by the 'Recording Britain' scheme 'to paint watercolours of our native heritage'. For Massingham, Hennell embodied all the true values that had been destroyed by 'industrial urbanism'. Regrettably, there had been a period shortly before the war when Hennell 'went modern' and 'got involved in the

obscurities and nightmares of the machine and of surrealism'; indeed, for Massingham, there could be little doubt that Hennell's reported descent into modernistic experimentation drove him mad. The schizophrenic breakdown that Hennell had experienced before the war (and described in a book called *The Witnesses*) showed what happened when a true countryman allowed himself to be 'unbalanced by the decadent sophistries of ultra-modernism' and lowered his guard against the 'types of modern art that reflect the diseased mentality of modern civilisation'.[13]

Whatever one makes of Massingham's judgement, and it deserved the controversy that it provoked at the time, there can be little doubt that the sense of emergency encouraged a certain cleaving to endangered appearances.[14] But what about the image itself? What was the nation that the scheme chose to record? Certainly it was archaic. The nineteenth century doesn't get much of a look in; indeed, anything modern is likely to be included under the rubric of damage (although one of Sir Giles Gilbert Scott's red telephone kiosks gets away with appearing in Bath). As for industry, there is Ian Ronald's smoke-filled picture of the Potteries (page 135), but in general the preferred marks of industry are of the extinct sort that can easily be incorporated into a rural scene: there are lots of windmills, old lime kilns, disused agricultural machinery, deserted tin mines in Cornwall.

It was a concerted ambition of the scheme to press towards the minor and previously unregarded. John Piper contributed some pictures of country houses like Buckland House and Fawley Court, as well as his immediately famous portrayals of Windsor Castle, but in many respects he seems closer to the spirit of the scheme with his images of tombstones at Hinton-in-the-Hedges (page 122), the remote village church of St Denis's Faxton, and the classical Screen built to shield the house of Easton Neston from nearby Towcester racecourse. This tendency towards the little known

extended to include the quirky and eccentric. Walter Bayes painted both the high life and the low life in London. He contributed some buildings, like the Naval Relics at Millbank, which were 'architecturally undistinguished' but likely to appeal 'to the sentiments of Englishmen' (RB I 26), and then retreated into the exoticism of the Zoological Gardens (page 105), where he was happy to show those Englishmen against a background of exotic foliage, elephants and pelicans. Rather than portraying the grand houses of Bedford Square, the scheme chose to record the charming and easily overlooked pagoda in the square's private garden (page 108). It opted for the Geffrye Museum in Shoreditch (pages 110,111), rather than the big national museums in Kensington or Bloomsbury. Through Phyllis Dimond, it developed a special affection for the curious lodges of London's grander parks.

Some indication of how this devotion to the vernacular and minor might actually catch people at their most patriotic is surely to be found in an essay that Gwyn Jones wrote shortly after the war to accompany a series of paintings by Kenneth Rowntree called 'A Prospect of Wales':[15]

> For most of us, after all, the meaning of Wales, the knowledge that what we see and feel is not elsewhere offered over the whole world's surface, will be found not in the famed vistas, the show places, the triadic Wonders of the Island of Britain, but in some corner of a field, a pool under a rock, in a bare sheep-walk or a cottage folded in a gully, in a hard road trodden by the feet of our fathers and their fathers before them; some private place that can never engage a general admiration, and for that is all the more dear.

At a time of war, such minor places could begin to command a general admiration in England as well as Wales. The scheme's commitment to the minor and overlooked involved its artists in a deliberate descent from the high concerns of Architecture and landscape aesthetics, and opened the way to a wider interest in the vernacular patterns of everyday life. It is here that the scheme starts picking up on the taken-for-granted details of the ordinary street with its shops and alleyways; on the inn signs, the backs as well as the fronts of houses, the bread-box at Dunstable Priory. It is also here that we find the emphasis on folkloric objects and old agricultural techniques – A.S. Hartrick's breast plough (page 75) or the slate fences of Mildred Eldridge (page 118) – and such decidedly local attractions as the shell and pearl decoration discovered by Walter Bayes inside the Hippodrome Cinema at Colchester (page 67) and Ethelbert White's Tarr Steps on Exmoor, recorded as 'the oldest bridge in England' (RB IV 56).

But despite the shared reservations over modernism, and the common concern with things vernacular, there are important differences to be found within the scheme. I will close by describing three variations on the overall theme of endangered England. W. Fairclough found his version in the villages of Petersham and Ham (see frontispiece) in Surrey. These villages were recorded because they were threatened by encroachment from London, but also because they proved that it was possible to have both 'highly aristocratic' residents and at the same time 'a strong spirit of

Thomas Hennell (1903-45)
SHEEP-SHEARING, GODMANSTONE, DORSET, 1940

parochialism' (RB I 80). As Palmer stressed, this quality was not a matter of upper-class visitors or of the 'country cottages' which were already extinguishing real villages elsewhere in the country. The 'best people' really lived here: 'they moved from one house to another, intermarried and exhibited all the symptoms of village society'. Fairclough's pictures reflect this aristocratic idea of the organic community: they show the big houses, the 'well-behaved' cottages, the 'peculiar mixture of grace and solidity' that characterised the best eighteenth-century cottages and barns (RB I 82). They provide glimpses through gateways and onto the great houses that lay beyond, and in the books Palmer matched them by gossiping away about the important people who had once lived there.

Thomas Hennell also found his ideal England in a village, but there the resemblance with Fairclough ends. Hennell's village was a much more rugged place like Worth Matravers in Dorset, an exposed quarrier's settlement that had never really had an aristocratic lord. The Purbeck stone trade had once paved cities and built cathedrals but, by the time Hennell passed through for 'Recording Britain', this noble craft-based industry was reduced to hacking out bird-baths for suburban gardens and the quarriers' limestone cottages were being turned into holiday homes. Hennell hated the modernising 'change' that was destroying the countryside too.[16] He hated the modern farm – condemning 'technical excellence' as 'a destroying factor because it substitutes a mechanical for a human standard', and preferring to conjure up a whole lost world from the pile of ancient agricultural implements that lay discarded in a corner of so many fields.[17] Unlike those of Fairclough, Hennell's villages couldn't be saved by the conservation of buildings alone. Indeed, Hennell's contributions strain against the architectural definition of the scheme, sometimes using buildings only as the pretext to show people

engaged in the customary activities that formed Hennell's real interest. He shows Waddock Farm near Dorchester, for example, but typically he gives part of the foreground to the human figure of its tenant. As for his sketch of the traditional sheep-shearing he found under way at Godmanstone in Dorset, it is hard to construe this image as having much to do with buildings at all. Hennell tried to record the last traces of the Englishman as disappearing species: the one that H.J. Massingham was inclined to eulogise as Downland Man. Hennell would have shared Massingham's interest in discovering 'where man belongs' ('where does man belong? He belongs to his own place which he has almost lost. In his own place he is able to be himself; in his own place he is in touch with what is beyond space and time')[18]. His village was disappearing right before his eyes. It was full of decay and its old buildings had been surpassed: the tithe barn survived as a mere cattle shed, and the superior old houses were now in humiliating service as guest houses. In the background, however, Hennell could still detect what Llewelyn Powys once called 'the tangible shadows of a static past'.[19]

Hennell preferred 'grit and English character rather than cabinet ministers and their slogans',[20] but such was the state of the country that he had to become something of a mystic and a vagabond to find what he was after. He tramped the country in a many-pocketed greatcoat like the one that his much-admired Samuel Palmer had worn a hundred years earlier. And sometimes he took refuge in a visionary topography that didn't need to be identified with particular places in the fallen modern world. Among his contributions to 'Recording Britain' is a watercolour of a gypsy encampment somewhere in Dorset. Hennell shows these free spirits, these bearers of ancient tradition, gathered round a fire in a wood with their dogs and their horses, their wagons and their prams all blending into the southern English foliage. The picture may be taken to demonstrate Hennell's

idea of the watercolour as a partly mystical and also resistant 'moment of vision' rather than a merely descriptive 'record' of a declining world.[22] It also suggests that, by the Forties, those who really knew 'where man belongs' had been obliged to take to the road.

Finally, there is the England of Barbara Jones. As we saw from her treatment of the Euston Arch, Jones's England was a place of follies, excessive ornamentation and Gothic neglect: the Eastbury Park gateway with trees growing out of it, Alton Towers (page 134), the Hop Castle in Chievely (page 40) (said by Palmer to fulfil 'the requirements of popular fiction' more than any other building in the record [RB I 138]). After the war, Jones would define a folly as 'a useless building erected for ornament', adding that 'follies come from money and security and peace; usually poor men do not build them, while only the calm of a settled life promotes enough malaise to breed a folly'.[22]

Jones cherished her follies and grottoes with an extra defiance during the war, but her 'personal' and 'amateur' England was also full of what she called 'the unsophisticated arts'. Just as Hennell had concluded that the period between 1860 and 1914 was governed by 'the most deplorable, perverted taste', Jones lamented the mechanisation which had 'coddled the creative impulse out of almost everything', declaring 1914 to have been the 'tombstone' of the old rural and early industrial crafts. Nevertheless, she celebrated the old 'popular arts' wherever they survived: the wooden fascias to be found on the platform canopies of old Victorian railway stations, roundabouts, taxidermy, jelly moulds, waxworks, tattooing and the famously luxurious houseboat of that popular hero of the musical theatre, Fred Karno. Perhaps the most striking examples she unearthed for 'Recording Britain' were the curious rustic porches that she discovered in the Victorian model village of Canford Magna. The porches were the work of John

Hicks, 'an unsophisiticated artist' whom Jones promptly wrote up in the *Architectural Review*, declaring him to have been 'the most gifted exponent of a minor, and a vanished, Victorian folk-art'. Here again the threat of war was contained within a larger sense of decline: as Jones pointed out, 'the porches are all that is left of him' and 'what remains. . . cannot survive for long'.[23] Subsequent years would show that, like the idea of the folly, the recollection of these 'unsophisticated arts' could be directed against the utilitarian values of the welfare state. But we have also had the opportunity to see what happens when the archaic and backward-looking frame in which Jones held these images is removed, and the idea of these popular 'unsophisticated arts' is finally taken over by the mechanistic and industrialising tendency that Jones had so persistently opposed. The result, unless I'm mistaken, was the disposable imagery of Pop Art. Popular culture became television: another decline, to be sure.

But there is no reason to end on an entirely depressing note. There is plenty in the rhetoric of 'Recording Britain' that seems to anticipate the polemical battles into which post-war conservationism has sometimes been drawn to its detriment: the setting off of the traditional nation against the reforming municipal state; the apparent prefigurations of the monstrous imagery which, having developed around the modern council tower block, has gone on to discredit the very idea of public housing; the distrust of nationalisation which, as Hennell believed, was already poised to do to those big industrial units what they themselves had done to the small tradesmen ('the town of Jarrow became ruined and derelict because the iron-works closed: but total nationalisation is the ruin of contintents').[24] But the defence

Barbara Jones
GATEWAY TO KITCHEN COURT, EASTBURY PARK,
NEAR BLANDFORD, DORSET, 1942

Eastbury Park. Nr Blandford, Dorset.
Barbara Jones 1942

of craft and of ordinary or 'unsophisticated' people's capacities has other potentialities too.

Rather than celebrating – or, for that matter, simply condemning – the 'Recording Britain' scheme as an expression of 'Englishness', we might usefully treat it as an occasion to separate the conservationist agenda from the cultural and social polemic that has clustered around it: first in the urgent emergency of the war, and then, more perniciously, in the period of the welfare state. The Euston Arch has gone but we should be glad to notice that not all the expected destruction has actually occurred. The corner house that Edward Walker found in Shrewsbury's Milk Street is still there – against all the odds as they were perceived at the time. Indeed, it is flourishing under statutory protection as a listed building. The melancholy and at times despairing imagery of the 'Recording Britain' scheme may have helped to motivate the institutional reform that made the conservation of historic buildings a state responsibility after the war. But the statutory conservation of landscapes, whether as Nature Reserves or Sites of Special Scientific Interest, is the product of a very different outlook. The pioneering bodies here – like the Nature Reserve Investigation Committee, which met during the war – owed more to a scientifically based ecological intelligence.[25] They avoided generalised aesthetic despair, and got on with defining practical measures that could be taken for the better. I suspect that it is in large part thanks to them that conservation has become more than the helpless cultural impulse it so often seems to have been before the war.

FOOTNOTES AND REFERENCES

1 Julian Trevelyan, *Indigo Days*, Macgibbon & Kee, London, 1957, p. 137.

2 Nikolaus Pevsner, *London*, The Buildings of England series, Penguin, London, 1952, p. 366.

3 Quoted from Arnold Palmer's commentary in *Recording Britain*, Vol I, Oxford University Press, 1946, p. 16. Future citations of Palmer's commentary to the four volumes are referenced in abbreviated form in the text.

4 John Betjeman, 'A Preservationist's Progress', in Jane Fawcett (ed.), *The Future of the Past; Attitudes to Conservation* 1147-1974, Thames & Hudson, London, 1976, pp. 55-63.

5 Gavin Stamp, 'Another Vision of Britain', *The Spectator*, 13 January 1990, pp. 8-12. Also, Stamp's article on 'Harold Macmillan' in the 'Heroes & Villains' column of *The Independent Magazine*, 17 February 1990.

6 James Lees-Milne, *Ancestral Voices*, Faber & Faber, London, 1984, p. ix.

7 Paul Nash, *Room and Book*, Soncino Press, London, 1932, pp. 38 and 42.

8 A.R. Powys, 'Tradition and Modernity' in *From the Ground Up*, J.M. Dent and Sons, London, 1937, pp. 43-4.

9 *Ibid.*, p. 67-8.

10 This problem also afflicted artists outside the scheme like Keith Vaughan, who ended up in Guildford prison in 1940 after setting up his easel beside a trench which had been dug to impede the invading army that threatened. As Malcolm Yorke remarks, British landscapes were not just 'neutral vistas of greenery' at this time. They also had a decisive 'strategic significance' which made their recording distinctly problematic. See Yorke's, *The Spirit of Place; Nine Neo-Romantic Artists and their Times*, Constable, London, 1988, p. 262.

11 Wanda Ostrowska, *London's Glory: Twenty Paintings of the City's Ruins* (with text by Viola G. Garvin), George Allen & Unwin, London, 1945.

12 John Farleigh, *It Never Dies: a collection of notes and essays* 1940-46, Sylvan Press, London, 1946.

13 H.J. Massingham's memoir of Thomas Hennell appears in Thomas Hennell, *The Countryman at Work*, The Architectural Press, London, 1947.

14 See Michael Macleod, *Thomas Hennell; Countryman, Artist and Writer*, Cambridge University Press, 1988.

15 Kenneth Rowntree and Gwyn Jones, *A Prospect of Wales*, Penguin, London, 1948, pp. 30-1.

16 Thomas Hennell, *Change in the Farm*, Cambridge University Press, 1934.

17 Thomas Hennell, 'British Craftsmen', in W.J. Turner (ed.), *British Craftsmanship*, Collins, London, 1947, p. 45.

18 H.J. Massingham, *Where Man Belongs*, Collins, London, 1946, p. 252.

19 Llewelyn Powys, *The Pathetic Fallacy; a study of Christianity*, Longmans, Green & Co., London, New York, Toronto, 1930, p. 102.

20 *Architectural Review*, March 1941, p. 56.

21 Macleod, p. 103.

22 Barbara Jones, *Follies and Grottoes*, Constable, London, 1953, p. 1.

23 Barbara Jones, *The Unsophisticated Arts*, London, The Architectural Press, 1951.

24 Hennell, *'British Craftsmen'*, p. 45.

25 Norman W. Moore, *The Bird of Time; the science and politics of nature conservation*, Cambridge University Press, 1987, pp. 29-30.

The Plates

The Church of St Peter and Paul (1130 onwards), built on the site of an Augustinian priory, is remarkable for its marriage of Norman and Early English styles. The aspect Rowntree has chosen shows the point at which the two styles are abruptly joined; Norman to the right, Early English (or Gothic), with its distinctive pointed arches, to the left. Aside from its architectural significance, the church holds an important place in English ecclesiastical history; from its Lady Chapel Archbishop Cranmer pronounced sentence of divorce against Catherine of Aragon in 1533.

Rowntree has treated his subject as a flat composition offering a pleasing exercise in contrasts of colour and texture – the varied greys and buffs of the weathered stone against the smooth grassy mounds of the churchyard, with the warmer tones of the leaning tombstones blackened with soot and lichen and, in the foreground, the soft reds of the brick wall.

Kenneth Rowntree (b.1915)
WEST FRONT OF THE PRIORY CHURCH, DUNSTABLE, BEDFORDSHIRE

John Piper (b. 1903)
TITHE BARN, GREAT COXWELL, BERKSHIRE

A dramatic, almost theatrical, image, this is firmly in the tradition of Samuel Palmer's mystical Shoreham landscapes. The artificially low viewpoint adds to our sense of the barn's imposing bulk and emphasises its church-like form (in spite of the addition of nineteenth-century windows of domestic type). William Morris, who lived nearby at Kelmscott, described it as being 'as noble as a cathedral'.

This thirteenth-century barn, built of Cotswold stone and slate in the 'decorated' style by monks of the Cistercian order, is in fact copied from ecclesiastical models, being cruciform in shape, with a nave and two aisles. As a tithe barn, its function was to store the tithes or tenths of farm produce contributed by the parish for the support of the parish priest or the monastic community, a practice compulsory in England since the tenth century. Though tithes were often replaced by a cash payment and abolished entirely in 1836, this barn was still used for agricultural purposes when Piper painted it.

Piper had been received into the Anglican church shortly before the war and some of his best-known images are his intense apocalyptic visions of English churches. In this visionary landscape the barn stands for the continuity of English agricultural life and perhaps for the role of the church as a presence in an increasingly secularised society.

The barn is now owned by the National Trust, who acquired it in 1956; popularly associated with the preservation of stately homes, the Trust has increasingly turned its attention to agricultural buildings.

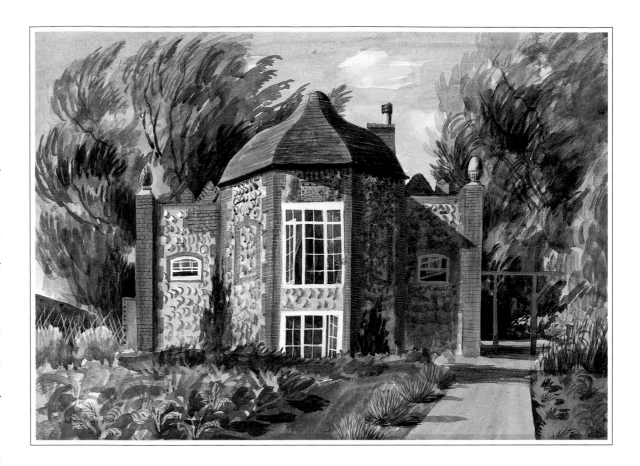

Barbara Jones (1912-1978)
THE HOP CASTLE, CHIEVELEY, BERKSHIRE, 1940

Situated between Chieveley and Winterbourne, Hop Castle is a Georgian hunting lodge in the form of charming folly, vaguely 'gothick' in style. The central block is an octagon surmounted by a roof of ogee outline, with lower wings to left and right. It is built of rough whole flints, which give it the appearance of a grotto. This theme is continued within: the entrance hall is lined with pebbles and shells.

This is another example of the modest but fantastic architecture which is so quintessentially British and yet so rarely considered worth recording. Jones made a particular study of such neglected architectural conceits for 'Recording Britain', later publishing an illustrated history and directory, *Follies and Grottoes* (1953).

Stanley Anderson (1884-1966)
ST BARTHOLOMEW'S, FINGEST, BUCKINGHAMSHIRE, 1940

No account of 'Recording Britain' would be complete without a view of a well-kept country church. The parish church is an emblem of peace and security, but was also a repository of nationalist sentiment focused in the sense of community and continuity that it represented. The church had a role in national and local life that transcended religion; church bells were silenced through the war years, to be sounded only to warn of invasion, and ultimately to declare victory and peace.

These ideas are embodied in Anderson's view of St Bartholomew's in the warm sunshine of early autumn, with the evidence of the harvest safely gathered in visible in the field beyond. Fingest, a small village in the Chilterns, is dominated by its remarkable church with a double-gabled fortress tower which is wider than the nave. This unusual arrangement suggests that the twelfth-century tower originally served as the nave; the present nave and chancel are more modest in scale and have been heavily restored whilst the tower remains substantially unchanged, except for the addition of the present roof in the seventeenth century.

Jordans is a Quaker village, the home and ultimately the burial place of William Penn, founder of the American state of Pennsylvania. His grave is in the grounds of the first (1688) Quaker meeting house, a simple, unadorned building which embodies the spirit of the movement. Nearby is the Mayflower Barn, so called because it is said to be built with timbers from the ship which took the Pilgrim Fathers to America. The small village was largely built by Quaker families in the 1920s, along the lines of Hampstead Garden suburb.

Stone Dean, the subject of Anderson's picture, is earlier; it was built by Peter Prince, a Quaker tallow-chandler in 1691. A rare image in 'Recording Britain', it shows a garden that had not been given over to vegetables.

Stanley Anderson (1884-1966)
STONE DEAN, JORDANS, BUCKINGHAMSHIRE

Thomas Webster (1800-1886)
THE VILLAGE CHOIR

Bow Brickhill was a handsome village of pink and white houses, a perfect subject for Badmin's meticulous skills. He would generally spend some time walking around a village to find the best and most characteristic view; here he has opted for the architectural variety offered by a prospect along the main street. A steep lane in the middle distance leads to All Saint's church, which stands like a castle on its thickly wooded hill, commanding a view of six counties.

Badmin was probably lead to paint Bow Brickhill by the fame of another picture, Thomas Webster's much-loved Victorian genre piece, *The Village Choir* (1847), acquired by the Victoria & Albert Museum as part of the Sheepshanks Bequest. Painted by Webster (1800-1886) when he was staying with his sisters at nearby Little Brickhill, the scene is set in All Saint's church and the choristers were all inhabitants of Bow Brickhill.

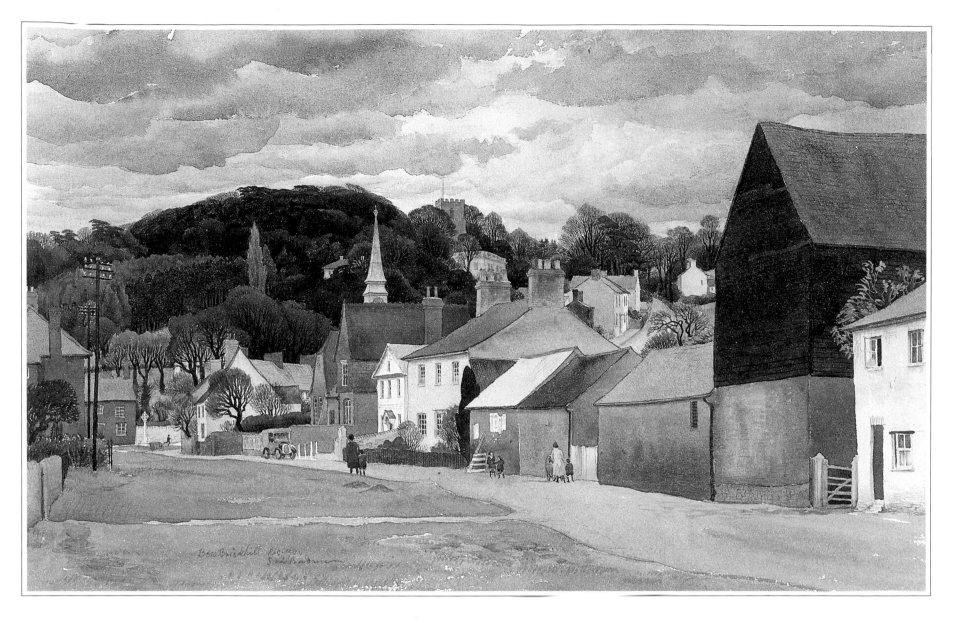

Stanley Roy Badmin (1906-1989)
Bow Brickhill, Bletchley, Buckinghamshire, 1940

Olney is famous as the home of Cowper, poet of the domestic and rural virtues; his poem 'The Task' is full of references to the place. Badmin's own creative vision found a subject in Olney's wide waterlogged meadows, which are regularly flooded by the River Ouse. This is crossed by a low five-arch bridge which seems too long in summer when the river flows tidily through its central arch, but in a wet winter (Badmin painted this in November) the course of the river disappears altogether and the whole of the broad valley becomes one sheet of water. A red-painted watermill and rows of willow trees mark the true course of the river.

Stanley Roy Badmin (1906-1989)
FLOODED MEADOWS AT OLNEY, BUCKINGHAMSHIRE, 1949

John Piper (b. 1903)
THE BRIDGE AT TYRINGHAM, BUCKINGHAMSHIRE, 1940

In his work for 'Recording Britain' Piper made a speciality of the landscape garden and the country-house park, with views at Fawley Court, West Wycombe and Stowe (see page 83); his subjects were the architectural conceits, the artfully contrived dramas and vistas which characterise these man-made landscapes. Previously a painter of abstractions, and much involved with the European avant-garde, he had reverted in the late 1930s to more conventional representational work. He was also engaged on designs for a number of theatrical productions.

House, bridge and screen at Tyringham were devised as a complete scheme by that master of architectural illusion, John Soane (1753-1837), in 1793-7. In Piper's picture both bridge and screen appear as flat and insubstantial as stage scenery, though in reality each is massively solid. By this device he emphasises their role as creators of dramatic effect, props designed to enhance the central figure in the drama, the house itself.

St Peter's is an example of an increasingly common phenomenon, the redundant church. The reasons are many, but are largely related to shifts of population: a village made up of weekend cottages and second homes cannot support a church, whilst a town which has grown rapidly may find itself with too many churches in an age when religious observance is declining. When Piper painted it, the church of St Peter's was already abandoned and empty, isolated from the town. The village of Stanton Low (or Stantonbury as it is also known) had long since been absorbed by New Bradwell, a mid-Victorian red-brick railway town.

The interior of the church was dominated by the magnificent chancel arch (c.1150) with its bands of crisp Norman carving; the round-headed outer arch had been reinforced by an inner pointed one at a later date. In the room beyond, the displaced Jacobean pulpit can be seen. The most vulnerable churches are those in decayed inner city parishes, or those which are isolated; St Peter's would probably have fared better had it been the focus of an integrated village site. As it was, it proved impossible to find funds to save the building and it is now a ruin. The chancel arch has been removed.

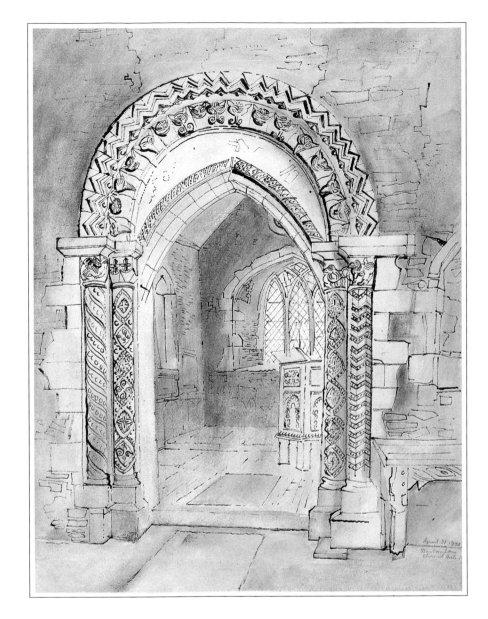

John Piper (b. 1903)
CHANCEL ARCH, ST PETER'S, STANTON LOW, BUCKINGHAMSHIRE, 1940

The chapel at Gwydir Uchaf, a simple structure blending Gothic and Renaissance styles, was built for private worship by local landowner Sir Richard Wynn in 1673. Its most remarkable features are the paintings, which cover the entire ceiling and the apex of the east wall. They represent an extraordinary medieval survival; wall-paintings were common in churches until the fifteenth century but, as examples of Popish idolatry, were defaced or coated with white-wash between the Reformation and the end of the Commonwealth.

The scheme of paintings belongs to the Counter-Reformation, using as it does a Catholic iconography of Creation, the Trinity and the Day of Judgement together with adoring angels, sacred symbols and Latin texts. Though naïve and crudely executed by an unknown artist, the paintings are the vernacular counterpart to the Italian baroque, rather than an example of traditional folk art. There is no attempt to render perspective and the figures are flat, but the scheme has an exuberance that is enhanced by the bold palette. The angels, in quasi-classical dress, are set against a pattern of gold stars, or tongues of fire (representing the coming of the Holy Spirit on the first Pentecost).

In 1952 the chapel was acquired by the Ministry of Works and is now maintained by the Welsh Historic Monuments Commission.

Kenneth Rowntree (b. 1915)
GWYDIR UCHAF CHAPEL (DETAILS OF CEILING), LLANRWST, CAERNARVONSHIRE

This is a remarkable sketch, for it demonstrates an unbroken continuity of the British landscape watercolour tradition. Young's style and subject owe more to Cornelius Varley (1781-1873) and to Constable than to any contemporary influences, combining, in the mountainous backdrop, the breadth of Constable's 1806 'Lakes tour' manner and, in the foreground, the minutiae so characteristic of Varley. Indeed, the whole of the 'Recording Britain' project belongs to the native tradition of topographical watercolour.

The picture is a late manifestation of the taste for the Picturesque, not only in its manner and in the subject matter, but also by virtue of its being a Welsh landscape. The mountainous scenery of the Lake District and Wales had, for Varley and his contemporaries, constituted the embodiment of the aesthetic theories of the Picturesque, with its emphasis on the foreground, and the Sublime, with its interest in dramatic and awe-inspiring distances; it was as a result of sketching tours by the Varleys and their associates that the public taste for wilderness and mountain scenery was fostered. Young's picture is a tribute to that shift in aesthetic values established by the end of the eighteenth century, and embodied today in the 'National Park' status of Snowdonia, the Lakes and the Peak District.

This is the only image from the Welsh series to show a view common enough even now: a scene without sheep or cattle, or any evidence of man's activities, domestic, industrial or agricultural. In the foreground are the rushing waters of the Dwyfor, and in the centre Craig Garn. Moel Hebog, in the top right-hand corner, blocks out Snowdon, six miles beyond. Garn Dolbenmaen is itself within the Snowdonia National Park, which is now suffering the fate of so many spectacular but accessible beauty spots – too many tourists, and the threat of unsightly developments to accommodate them.

Richard L. Young
GARN DOLBENMAEN, CAENARVONSHIRE

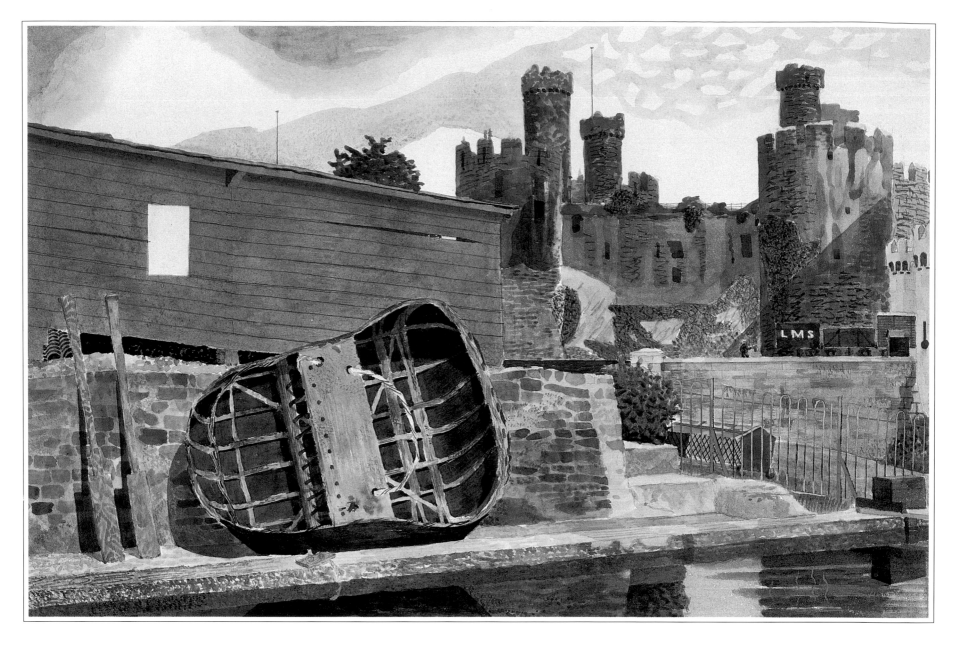

Kenneth Rowntree (b. 1915)
Conway Castle, and Coracle, Caernarvonshire

Rowntree worked extensively in Wales; though he produced only nine drawings for the 'Recording Britain' project, he made a series of twenty exquisite watercolours illustrating *A Prospect of Wales* (published by King Penguin, 1948).

One of the most distinctive of Welsh landmarks, Conway was built around 1280 by Edward I, one of a bastion of castles established to maintain his hold on north Wales. It was subsequently granted by Charles II to the Earl of Conway and has remained in a derelict condition since he set about dismantling it. The castle stands now as 'the most picturesque ruin in Wales'. So familiar was it that Rowntree chose to subordinate it within a larger composition, taking as his vantage point a site inside the mussel-cleansing station belonging to the Ministry of Agriculture and Fisheries.

In the foreground is a coracle, that traditional Welsh fishing boat, made of stretched canvas over a framework of split and interwoven rods rendered watertight with a coating of tar and pitch. This primitive boat was in use at the time of the Roman invasion and, though no longer common, can still be seen today.

Ruskin Spear (1911-1990)
DERELICT CHINA-CLAY WORKS, BELOWDA BEACON, ROCHE, CORNWALL

In his only contribution to 'Recording Britain' Spear completed a group of nine watercolours in and around the village of Roche, north of St Austell. Roche lies at the heart of the china clay district; the industry still thrives but individual workings have been abandoned as reserves are exhausted. Like the engine-houses of abandoned tin-mines (see page 56), such shells soon become indistinguishable from much older ruins. Roofless, with gaping windows and crumbling lichened walls, this grim grey block is shown being reabsorbed by nature with no Ministry of Works or Department of Environment to arrest the decay. Though visually and physically a counterpart to Sudeley Castle (pages 80-81), as an industrial ruin it has no perceived cultural value.

Through the 1930s and 1940s painters had been attracted to the Cornish landscape with its wide rugged spaces dominated by wind and weather, a landscape of elemental forces. This spirit is evident in Spear's bold brightly-coloured sketches, which are as much about the atmosphere of sunshine, scudding clouds or approaching storms as about the physical features of the landscape.

Olive Cook
DISUSED TIN MINE, ST AGNES, CORNWALL

Tin mines are perhaps the most distinctive and familiar monuments in the Cornish landscape, relics of a now defunct industry which once employed thousands. Cornwall's wealth was founded on minerals – lead, copper, iron, zinc, and tin, which is found nowhere else in the country. St Agnes, on the north coast of the peninsula, was one of the major centres of tin-mining, but as the industry declined so did the population of the town; it now numbers less than in the mid-nineteenth century.

For hundreds of years Cornwall held a virtual monopoly of the world's tin production, but by 1937 it was in terminal decline. The seams were not exhausted but tin was by then being produced more cheaply in the Far East. The landscape is now littered with the ruined engine houses that are the most visible sign of the 'knackt bals' or abandoned mine-workings. The last commercial tin-mining operation closed in 1988.

Now, like so many other West Country coastal towns, St Agnes has become a popular holiday resort, with tourism replacing tin as the economic base. In spite of the popularity and affordability of foreign destinations such as Spain, Greece, Portugal and Italy, the West Country, specifically Devon and Cornwall, remains a favourite holiday destination – as testified by the inevitable traffic jams on major routes west through the summer months.

Cook is better known as a writer than as a painter, but this rigorous and characterful image, very much in the neo-Romantic manner, demonstrates her considerable abilities in the medium.

Barbara Jones (1912-1978)
Round House, Veryan, Cornwall, 1943

Despite fanciful theories as to their origin and inspiration it seems that this and the other four Gothic-style round houses in Veryan were built in the early nineteenth century by Hugh Rowe, a builder from nearby Lostwithiel. Popular superstition has it that the houses were made circular so that there should be no corner for the devil to hide in. Their local name is 'Parson Trist's houses' and this example, sited near the church, incorporates certain ecclesiastical features apparently stolen from the chapel at Creed, a few miles to the north-east. This example has a slate roof and central chimney; the others, sited in pairs at each end of the village, are thatched and surmounted by crosses.

English villages abound in such eccentric architecture; Jones herself specialised in depicting such oddities, writing and illustrating *Follies and Grottos* (1953) and *The Unsophisticated Arts* (1951).

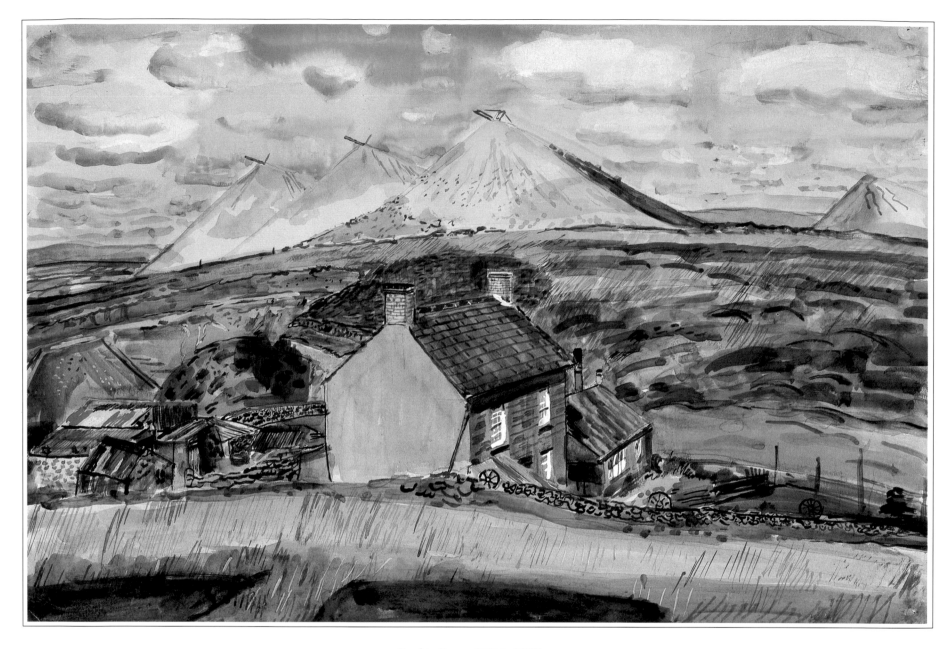

Ruskin Spear (1911-1990)
GREAT WHEAL PROSPER, TRESAYES, CORNWALL

Two major industries have left their mark on the Cornish landscape; tin-mining is now all but finished, the abandoned engine-houses littering the landscape like so many small ruined castles, but the production of china clay still flourishes, adding twenty million tonnes a year to the wastes which form great white pyramids across the moors. China clay (or kaolin), the decomposed felspar of granite, has for long been one of the UK's principal exports: 'In normal times the china-clay industry of Cornwall and Devon ranked second in importance only to coal in the tonnage and value of the raw material exported from this country. At present, because of the coal shortage, it ranks first' (*Report of the Working Party on China clay,* March 1948).

First discovered in Cornwall in the mid-eighteenth century, china clay has a multitude of uses; a large proportion is used in the manufacture of paper, with the remainder used for pottery, linoleum, paint, textiles, rubber goods, cosmetics and medical preparations. Devon and Cornwall are the only counties in which it is found in workable quantities.

Spear's vigorous, colourful sketch shows how the spoil heaps dominate the landscape, a range of pale mountains whose regularity betrays their man-made origins. The Department of the Environment is now investigating the feasibility of an imaginative scheme which would use the china clay wastes to infill disused quarries in the Mendip Hills, thus removing two eyesores in one operation.

Mildred Eldridge (b. 1909)
BAPTISM IN THE RIVER CEIRIOG, DENBIGHSHIRE, 1941

Most of the 'Recording Britain' project centred on the human relation with the landscape in the form of buildings and agricultural practices. Few painters show us the traditional customs, as much threatened by progress as the face of the landscape itself. Such practices as this river baptism by total immersion are characteristic of small enclosed tight-knit communities united by strong common bonds – in this instance an isolated land-based livelihood and a shared religion.

The sketch is inscribed on the back '(Chapel) Baptism in River Ceiriog below Portfadog Glyneriog Valley, not often practised now as pneumonia follows without fail'. Eldridge's picture thus records what was, by 1940, a rare survival of a more rigorous way of life. By this date many Baptist chapels had installed sunken tanks offering a less hazardous initiation.

Kenneth Rowntree (b. 1915)
THE SMOKE ROOM OF THE ASHOPTON INN, ASHOPTON, DERBYSHIRE, 1940

It is often forgotten that 'Recording Britain' was as much concerned with interiors as with exteriors and landscape settings. The Ashopton Inn, properly called the Snake, was the object of a comprehensive study inside and out, five images in all. This view of the Smoke Room best sums up the character of the place and the spirit of the English public house in general.

The many functions of the pub in village life are set out for us in this spartan corner, with its bare wooden benches and single inadequate ashtray: a social centre where the locals trade gossip, a haven for the traveller (mostly, in this area, walkers and climbers), purveyor of food and drink, and recreational facility. Simple and plain, with no concessions to comfort, it is clearly a male preserve with its dartboard, the stuffed fish (a token symbol of rural pursuits) and the functional unadorned calendar.

Such a bar is a rare sight now that the national brewing monopolies, with their chains of tied houses, have imposed a plush and shiny uniformity on all but a handful of country pubs. Even those that have escaped the unimaginative efforts of corporate design have adopted a self-consciously 'country' image in which the quaint and the cosy are applied like a veneer.

The crescent in Buxton was built to rival that at Bath. It is generally acknowledged to be the masterpiece of architect John Carr of York (1723-1807), who was employed by William Cavendish, 5th Duke of Devonshire, to realise his grand design for remodelling the town.

Rowntree's cramped view, taken from a wooded area of rising ground, gives an accurate impression of the awkward site – not that originally chosen – in which the buildings are compressed into a short deep concave, overwhelmed by the mound known as St Ann's Cliff and encroached upon by the large stone shelter to St Anne's well, added in 1894 (until recently the local hospital).

The crescent had, it seems, been commandeered for military purposes; the arcades are blocked with sandbags and a protected entrance constructed by the freestanding, barricade. The picture is unusual in the 'Recording Britain' oeuvre in its overt reference to the war.

Though the functions of the buildings have changed, and Buxton has long since lost its focus as a spa, the town has remained largely intact, escaping the twin evils of demolition and development which have blighted the historic centres of too many English towns.

Kenneth Rowntree (b. 1915)
THE CRESCENT, BUXTON, DERBYSHIRE, 1940

Kenneth Rowntree (b. 1915)
WESLEYAN METHODIST CHAPEL, ASHOPTON, DERBYSHIRE, 1940

Methodist chapels generally follow a common model; built by dissenting congregations, usually poor, who did not look for religion in external symbols, they were invariably plain and functional. They were also generally small, both because the numbers of their congregation were limited and because the land available to them was usually no more than an awkward plot, or a scrap of waste ground.

This is a typical example of the nineteenth-century meeting house, rectangular and single-storied. Architecturally, such chapels took their form from the cottages and farmhouses around them, thus offering no visual challenge to the established church. As here, traditional styles and local materials were used (though the windows have been altered from the original and fitted with frosted glass?). In this case it seems that the congregation later expanded: as the plaque notes the first building dates from 1840; according to Rowntree's pencilled inscription the extension to the left was added in 1898.

Now many of these chapels are redundant and, lacking the vociferous defenders of the churches, are to be found converted into cottages, shops or garages. This example escaped that fate, being drowned, along with the entire village of Ashopton, in the creation of the Ladybower Reservoir.

Derbyshire was the only county for which the 'Recording Britain' committee received a local plea that specific records be made. It was a peculiarly urgent case as the letter from the secretary of the local branch of the Council for the Protection of Rural England (CPRE) makes clear:

A large and exceptionally beautiful area is now being worked on by the Derwent Valley Water Board for their new Ladybower Reservoir. This is the area around Ashopton and Derwent villages, about 12 miles west of Sheffield. Besides submerging lovely river, woodland and hill scenery, it will submerge the famous Derwent Hall, Derwent Village, and the Packhorse Bridge, which it is hoped to remove and rebuild. Artists' records of this region would be of much historical and aesthetic interest. . .

Thus in this seemingly idyllic agricultural landscape, there are in fact signs of change and decay. Though the house itself, set against the bank of freshly ploughed fields, is neat and well-kept, the outhouse is roofless and the dry-stone walls crumbling. The clue to its decline can be found in the white board in the field in the foreground; this marked the perimeter of the new reservoir. With the water lapping almost at its doorstep it was no longer viable as a working farm, surviving instead to become a weekend cottage, yet another statistic in the changing profile of the rural population.

Rowntree completed sixteen drawings of land and buildings scheduled for drowning in and around Ashopton. They offer a graphic illustration of the damage to the landscape effected to service a growing urban population.

The Packhorse Bridge was dismantled by the local CPRE branch, and in 1959 re-erected at Slippery Stones; all the other buildings were submerged and when reserves are low the spire of the church can be seen rising disembodied from the water.

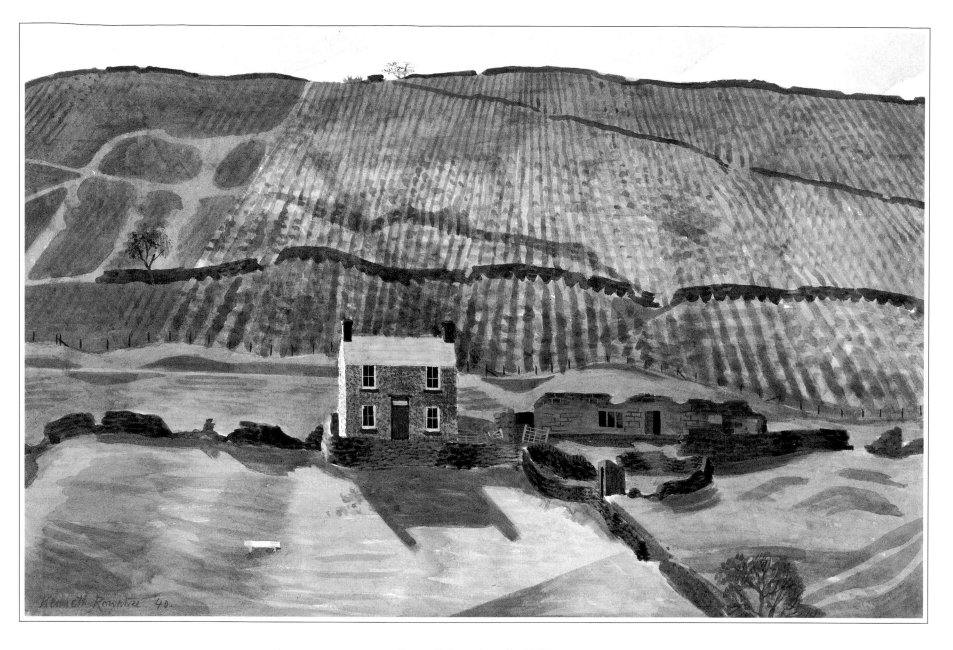

Kenneth Rowntree (b. 1915)
UNDERBANK FARM, WOODLANDS, ASHDALE, DERBYSHIRE, 1940

Thomas Hennell (1903-1945)
STAIR HOLE, LULWORTH COVE, DORSET

One of the most dramatic and beautiful features of the southern coast, Lulworth Cove is also a site of major geological significance. The stratified cliffs of Stair Hole are clearly visible in Hennell's sketch. This area has been successfully preserved from inappropriate development but other parts have been less fortunate. In the 1930s the Council for the Preservation of Rural England produced a report detailing the despoliation of Britain's coastline: bathing huts, refreshment kiosks, funfairs and caravan sites.

Little was achieved until, in 1969, the National Trust launched Operation Neptune to acquire 900 miles of coastline, having estimated that the remainder of the 2,750 miles of English coastline was already 'beyond redemption'. A further refinement was the designation of heritage coasts in 1972. The Purbeck coastline of Dorset, which includes Lulworth Cove, was one of the first to be so defined. Paradoxically, the establishment of an army range on the heathland around Lulworth has also helped to preserve its natural character by excluding building and farming.

This, like most of Hennell's watercolours, was painted out of doors, with the barest minimum of preliminary sketching. The fluid qualities of the watercolour medium produce an effect of freshness and immediacy. This example perfectly illustrates his belief that 'we look in landscape painting not primarily for a rationalised statement nor for a description of fact, but for the moment of vision'.

Wareham is an ancient town of Saxon origins, still standing within the low earth ramparts of its original defences. The four main streets, laid out by the Romans, follow the points of the compass. On South Street is the 'Black Bear'. Built around 1800, it was a regular stopping-place for the London coaches. In place of the usual painted board, it has an outsize plaster bear on the columned porch to indicate its name. (For another type of inn-sign, see page 115). Such models – horses, lions, swans, dragons, harts, lambs and unicorns – were commonplace at one time, but have often been lost in the course of refurbishment, for a painted board is cheaper to replace and maintain.

Barbara Jones (1912-1978)
THE 'BLACK BEAR', WAREHAM, DORSET

Barbara Jones (1912-1978)
COTTAGES AT CANFORD MAGNA, WIMBOURNE, DORSET 1942

Model villages, of which Canford Magna, near Wimbourne, is an example, were a phenomenon of the nineteenth century. Canford was the work of Sir Ivor Bertie Guest, who began by imposing a spiritual perfection to match the material when he replaced the village pub with a school and a mortuary chapel in 1866. Between 1870 and 1872 two rows of cottages were built for the estate workers; in their original form these were plain and dull but they were transformed by the addition of extraordinary rustic porches built by a local thatcher, John Hicks. Jones made an extensive study of these exotic embellishments which she wrote up and illustrated for the *Architectural Review* (April 1944):

Each porch was the result of many weeks' work, beginning with a twisted branch or knot, nailed up and left while Hicks disappeared for days together to collect oak boughs of suitable shape for his idea. . . obviously he took immense pains over it, as no wood has been pared down and the exactness of diameter and curve is remarkable, with even knots and projecting twigs deliberately arranged.

Hicks worked on these structures over a long period, from 1883 to 1898. For a pair of older thatched cottages he made thatched porches (one is shown on the right); later examples have steeply pitched tiled roofs and are more restrained, purged of romantic motifs in favour of largely geometric designs. From each of the original groups of four cottages, one has been lost. The porches themselves, like so much wooden architecture, are ephemeral; the guide books make no mention of them, and Jones's watercolours, set in a *trompe l'oeil* rustic frame, may stand as the only record, thus emphasising 'Recording Britain's' concern with the undiscovered, the previously unpictured and subjects of purely local fame.

The 'Camden Town' manner is evident in all of Bayes's contributions to 'Recording Britain' (he was a founding, but minor, member of the Camden Town Group), but this drawing in particular demonstrates his debt to Sickert, the chief exponent. The music hall interior, with its drama of light and colour, was a favourite subject for Sickert. But where Sickert's views show flaring gas jets or the glow from the stage highlighting rows of animated faces disembodied in the darkness, Bayes's paler watercolour tones emphasise the blazing lights and sparkling surfaces of the pink and white and gilt decor. Such richly ornamented interiors were a characteristic of the Victorian theatres; the elaborate shell and pearl motif seen here above the stage is a reference to local pride – Colchester has long been famous for its oysters.

Victorian and Edwardian theatres have been lost in depressingly large numbers over the last thirty years or so, as other entertainments have steadily reduced audiences for live theatre. The Colchester Theatre, which opened in 1905 as the Grand Palace of Varieties, became in turn a cinema and a bingo hall. On a prime town-centre site it could easily have been yet another victim of the developers; instead it has been restored inside and out and opened as a nightclub.

Walter Bayes (1869-1956)
THE INTERIOR OF THE OLD GRAND THEATRE, NOW THE GAUMONT HIPPODROME, COLCHESTER, ESSEX

Michael Rothenstein (b. 1908)
POST MILL, FINCHINGFIELD, ESSEX

O ne of England's more picturesque villages. Finchingfield
combines all of the essential elements of the 'typical' village –
the church, a green with a pond, an eclectic but harmonious mix
of cottages and a windmill. This is, to be precise, a post mill. The
entire structure, supported by a central post, could be turned so that
the sails always faced into the wind.

This mill, with its brick-walled roundhouse below, was built
around 1760 on an artificial mound twenty feet above the road.
Originally one of four, it now stands alone. Its history is similar to
that of many other mills across Britain; redundant by 1904 it
survived, though increasingly dilapidated, until 1947, when it was
purchased by Sir John Ruggles of nearby Spains Hall and presented
to the villagers who repaired it by public subscription. It was derelict
again by 1957, and the responsibility for its preservation was taken
on by the County Council. It is still open to the public.

Rothenstein, who lives only a few miles away at Great Bardfield,
painted several of the local mills. Here he chose to show the weed-
choked yard behind the mill, a symptom of its long neglect. The
thatched roof beyond belongs to what was once the miller's cottage.

C ontrast Piper's dramatically lit theatrical image (page 122) with
Rowntree's more prosaic view of a similar subject. The tomb-
stones here are themselves more restrained, lacking the macabre
exuberance of the seventeenth-century examples. These unor-
namented slabs date from the first half of the nineteenth century and
form a part of one of the longest consecutive rows of family grave-
stones in Britain; there are nearly twenty in all, with some marking
the grave of more than one person.

Rowntree has chosen the most pathetic episode of the Livermore
family narrative, recording the early deaths of four of the daughters
of Edward and Sarah Livermore. Martha Susannah died of 'a slow
decline' in 1827, at the age of fourteen. In the autumn of 1840 Emma
was thrown from her horse, aged twenty-two. Eight months later,
Jane, aged nineteen, died of a heart attack, closely followed by
sixteen-year-old Maria who succumbed to smallpox.

Country churchyards such as Barnston act as a valuable index of
social history, offering a vivid insight into the lives – and deaths – of
earlier generations. Sadly, such fine examples of the mason's craft,
such evocative fragments of our past, have been stripped away in the
wholesale clearance of churchyards, in pursuit of order and easy
maintenance, which began in the eighteenth century and reached
its height in the 1950s and 1960s. Churchyards have all too often
been reduced to dull suburban lawns in which the church is stranded
in incongruous isolation. The stones themselves are at best pre-
served as flagstones, at worst broken up and used as hard core.

An uncleared churchyard can also be a haven for wildlife, some-
times harbouring as many as a hundred different lichens (some
apparently confined to graveyards) and other plants extinct on more
rigorously husbanded land. A recently established charity is now
encouraging the preservation of such places to protect rare or
endangered species.

Kenneth Rowntree (b. 1915)
THE LIVERMORE TOMBS, BARNSTON, ESSEX

With the exception of a picture of Brent Hall, all of Rowntree's Essex views for 'Recording Britain' are of churches, inside and out. At the time of the commissions he was living in the county, at nearby Great Bardfield, where he was one of a group of painters that included Michael Rothenstein, Edward Bawden, Eric Ravilious and Thomas Hennell (a visitor rather than a resident). This group was defined by geography rather than by style, but all were working on topographical subjects, primarily in watercolour. Ravilious and Bawden were largely responsible for reviving the art of watercolour painting in the 1930s, bringing to it a fresh distinctive style with a strong emphasis on pattern and texture. On the evidence of his 'Recording Britain' pictures Rowntree was very much a part of this tendency.

Here he uses an unusually narrow upright format, appropriate to the form and proportions of this fourteenth-century church with its round tower and its narrow wooden pews. Both interior and exterior were even then showing signs of neglect in flaking plaster and the overgrown churchyard. The church retains at least one of its original consecration crosses – the red-painted circular motif above the pew – which is dated to 1380. These devices were intended as a defence against demons and the Devil; they were usually in sets of twelve but very few complete sequences now survive.

Kenneth Rowntree (b. 1915)
SS PETER AND PAUL, LITTLE SALING, ESSEX

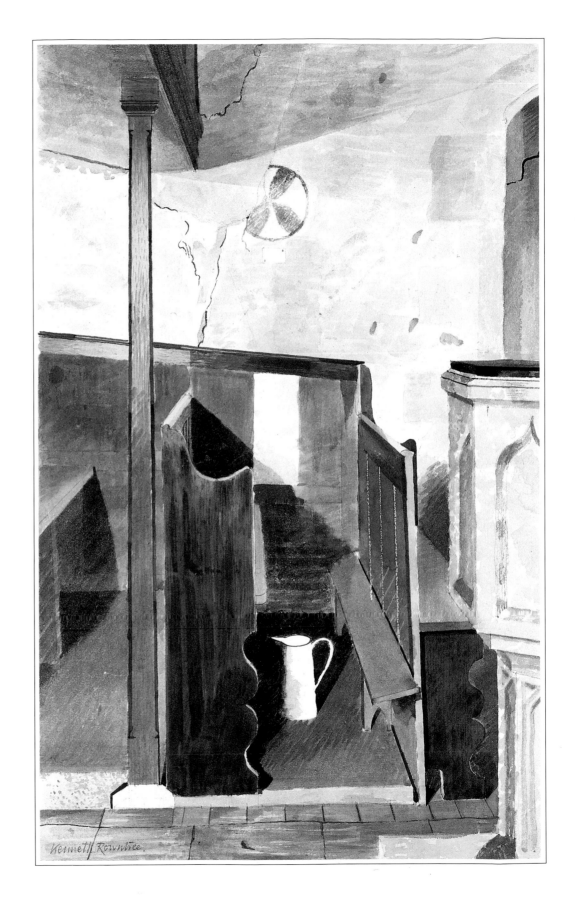

Graham Bell (1910-1943)
OLD BRIDGE, BRIDGEND, GLAMORGAN

More 'Recording Britain' pictures were painted in semi-anglicised Glamorgan than in any other Welsh county. Bell contributed only four watercolours, all of them in this area. His distinctive style, in which blocks of translucent colour overlap, is derived directly from Cezanne, particularly his work of the 1902-1906 period. The technique is very effective for the notoriously difficult task of describing water and reflections.

The river is the Ogmore, and the bridge dates from the eighteenth century. Only two arches are now visible, but on the evidence of the massive cut-waters on the upstream side it would appear that other arches must exist, hidden now by the surrounding houses. These cut-waters are superfluous today, for the river is both shallower and quieter than it once was. Narrow, steep and cobbled, the bridge is unsuited to motor traffic; fortunately, it has not been demolished but merely supplemented by a concrete bypass, which crosses the river at a point between the old bridge and the Wesleyan Methodist chapel, whose spire can be seen centre right.

Anderson has chosen a deliberately perverse view of Painswick, avoiding the tall spire of St Mary's Church, visible on every approach and the most commonly pictured feature of the town. Instead, he gives us a more intimate and domestic aspect, using a low viewpoint which gives us a sense of scale. The view here is of Victoria Street and the central bus stop.

Transport has, of course, been one of the major factors affecting the growth or decline of country towns and villages. The rise of private car ownership over the last forty years has made residence in rural villages feasible, as well as desirable, for the urban worker who can commute to the nearest centre. This has altered the character of the village, with incomers outnumbering locals; demand for a share in the rural idyll has pushed house prices in picturesque villages – and in the Cotswolds especially – to levels beyond the reach of the agricultural worker and his family. At the same time, the proliferation of private transport has led to

a decline in demand for the local bus services, which have consequently been graduallky reduced, further isolating those most in need – the elderly, young mothers, the poor. Various initiatives have been introduced in response to the problem – community mini-bus services, etc, but too late to preserve the character of towns such as Painswick, which lose their post offices, greengrocers and hardware stores to tearooms (the handsome Georgian edifice in Anderson's picture was already such by 1940), gift shops, antique galleries and interior decorators' showrooms, catering to the new class of residents who do their general household shopping elsewhere, and to the tourist.

Stanley Anderson (1884-1966)
THE BUS STOP, PAINSWICK, GLOUCESTERSHIRE, 1940

Agricultural practices feature largely in the 'Recording Britain' collection, not surprisingly perhaps, in view of the fact that with the onset of war self-sufficiency had become a vital concern. Farmers were under pressure to maximise domestic food production; the inevitable result was the rapid mechanisation of a conservative and traditional industry. Under the Lend Lease scheme (1941) Britain was supplied with American food and agricultural machinery; the number of tractors in use increased from sixty thousand in 1938 to two hundred and sixty thousand at the end of the war.

The breast-plough, though common at the turn of the century, was already an anachronism when Hartrick recorded this example: Thomas Hennell, in his illustrated book *Change in the Farm* (1934) noted it as being virtually extinct. Hartrick is here recording an isolated survival of the kind of basic subsistence farming, reliant on the horse and manual labour, which was to be increasingly marginalised by the transformation of agriculture to agribusiness. Ploughing in a grey wintry landscape Hartrick's anonymous farmer belongs to an age when farming practices followed the seasons. Chemicals, new technology and intensive factory farming methods have liberated the modern farmer from many of the unpredictable effects of soil and climate.

Hartrick lived for ten years at Tresham, until taking up a post at the LCC School of Arts and Crafts, Camberwell, in 1907, but maintained his links with the area. He and his wife redecorated the little church as a memorial to the unnamed dead whose tombstones had lost their inscriptions and his wife was subsequently buried there in 1934.

Archibald Standish Hartrick (1864-1950)
LANDWORK IN WARTIME: PLOUGHING
One of four scenes showing agriculture in wartime, commissioned by the Ministry of Information, 1940.

A S Hartrick (1864-1950)
Breast Plough at Tresham, Wotton-under-Edge, Gloucestershire

ennell produced an almost identical drawing of this scene (c 1941-3) for a series illustrating country crafts, and brought together by J M Richards as *The Countryman at Work* (1947). This was perhaps his original sketch, later repeated and worked up in colour for 'Recording Britain'.

The subject is the workshop of Michael Cardew, one of Britain's foremost studio potters. A pottery had been established at Winchcombe for at least fifty years before the picture was painted, but the practice was given new life by Cardew's arrival. Examples of the product — large clay flowerpots — can be seen stacked in the foreground and the location of the kiln is indicated by the tall brick chimney which acts as its vent.

Hennell wrote and/or illustrated a number of books on farming, on country life and traditional crafts, and many of his contributions to 'Recording Britain', in the Cotswolds, Dorset and his native Kent, illustrate these concerns. As he wrote in the preface to *Change on the Farm* (1934):

All the country's history, and not only a chronicle of small beer, is written out in the carpentry of broken carts and wagons, on the knots and joints of old orchard trees, among the tattered ribs of decaying barns, and in the buried ancestral furrows and courses which can still be traced under the turf when the sun falls slantwise across the fields in long autumn afternoons.

The Winchcombe Pottery was an appropriate subject for Hennell, because, exceptionally amongst English studio potters, Cardew derived his inspiration from native rather than Japanese models, and specialised in lead-glazed slipware for everyday use, notably large cider jugs. He left Winchcombe in 1942 to pursue a teaching career in West Africa.

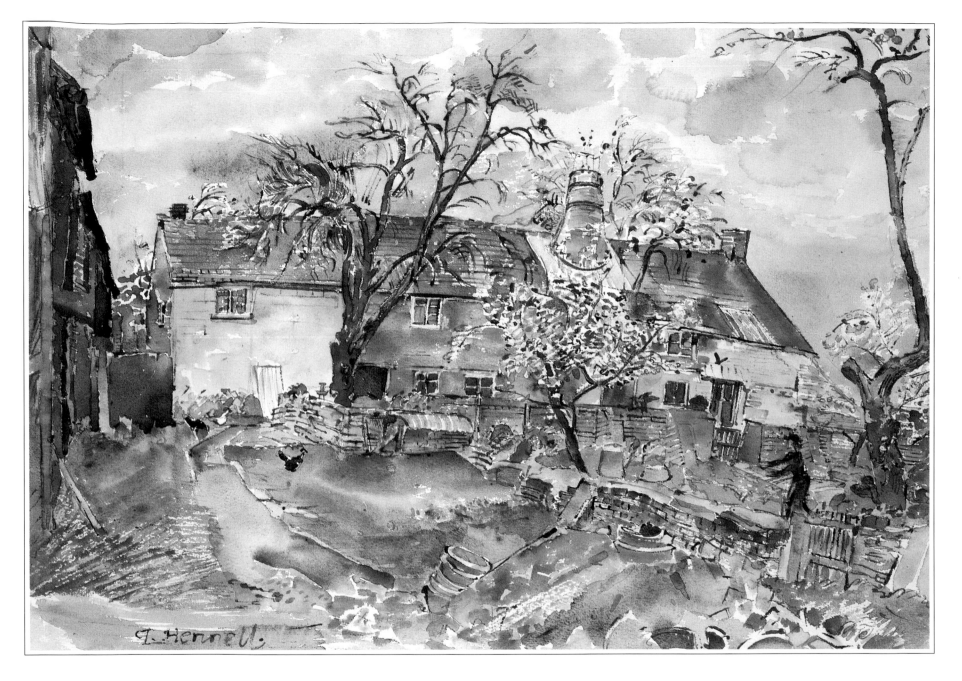

Thomas Hennell (1903-1945)
WINCHCOMBE POTTERY (EXTERIOR), GLOUCESTERSHIRE

Phyllis Ginger
THE PROMENADE, CHELTENHAM, GLOUCESTERSHIRE, 1942

The Promenade was laid out as a tree-lined ride in 1818, at the height of Cheltenham's prosperity as a spa town. Gentle walks were recommended as exercise to those who came to take the waters at one of the six pump rooms, hence the proliferation of wide streets planted with lime, chestnut, sycamore and plane, and well-planned parks and gardens.

In decline during the early years of the twentieth century, Cheltenham was revived by the second world war: American servicemen (who appear in several of Ginger's Cheltenham scenes) were billeted in its many unoccupied houses and wartime production of aircraft components stimulated the town's industrial development. Wartime damage was both direct – a number of houses were destroyed in the air raids of 1940 and 1942, and indirect – fine buildings such as the Pittville Pump Room suffered from neglect, and the ironwork (as in Bath) was lost to salvage.

Since the war the town has promoted itself as a holiday and conference centre, exploiting the parks and gardens, the elegant hotels and many cultural facilities surviving from its Regency heyday. Like so many English towns it lost key buildings to the mania for demolition and development in the 1960s, but in 1973 much of central Cheltenham was declared a Conservation Area; the Promenade itself is now a shopping street of exceptional beauty.

Tocknells Court, a fine seventeenth-century Cotswold stone manor house, was built on the profits of the wool trade, but for Rothenstein it bears a significance beyond its own specific history. Perhaps more than any other contributor to 'Recording Britain' he was concerned to render the spirit of place as a metaphor for the mood of the time. His compositions are the antithesis of the bucolic detail of Anderson, the neat busy-ness of Badmin, the self-effacing minutiae of Dimond; rather they are pared down, giving us the barest outlines consistent with topographic accuracy, and heavy with foreboding.

This sombre portrait of a distinguished house is almost entirely monochrome. The only colour is to be found in the wilting cyclamen plants on the windowsill in the immediate foreground. As winter and neglect take their toll on the plants, so time and circumstance contribute to the decline of the house and the lives it encompasses. The windows and the door appear dull and blank, like so many blind eyes, as if the house had already been closed up and abandoned.

Michael Rothenstein (b. 1908)
LOWER TOCKNELLS, NEAR PAINSWICK, GLOUCESTERSHIRE, 1940

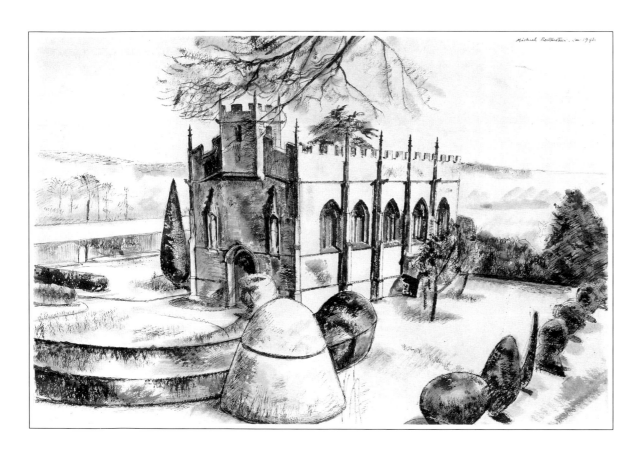

Rothenstein claims that in his choice of subject matter for 'Recording Britain' he was especially drawn to the symbolic and to those buildings which could contain a larger meaning beyond the specifics of locality. Such preoccupations are clearly evident in this drawing of the empty shell of Sudeley Castle, a fifteenth-century house which once belonged to Sir Thomas Seymour, second husband to Henry V111's widow Catherine Parr. Desertion and subsequent decay were responsible for its now ruinous state, but this is not immediately apparent. It could as easily be one of the hundreds of historic buildings damaged in the German bombing raids. Rothenstein thus draws a subtle parallel between the effects of 'progress' and of war.

In this picture we look across the width of the building, our view framed by a window; this is in itself symbolic for it is simultaneously a window on the past and on a probable future. The drawing is monochrome except for the mosaic of lichens stippling the walls and the alder branch curling over the sill, emblems of survival, resurrection and hope, a hope embodied in the purpose of the 'Recording Britain' project as a whole.

Michael Rothenstein (b. 1908)
THE CHAPEL, SUDELEY CASTLE, GLOUCESTERSHIRE, 1941

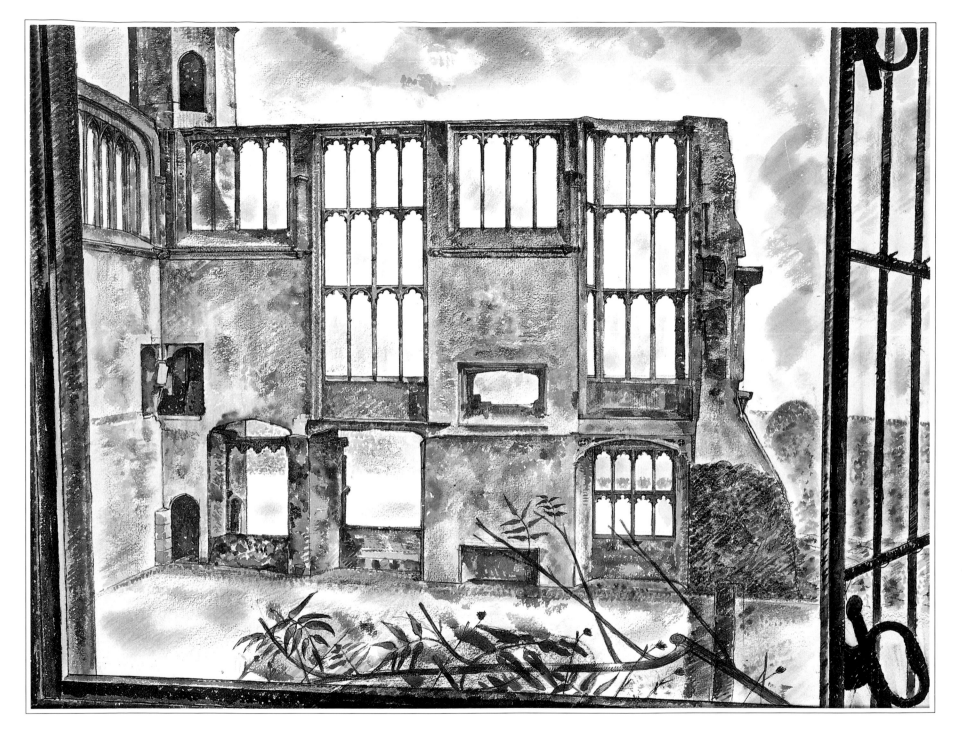

Michael Rothenstein (b. 1908)
BANQUETING HALL, SUDELEY CASTLE, GLOUCESTERSHIRE, 1941

In accordance with their somewhat vague brief the 'Recording Britain' artists sought out places or institutions peculiarly British. At Stowe, the landscape garden, or *le jardin anglais,* had found its apotheosis; by 1750 its scenery was generally accepted as the finest realisation of the eighteenth-century's concept of Ideal Nature. An initial phase of design employing architects Bridgeman, Vanbrugh and Gibbs was succeeded around 1730 by the more painterly vision of 'Capability' Brown and William Kent. The latter was responsible for many of these follies, grottoes and monuments which complete the prospect, forming a focus for each carefully contrived view, or the serendipitous goal of serpentine meanderings.

The Temple of British Worthies, visually and conceptually a reply to The Temple of Ancient Virtue across the lake, was designed by Kent around 1735 as part of that area designated the Elysian fields. A monument to native genius in the arts, sciences, exploration and statemanship it formed a key part of a scheme to impose a moral – political significance on the landscape. Indeed the landscape garden, that 'amiable conjunction of art and nature' was devised to express the perfectability of Nature and, by association, Man.

The house itself became (and still is) a public school in 1923, and the gardens, though they remain substantially intact, suffered a benign neglect. The gardens were given to the National Trust in 1989 and maintenance and restoration is underway. The appeal of these monuments for Piper (who did two more drawings at Stowe) seems to have been their theatricality — like stage flats many are insubstantial, grandiose façades, designed to be seen from one side only.

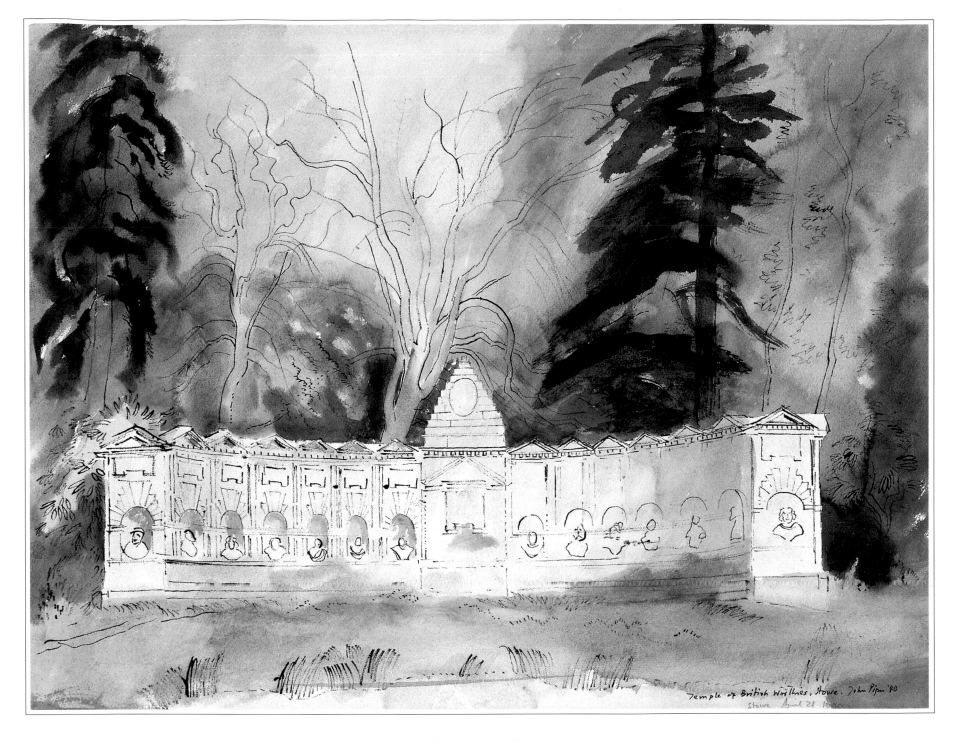

John Piper (b. 1903)
THE TEMPLE OF BRITISH WORTHIES, STOWE, GLOUCESTERSHIRE, 1940

Puller was one of the most prolific and widely travelled of the 'Recording Britain' artists, covering nine counties (a total only exceeded by Barbara Jones and Martin Hardie). She seems to have been an amateur, for her career is not recorded.

This watercolour is one of six studies she made in the market town of Tetbury. A companion picture shows the local livestock market which is just to the left of this scene. This bird's-eye view focuses on the station, with the railway carriage painted in the distinctive and elegant livery of the Great Western Railway Company. Before the nationalisation of the railways in 1948, the network was divided between several regional companies, a situation which may well be revived in the 1990s.

From its introduction in the 1840s the railway exercised a profound influence on demographic change in the countryside. It ended the isolation of many rural communities, and villages lying along the major lines of the rail network have been transformed from agricultural settlements into dormitories for those who commute to the towns and cities. Increasingly the character of rural settlements is dictated by transport policy. Thomas Beeching's savage cuts in the branch lines in 1965 imposed a new isolation on the communities affected, an isolation aggravated by the decline in country bus services. Local initiatives are now trying to reverse this trend: in 1989, for instance, four village railway stations were reopened in Staffordshire and more are planned. Tetbury itself is amongst those towns which no longer possess an operative railway station.

Louisa Puller (1884-c.1963)
Railway Station at Tetbury, Gloucestershire, 1942

The beech avenue at Lasham was, like the Derbyshire village of Ashopton, and the Suffolk farms recorded by Louisa Puller, an urgent case under immediate threat. On 7 October 1941 a letter in *The Times* from Sir George Jeffreys MP drew attention to the proposed siting of an aerodrome and the consequent danger to a famous avenue of trees. Hennell was offered the commission to record the site almost immediately.

The avenue followed the boundary of the constituencies of Basingstoke and Petersfield and the parishes of Lasham and Herriard. It was planted by George Purefoy Jervoise of Herriard Park in 1809, a premature celebration of the Jubilee of George III, due the following year. Though the trees of the mature avenue were remarkable for their beauty and uniformity, four-fifths were felled, leaving only two short lengths totalling a quarter of a mile.

The beech is a native of the dry limestones and chalks of south-eastern England. Another stand of famous beeches can still be found a few miles south of Lasham in Gilbert White's Selbourne (though here they are a natural rather than a man-made feature). White wrote of the Beech in his *Natural History* (1789) as 'the most lovely of all forest trees whether we consider its smooth rind or bark, its glossy foliage, or graceful pendular boughs'. These are the qualities which made it a favourite tree for avenues and for ornamental landscaping.

Thomas Hennell (1903-1945)
The Beech Avenue, Lasham, Hampshire

The title does not locate the house precisely within the town, but the best Regency architecture was to be found in Mount Ephraim and the Calverley estate, to the north and east of the centre. These elegant residential districts were the legacy of the town's wealth and status as a fashionable spa town patronised by royalty. This house, with its green-shaded verandah, is lavishly ornamented with wrought-iron work – slender pillars, railings and window-sill grilles trim the facade like black lace.

Hooper's lively style, with its strong black-ink outlines, was perfectly adapted to such subjects.

Though Tunbridge Wells suffered some bomb damage, and later saw development on the outskirts, the character of the town has remained substantially unchanged. It has lost its focus as a spa town – tasting the waters is now just an amusing diversion for summer tourists – but it thrives now as a commuter town for London and as a centre of the local antiques trade.

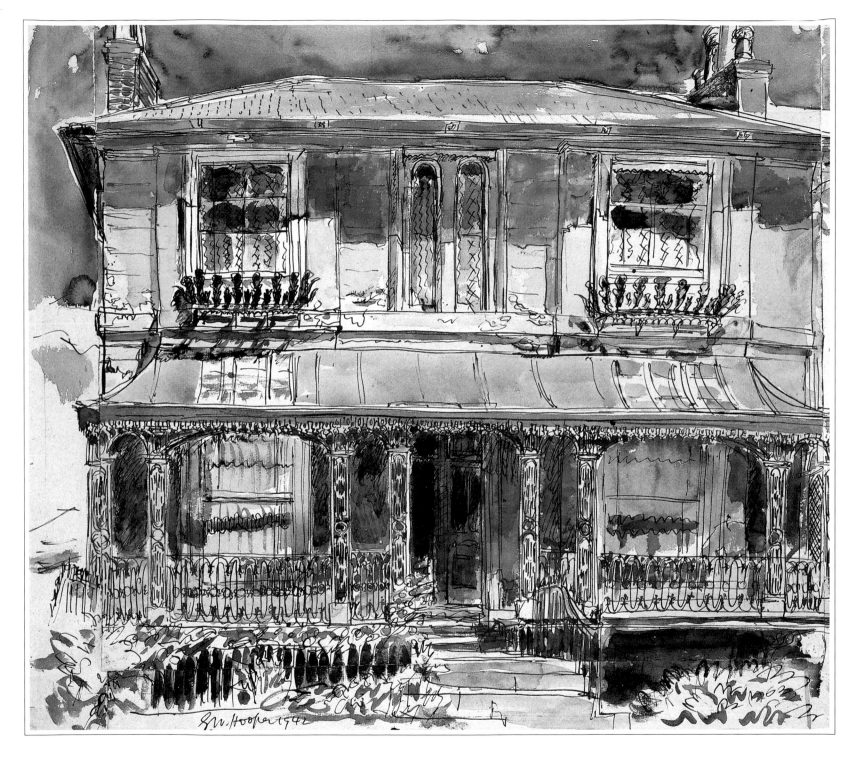

George W Hooper (b. 1910)
REGENCY HOUSE IN TUNBRIDGE WELLS, KENT, 1942

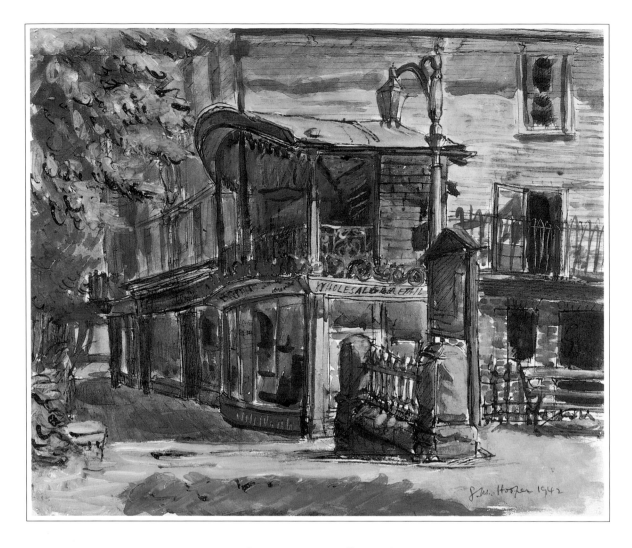

George W Hooper (b. 1910)
THE MUSIC GALLERY, TUNBRIDGE WELLS, KENT, 1942

The Music Gallery, with its pretty early nineteenth-century balustrading, stands on the eastern side of the Pantiles, a parade of eighteenth- and nineteenth-century shops described as 'the perfect pedestrian precinct'. Like Buxton (page 61) and Cheltenham (page 78), Tunbridge Wells is a spa town; the Pantiles was laid out in 1638 as a promenade for those taking the waters from the iron-rich springs which still bubble up at the north-west end.

The houses and shops on the west side were rebuilt after 1687 in a regular manner, with a colonnade. The raised walk was first paved in 1700 with the so-called pantiles. It was later repaired with flagstones, but fifteen of the original square earthenware tiles have been relaid near the spring. A row of pollarded lime trees marks the drop to the lower walk on the south side. Hooper's picture, though focusing on one building, captures perfectly the mood of peace and civility in the street; an example of successful town planning.

Seven drawings were made in Tunbridge Wells, a tribute to its architectural riches, and a response to a then recent insensitive development: the council had demolished Decimus Burton's distinguished Calverley Parade in the late 1930s to make way for the unremarkable neo-Georgian civic centre. Worse was to come, with disastrous intrusions into the civilised integrity of the Pantiles itself. Fortunately the latest developments have been more enlightened: the Corn Exchange and the old Victoria Hotel, crumbling from neglect, have been rebuilt behind their façades with an appropriate continuity between exterior and interior, and a gap in the colonnaded terrace has been skilfully filled with three floors of flats that reproduce the gable-ends and brick of neighbours rebuilt in Edwardian times.

Wickhambreux, four and a half miles east of Canterbury, is another one of those 'perfect' picture-postcard villages which convey the essential character of rural England as we like to imagine it. Little bridges cross the stream to cottage gardens and the green is shaded by chestnuts and limes. The most eye-catching feature is the tall white weatherboarded water mill (still in use). Such mills were once a familiar sight in Kent; there are similar examples at Farningham and at Bexley, though the latter has been converted into a restaurant, a common fate for these attractive well-sited buildings.

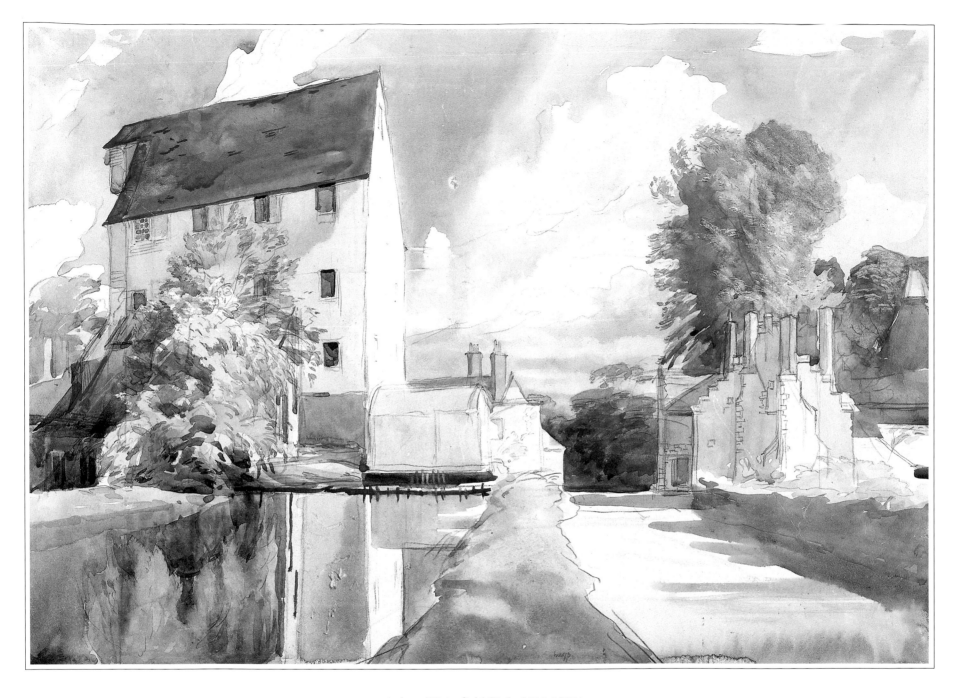

Aubrey Waterfield (Exh. 1911-1931)
WICKHAMBREUX MILL, KENT

In a set of three meticulous watercolours of the interior of Chegworth Mill Badmin illustrated the complete process of milling grain. On the top floor are bins into which the grain is poured, descending to the grindstones below through an agitated trough. The grain is fed between the grooved rotating stones and the resulting meal or flour passes through funnels into sacks on the ground floor, as we can see here.

With a rich variety of browns Badmin gives us every detail of his subject, from the texture of the sacks to the grain of the floorboards and the random scatter of sieves and scoops. A single touch of colour is provided by the artist's canvas bag and portfolio set down in the right-hand corner. Badmin's subsequent successes as an illustrator are prefigured in this skilful composition. As a critic had observed of his work in 1934, he had the power of 'miraculously reconciling minute detail with atmospheric breadth', here embodied in the sunshine slanting across from the open door and the fine dust hanging in the air.

The attentive reader may notice that this watercolour is dated 1936, though the 'Recording Britain' project was not conceived until 1939. Heightened security in the southern counties caused serious problems for artists, particularly in rural areas, and as a consequence the Committee agreed to supplement the record with some works painted earlier. In addition to Badmin's three mill studies and a panoramic view of Dover of the same year, the Kentish group includes watercolours by Martin Hardie (1875-1952) of Whitstable and West Malling, dated 1934 and 1937 respectively.

Stanley Roy Badmin (1906-1989)
CHEGWORTH MILL (GROUND FLOOR), HARRIETSHAM, NEAR MAIDSTONE, KENT, 1936

The Martello Tower, silhouetted against a calm sea, is the central focus of a wider view which encompasses Folkestone harbour to the right and a patchwork of allotments laid out on the leeward side of the promontory. Folkestone stands at the eastern end of the Weald of Kent where it dies away to the sea; an elegant prosperous seaside resort since the eighteenth century, it had flourished with the coming of the railway in 1843 and the establishment of the cross-channel service to Boulogne.

From Hill's vantage point the town itself is invisible, tucked away below the cliffs – his subject is rather the nation's strategies of defence against invasion, past and present. The allotments, product of the patriotic drive towards self-sufficiency (see page 102)

symbolise the spirit of the home front. The Martello tower stands for the continuity of independence and a history of resistance to European domination. Built between 1804 and 1812, these squat fortifications (103 in all along the coast from Sussex to Suffolk) were intended as a defence against France during the Napoleonic Wars. Adapted from a round fort, the Torre della Martella in Corsica which had successfully repelled English forces, Martello towers themselves inspired the concrete pill-boxes of the Second World War defences. Most have now been pulled down, but Kent retains several between Dymchurch and Folkestone; at least one of them has been converted into a novel holiday cottage by the Landmark Trust.

Adrian Hill (1895-1977)
MARTELLO TOWER, FOLKESTONE, KENT

Adrian Hill

KENT

The shining white tower of St Martin's is seen from within a farmyard, suffused with golden light. The scene has strong affinities with the pastoral idylls painted by Samuel Palmer (1805-1881) in and around another Kentish village, Shoreham. The English neo-Romantics of the 1940s, among them John Piper, acknowledged Palmer as a powerful influence for his 'ability to see in . . . things something significant beyond ordinary significance'.

Like Palmer's visionary landscapes, Waterfield's picture transcends its time and becomes an incarnation of a more perfect past, a golden age of salvation and divine fertility. Like Palmer too, Waterfield employs the symbolism of the rich harvest, in the red waggon with its overflowing load and the neat conical haystacks which echo Shoreham subjects and recall the long continuity of farming practices, Such abundance was, for a nation at war, an emblem of hope, a promise of security and salvation. The barns also, with their mossy thatches, belong to Palmer's vision of an 'Ideal' rural past.

Aldington itself, an attractive but otherwise unremarkable village, owes its small fame, and thus its place in 'Recording Britain', to two of its former rectors, the humanist writer Erasmus and the scholar and teacher Thomas Linacre.

Samuel Palmer (1805-1881)
LANDSCAPE WITH BARN, SHOREHAM, KENT

Aubrey Waterfield (Exh. 1911-1931)
ALDINGTON CHURCH, KENT

In keeping with her taste for follies and for folk art Jones chose an unusual subject in Crystal Palace Gardens — three of the life-size models of Jurassic reptiles (or dinosaurs) which inhabit the lower reaches of the steeply sloping site. As she explains, in a note on the back of the drawing, these figures were a manifestation of 'Victorian Education', intended to instruct rather than entertain; they were arranged naturalistically on islands and in the waters of the ornamental lake, in the manner of an open-air museum display.

The Crystal Palace itself, originally built in Hyde Park to house the Great Exhibition of 1851, was dismantled and re-erected on the hillside site at Sydenham in 1854. It was destroyed by fire in 1936, leaving a bare, raised terrace overlooking the gardens. The statues were part of the original garden scheme laid out by Joseph Paxton, the architect of the Palace itself. They were made of bronze, realistically modelled and painted, under the direction of palaeontologist Professor R. Owen. They can still be seen peering from the bushes and have since been joined, somewhat incongruously, by a gorilla (by David Gwynne, 1961).

Much of the park is now given over to sporting facilities, and the future of Crystal Palace gardens has been the subject of debate. Plans to rebuild the Palace as an exhibition centre have proved impracticable, and the latest scheme will see a luxury hotel erected on the site.

Barbara Jones (1912-1978)
CRYSTAL PALACE GARDENS, SYDENHAM, KENT, 1942

The 'Recording Britain' commissioning committee tried, whenever possible, to employ local artists for their enhanced knowledge of, and sympathy for, their subjects. This policy was particularly successful in Lancashire where all the artists, including Dawson, were from the north-east.

This tower mill was one of four mills in the flat windy Fylde area to be illustrated for 'Recording Britain'. By 1947 there were already two thousand derelict mills in Britain; they were afforded special protection by the Society for the Protection of Ancient Buildings and under the Town and Country Planning Act of 1932. This eighteenth-century example was last used in 1935 and was already in a state of some decay when Dawson painted it five years later; by 1969 it had only two sails left.

Unlike the wooden post-mills, in which the whole structure rotated around a central pole, the tower mill was built of brick or stone and only the cap, carrying the sails, turned. Windmills, like the Kentish oast houses, are relics of an agricultural past that has been superseded by newer, faster, mechanised methods of production. Both can now be seen, stripped of their mechanisms and converted into desirably distinctive houses.

Byron Dawson (1886-1968)
CLIFTON MILL, NEAR PRESTON, LANCASHIRE, 1940

Downham village, in the shadows of Pendle Mill, has changed very little since Dawson sketched it fifty years ago. That it remains virtually unspoilt can be attributed to the benign influence of the Assheton family who have lived there as lords of the manor for four hundred years. The present Baron Clitheroe of Downham lives at the Hall, a house of ancient origins refaced in a classical style around 1835. In the parish church of St Leonard, seen here at the top of the lane, a memorial to the last member of the Assheton family to die bears a Latin inscription which, loosely translated, advises that 'if any memorial should be needed, just look around you.' The reference is to Sir Ralph Assheton who paid to have cables laid underground rather than allow the landscape to be disfigured with electricity pylons.

Downhams's well-preserved picturesque beauties earn it a place in *The Shell Book of English Villages* (1980), a catalogue of settlements 'outstandingly beautiful or historically interesting'. Downham qualifies for inclusion on both counts. The old stocks still stand (a rare survival), as do the bridges over the stream that winds through the village green, but foremost among its charms are the cottages, built and roofed with the warm-coloured local stone. By adhering to local materials and traditional styles, the village is preserved as a visually harmonious whole in which the houses appear almost as natural growths. All too often otherwise homogenous villages in which buildings of different ages are blended together unobtrusively by a shared material, have been marred by the addition of much-needed housing in an unsympathetic style, brick-built with roofs of dull slate or Redland tile.

Downham lies at the heart of the so-called 'witch country' around Pendle. Today, as local tourist boards vie with each other to market their region by defining the experiences it offers, packaging a readily accessible 'history' of everything from the Roman occupation to coal-mining, the village forms part of the ubiquitous 'tourist trail'.

Byron Dawson (1886-1968)
Downham Village, near Clitheroe, Lancashire, 1940

LANCASHIRE

Byron Dawson (1886-1968)
VIEW OF PRESTON FROM HIGHER WALTON, LANCASHIRE, 1940

Palmer, in his original introduction to Lancashire, explained that recording the county was regarded as urgent, regardless of the war; he speaks of its exceptional beauties disfigured by pylons and factory chimneys. This view, which directly confronts the urban industrial threat to the rural traditions that formed the English landscape, is virtually unique in the 'Recording Britain' collection. Only Albert Pile with his studies of the Manchester Ship Canal approaches the same subject, though these views were of an industry already in decline.

Dawson has taken as his subject here the stark contrast between town and country, the rural and the industrial landscape. Dawson's sketch suggests a gulf between the two, clearly defined by the river which bisects the picture at the point where the high ground gives way to the flat fields of the coastal plain around Preston. It is not only a cotton town but also a port: cranes at the docks can be seen on the horizon, amongst the smoking factory chimneys.

Preston and its suburbs now encroach on Higher Walton, which stands, beleaguered, just north of the M6/M61 junction .

This top-heavy row of timber-framed houses has the air of an exaggerated caricature, so pronounced are the angles of the bulging walls and buckled window frames. The Old Shambles was, and is, the last surviving fragment of the original medieval settlement in central Manchester. The city as it is today is largely a creation of the Industrial Revolution and the subsequent growth of manufacturing trades. Though the buildings had gone, the medieval street pattern persisted in this area until 1941, when all was swept away in a new development which left the Shambles exposed to view from all sides, no longer one half of a narrow lane.

Pile specialised in architectural subjects and was to become an official artist to the Ministry of Information, following his stint on 'Recording Britain'.

Albert Pile (1882-1981)
THE OLD SHAMBLES, MANCHESTER, LANCASHIRE, 1942

DIG FOR VICTORY
Poster issued by the Ministry of Agriculture to
aid the war effort in 1941

The title that Palmer gives to this picture is misleading, for the church of Holy Trinity is really no more than an incidental feature of the composition. As Badmin's own inscription makes clear, his subject is the digging and planting of 'The New Allotments' to be seen in the foreground.

Allotments, an invention of the Scots in the late nineteenth century, came to England and Wales with the Smallholdings Act of 1908, which made it a statutory duty for local authorities (district or parish councils) to provide allotments wherever there was a need. For a small annual rent families could (and still can) hire a plot to supplement a low income and a poor diet with a supply of fresh vegetables. This was a valuable resource for the gardenless residents of the cities and the industrial towns.

With the outbreak of war the allotment was a key tool in the drive to maximise food production. Between 1939 and 1945 the number of allotment gardens increased from 800,000 to 1,500,000, testimony to the startling success of the 'Dig for Victory' campaign.

The cultivation of allotments has declined and though some areas have waiting lists, it is now common to see unused plots. Nor is the contemporary allotment devoted exclusively to vegetables; in a reversal of wartime practice, when many much-loved flower gardens (such as that belonging to the painter Cedric Morris) were given over to vegetables, it is now not unusual to see these once utilitarian plots devoted to roses or chrysanthemums.

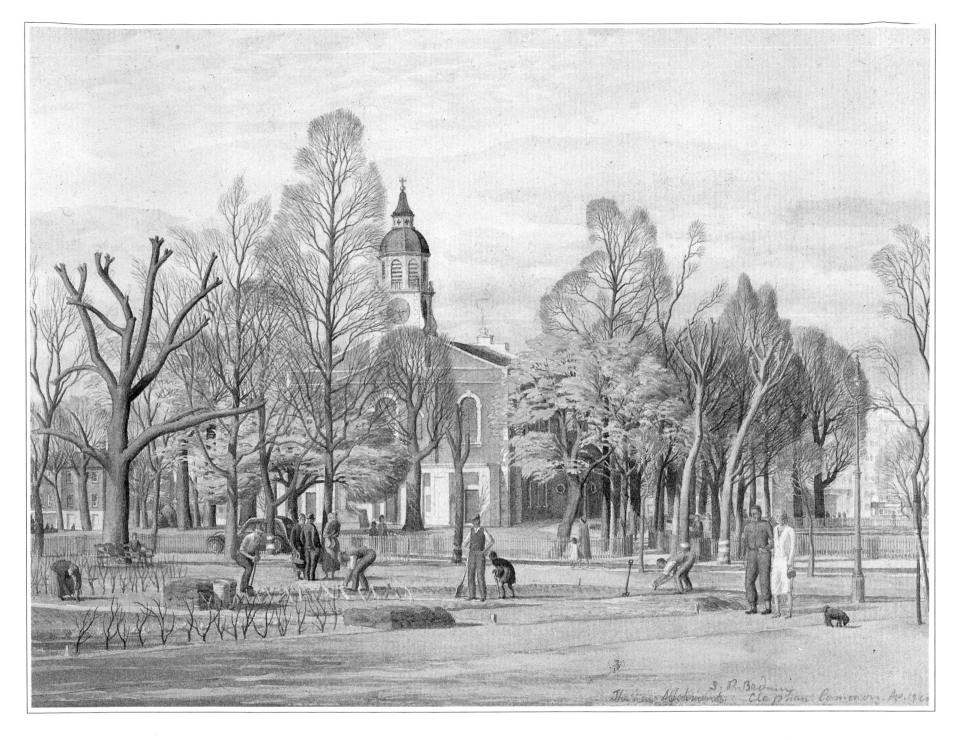

Stanley Roy Badmin (1906-1989)
HOLY TRINITY, CLAPHAM COMMON, LONDON 1940

Walter Bayes (1869-1956)
REGENT'S CANAL DOCKS, STEPNEY, LONDON

Bayes contributed more London views than any other artist, mostly parks, gardens and interiors. This is for him a rare departure, being almost entirely industrial. Regent's Canal, nine miles long, had been built to link Birmingham and the Midlands to the lower reaches of the Thames. The canal joins the river at Regent's Canal Dock, situated between the larger London Docks (upstream) and East India Docks (downstream). Bayes's picture shows the point where the canal passes under a bridge (carrying the Commercial Road) into the dock basin.

The secondary subject is signalled by the heap of rusty pinkish metal at the centre of the picture; this is the site of Cohen's scrap iron, one of the many businesses collecting and recycling iron for the armaments factories. Much of this scrap was in the form of park railings, garden gates and other decorative ironwork (see page 131). With a rare touch of humour Bayes has added beneath his monogram, lower right, the legend 'Retouched by A. Hitler', presumably a reference to subsequent bomb damage!

Walter Bayes (1869-1956)
ELEPHANT RIDING, ZOOLOGICAL GARDENS, REGENT'S PARK, LONDON

The Zoo is a famous and much-loved institution; set in the north-east corner of Regent's Park and bounded on one side by the canal, it was a favourite destination for a day out. Bayes painted two aspects of the zoo – this and the Pelican Pool – which convey the spirit of the place, rather than focusing on any of the architectural features, some of which (the Mappin terraces [1913] and the Lubetkin/Tecton penguin pool [1934]) are of international importance.

This was an era which allowed a degree of exploitation of the animals of a kind we now find rather demeaning and distasteful, such as riding on elephants and camels, and the chimpanzees' tea party. These have now been discontinued as the Zoo has emphasised its educational and scientific role. The Zoo remained open through the war, though certain precautions were taken: all the poisonous snakes were destroyed and many animals were evacuated to the Zoo's outpost at Whipsnade, Bedfordshire.

The Zoo is currently the centre of controversy. Not only is it regarded by many as being outmoded and inadequate on its cramped site, it is also, like most national academic institutions, seriously underfunded and must attract more visitors in order to survive. The management has outraged local residents by proposing 'theme park' style attractions, and planning a further expansion into the Park.

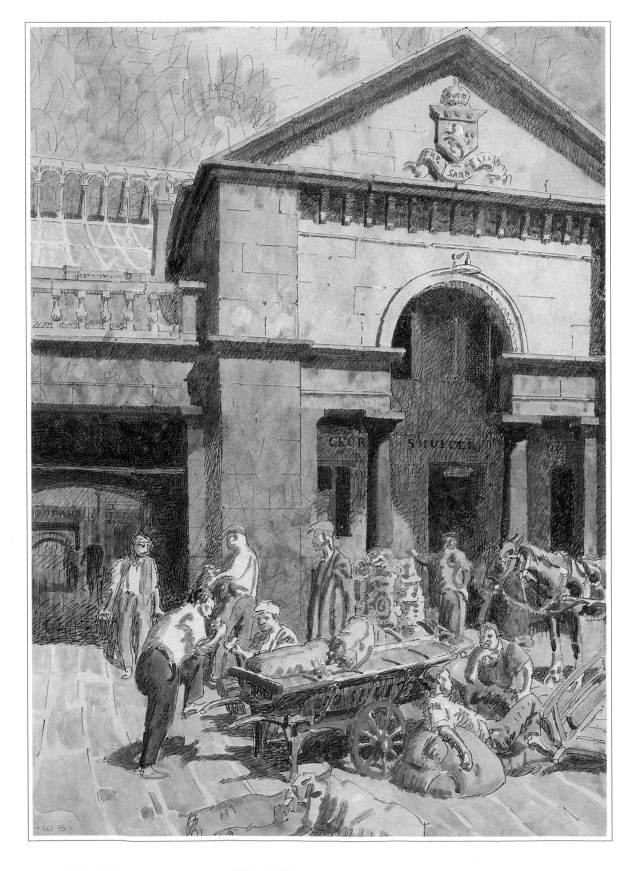

The name Covent Garden has a variety of associations; these days it conjures up images of the Royal Opera House and of a fashionable shopping centre. When Bayes painted this the name suggested, above all, fruit and vegetables; for it was the site of the principal London market in these commodities. The area had long been connected with this trade, being originally a produce garden for Westminster Abbey.

Covent Garden was the first square to be laid out in London. Bounded by piazzas and a church (the work of Inigo Jones) it was a market place from the middle of the seventeenth century. A Market Hall offering permanent covered stalls was built in 1828-30. It eventually became the principal market for foreign fruit, to be succeeded, in wartime, by vegetables. The site had originally belonged to the Earls of Bedford, with market rights being granted to them by Charles II in 1671; it is the Russell crest that appears above the portico in Bayes's drawing, though ownership passed from the family in the early years of this century.

In 1974 the market moved out to new premises at Nine Elms, Battersea, leaving a prime site free for development. A sympathetic conversion transformed the market building into a smart shopping mall that has remained a magnet for tourists ever since.

Walter Bayes (1869-1956)
COVENT GARDEN MARKET, LONDON WC2

Phyllis Dimond
KINNERTON STREET, WILTON STREET, LONDON SW1, 1942

Kinnerton Street in Knightsbridge was a more modest area in 1942 than it is now, as we can see from these two shops flanking the passage of St Ann's Close (which still survives). The street has a shabby air, with crumbling steps and cracked and peeling stucco above the shop fronts Both have their windows covered over or boarded against bomb damage, in order to minimise injury from flying glass.

All of Dimond's contributions to 'Recording Britain' were of London subjects; together with a number of the other contributors, including Fairclough, Walker, Jones and Rowntree, she was subsequently involved with a similar topographical project, the book *Londoner's England* (Avalon Press, 1947). This was inspired by 'Recording Britain' and showed scenes in London and the Home Counties that had survived the war unscathed.

Phyllis Dimond
THE SHELTER, BEDFORD SQUARE, LONDON WC1

Phyllis Dimond was one of the last artists to be recruited to the 'Recording Britain' team; she had seen one of the shows publicising the work of the scheme at the National Gallery in July 1942, and applied to the co-ordinator Arnold Palmer. She was approved and began work on the first of her twelve drawings (all in London) two months later. It was Palmer, representing the committee, who suggested as a subject the variety of park lodges and shelters. Dimond was to depict eight of these in all. At that time most of the London parks and garden squares contained a shelter of some kind. This, one of the more modest examples, being built only of wood, was known as the Pagoda; it had been installed some time in the 1840s.

The Bluecoat School for boys, an attractive building in the style of Wren, still stands in Caxton Street. It was once part of a network of charity schools in the area, including Greycoat School for girls and Greencoat School for orphans, both now gone but commemorated in the street names. It was built in 1709 at the expense of William Green, founder of what is now Watney's brewery, and continued as a school until 1926. In 1954 it was acquired by the National Trust; restored in 1975, it now houses a National Trust shop and information centre.

Phyllis Dimond
BLUECOAT SCHOOL, CAXTON STREET, LONDON SW1

Phyllis Dimond
A DOORWAY AND PART OF A STAIRCASE,
GEFFREYE MUSEUM, SHOREDITCH, LONDON

The Geffrye Museum was not built as such; originally it was a series of fourteen almshouses for widows of former members of the Ironmongers' Company, funded by a bequest from Sir Robert Geffrye, who had been Clerk of the Company. The identity of the architect is not known. The houses were set out to a conventional plan, with the building arranged around three sides of a rectangular garden. When built in 1715, they were in open countryside; by 1910, when the occupants were moved out to quieter surroundings, the houses formed an oasis within the teeming East End, hedged about on all sides with factories, workshops, houses and railway lines.

The Geffrye represents a rare success story; the site was saved by the intervention of the London County Council, together with Shoreditch Metropolitan Borough and private subscribers, who acquired it in 1914 in order to install a museum. After knocking through to connect the houses, a sequence of period rooms was created, ranging from the sixteenth to the nineteenth centuries (an example of 1930s decor was added later). Such a display is particularly relevant in an area with a high concentration of cabinet-making businesses.

Phyllis Dimond
THE GEFFRYE MUSEUM, KINGSLAND ROAD, LONDON E2

Barbara Jones (1912-1978)
DORIC ARCH, EUSTON STATION, LONDON NW1, 1943

In 1835 the London & Birmingham Railway won permission to extend the line from Camden Town to Euston Grove; their subsequent report announced that

> The Entrance to the London Passenger Station opening immediately upon what will necessarily become the Grand Avenue for travelling between the Metropolis and the Midland and northern parts of the Kingdom, the Directors thought that it should receive some architectural embellishment. They adopted accordingly a design of Mr Hardwick's for a grand but simple portico, which they considered well adapted to the national character of the undertaking.

This emblem of enterprise and confidence, popularly known as the Euston Arch, was to become a *cause célèbre* in conservation history. On several occasions its demolition was proposed; its destruction was finally achieved with indecent haste, in 1961-2, to forestall the efforts of preservation societies arguing for its listing as a protected building. This is only the most notorious of the many demolitions effected by British Rail, whose record with listed buildings is allegedly the worst of any public body.

In Jones's picture, we get an immediate sense of scale with the massive, sombre arch dwarfing the figure beneath. Originally pale sandstone, it had by this time blackened and its harmonic proportions been marred by spiked gates. Intended as an entrance, it ended its days relegated to the role of exit.

Phyllis Ginger (b. 1907)
PARK VILLAGE EAST, LONDON NW1

The area around Regent's Park received extensive coverage in 'Recording Britain' with pictures by Enid Marx, Walter Bayes, Phyllis Dimond and Phyllis Ginger. This was a response to its architectural variety and significance and the lack of existing illustrative material. Park Village East and West, both painted by Ginger, lie just outside the north-east corner of Regent's Park, part of the great scheme of streets and squares designed by the architect John Nash from 1811.

In the two Park Villages Nash established the tradition of the small suburban villa. The application of the village idea to an urban situation anticipated the Victorian suburbs. Park Village East (much the larger of the two residential retreats) was laid out and begun by Nash in 1824, and completed by Pennethorne. The closely set villas exhibit a miscellany of styles: classical, Italianate and gabled Tudor. Park Village West is smaller, tightly enclosed in a winding street, whilst Part Village East is strung out against the canal. Half the houses were lost when the adjacent railway cutting was widened.

Ginger's view shows the road closed – bomb damage perhaps? – and a distant barrage balloon – constant reminders to the artists of the urgency of their task.

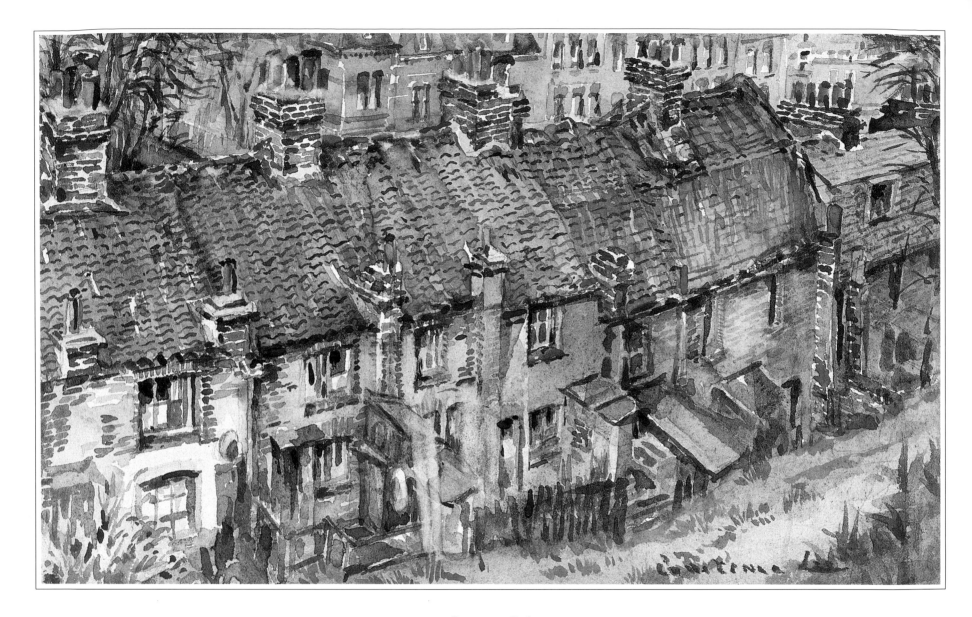

Constance L. Lee
COTTAGES AT CROUCH END, LONDON N8

This is not an obvious subject for a picture: a row of small, cramped cottages backing onto waste ground. In a rural setting – which no doubt this terrace enjoyed when first built – it would have appeared picturesque; here it seems mean and squalid against the larger Victorian villas beyond. A note on the back of the drawing explains that the cottages were demolished shortly after it was made.

Generally the London record concentrated on the centre, and the smarter residential areas to the north and west; Regent's Park, Hampstead, St John's Wood, Kensington and Chiswick. This, and Fairclough's views in Wapping were rare timid forays into less aesthetic surroundings.

The tavern's name derives from a specific local connection: the Knight's of St John of Jerusalem held the Manor of Lileston on this site from 1312. This is of course the origin of the designation 'St John's Wood'.

The chief beauty of the tavern, and the reason for its inclusion in the record, is the painted plaster plaque dating from around 1820. Such signs are rare survivals; more common are the effigy signs placed over porticos (see Barbara Jones's picture of the 'Black Bear', Wareham, page 65) and the painted board hung from the iron bracket.

Enid Marx (b. 1902)
THE KNIGHTS OF ST JOHN TAVERN, QUEEN'S TERRACE, ST JOHN'S WOOD, LONDON

Walter Bayes (1869-1956)
THE FAIR GROUND, HAMPSTEAD HEATH, LONDON

Entertainment, leisure, people at play – these are the recurrent themes of Bayes's many 'Recording Britain' pictures. A sense of holiday characterises the invariably sunny scenes in parks and gardens, on towpaths and river terraces. His interior studies show the companionable pleasures of dining and drinking.

Here at the fair two gypsies relax on the steps of their caravan; it is the traditional horse-drawn kind, boldly painted and decked out with bright curtains and potted plants. The travelling fairs were, and still are, a regular seasonal attraction on the commons of London.

Watch Houses were the first primitive police stations, introduced in the mid-thirteenth century. Watchmen were largely ineffectual, their duties being primarily defence of property and warning against fires. No proper civil force for maintaining law and order existed until the formation of the Metropolitan Police in 1829.

In 1939 there were eight or nine Watch Houses remaining in London. This example, properly known as St Clement Danes' Watch House, dates from the early nineteenth century and seems to be the solitary survivor.

Edward Walker (1879-?)
THE WATCH HOUSE, STRAND LANE, LONDON

Mildred Eldridge (b. 1909)
SLATE FENCES, ABERGYNOLWYN, MERIONETHSHIRE, 1943

These slate slabs set in a bleak landscape of windswept hills suggest, at first glance, standing stones or tombstones (for which slate was commonly used in this locality). Abergynolwyn, together with Blaenau Festiniog, Llanberis and Bethesda, was one of the principal slate-quarrying districts of Wales and so slate was used there as a substitute for stone in all kinds of construction including sheep-folds and garden fences.

Vernacular architecture derives its distinctive character from the marriage of geologically related building materials – for instance, the grey Welsh stone with the darker grey of the local slates. Slate has always been used in the main as a roofing material because it can be easily split into extremely fine sheets and trimmed into neat rectangles. Slate from north Wales had been used at Chester as early as the fourteenth century, but only became widely used in England in the nineteenth century, distributed across the country by the canals and railways. It was welcomed by architects and builders for its great practical advantages: it is strong, durable, non-porous, and easily worked. It soon ousted stone and thatch, and thus the regional distinctions in vernacular buildings, imposing instead a monotonous uniformity. Now, of course, slate itself has become too expensive and is increasingly replaced by mass-produced tiles of asbestos or concrete in garish shades of red or green.

All of the twenty drawings which Eldridge contributed to the 'Recording Britain' project are of Welsh subjects; she has lived at Pwllheli, Caernarvonshire, for many years.

Bayes, though, with the exception of A. S. Hartwick, the oldest of the 'Recording Britain' artists, was nevertheless one of the most prolific, contributing twenty-nine watercolours of London subjects, twenty-three of Essex, and a further twenty in four other counties. Whilst most of his fellow contributors were fresh from art school, Bayes was a well-established painter and teacher. As a founder member of the English fauvist association, the Camden Town Group (1911-1914), he had developed a distinctive palette dominated by tones of gold and mauve, and a strong graphic style in which texture and shadow were emphasised by dense cross-hatching.

The White Hart, with its stable-yard behind, was originally a coaching inn. Bayes has peopled the scene appropriately (or possibly some fancy-dress reconstruction is in progress); a lady in Victorian dress has just arrived by horse-drawn carriage, and is being greeted by a servant. Two fresh horses are being led forward.

Coaching inns were established on the main roads as staging posts; when journeys across country were measured in days rather than hours, both horses and passengers needed refreshment and overnight accommodation. Brentford was on the Great West Road, a major route out of London. With improvements in transport the great coaching inns have long since lost their *raison d'etre,* though they continue to offer hotel accommodation and often, as here, a restaurant; the stable-yard usually serves as a car park.

Walter Bayes (1869-1956)
THE YARD OF THE WHITE HART INN, BRENTFORD, MIDDLESEX

According to *Baedeker's* guide 'a special industry of Lynn is the manufacture of merry-go-rounds' and Savage's Yard was the headquarters of this trade. Savage himself, originally an agricultural engineer, developed and built magnificent steam-powered roundabouts and fairground organs. By the time Jones painted this , how-

Barbara Jones (1912-1978)
FAIRGROUND
No. 2 from the School Prints Series, 1946

ever, such machines formed only a minor part of the firm's production, the fashion for the traditional fairground having been superseded by brasher, more sophisticated amusements. The simple pleasures of the steam-driven roundabout seem tame beside the breathtaking thrills offered by the funfair and now the theme park, though an indulgent nostalgia keeps at least one steam fair in regular demand around the country.

Jones's picture is redolent of neglect and decay, the bright figures relegated to a dark and dusty corner. The horse that forms the centre-piece of the picture is only lightly carved, most of the decoration being painted 'trompe l'œil' in imitation of carving. This would have been an inner-circle horse counterfeiting the elaborate styling of the outer horses. In the foreground the unravelling concertina of card is a length of organ music with slits for notes, designed to be played by mechanical means like a pianola role. The two figures on the organ itself are automata who would strike bells or drums in time to the music.

Barbara Jones (1912-1978)
SAVAGE'S YARD, KING'S LYNN, NORFOLK, 1942

John Piper (b. 1903)
TOMBSTONES, HOLY TRINITY CHURCHYARD,
HINTON-IN-THE HEDGES, NORTHANTS

Gravestones first became common in the late seventeenth and early eighteenth century, a commemorative exhibition of status by an increasingly prosperous, literate and self-conscious class of farmers and tradesmen. (The gentry continued to be commemorated, and often buried, inside the church.)

In the churchyard of Holy Trinity there were between twenty and thirty of these headstones, exhibiting in high relief 'ebullient carving of a specially bold character'. The stone is local and so is the workmanship, though sadly anonymous. The designs employed by the seventeenth and eighteenth-century masons were never mere decorations – everything was weighted with meaning, referring directly or indirectly to man's mortality and to bodily corruption. But there was hope too: the winged head, seen here at the top of the smallest stone, was commonly used as a symbol of the soul.

The vivid images of cherubs and skulls, festoons and shields, share a Baroque exuberance to which Piper's theatrical style and antiquarian sensibilities were well suited. His preferred subject matter was the man-made past, ruins and other buildings suffering the aesthetic effects of age and neglect. These images of 'Pleasing Decay' (the title of one of his articles) embody the picturesque spirit of neo-Romanticism.

At first glance Towcester High Street seems an unlikely choice of subject, prosaic and unexceptional, the main thoroughfare of a typical English market town. But by choosing to record such a familiar scene Badmin showed remarkable prescience, for it is the ordinary, unprotected by any special status, which has been lost or transformed in the intervening fifty years. The High Street, in its traditional character as commercial centre, is being superseded by the bland uniformity of the shopping mall; the individuality of local buildings and local retailers are swept away by chain stores housed in red brick, concrete and plate glass. The integrity of the shop front is now destroyed by plastic fascias in vivid colours, neon signs and incongruous awnings. Planning controls are notoriously weak, even in designated conservation areas and a Department of the Environment circular issued in 1985 compounded the problem by advising local councils that 'aesthetics' should be considered largely irrelevant to the evaluation of a proposed development. The effects have been seen in a succession of unsightly and environmentally insensitive schemes.

Towcester High Street has largely escaped this fate and retains many of the original shop windows and façades. The Pomfret Arms itself has been renamed the Saracen's Head and is at present closed up, pending refurbishment or a change of use.

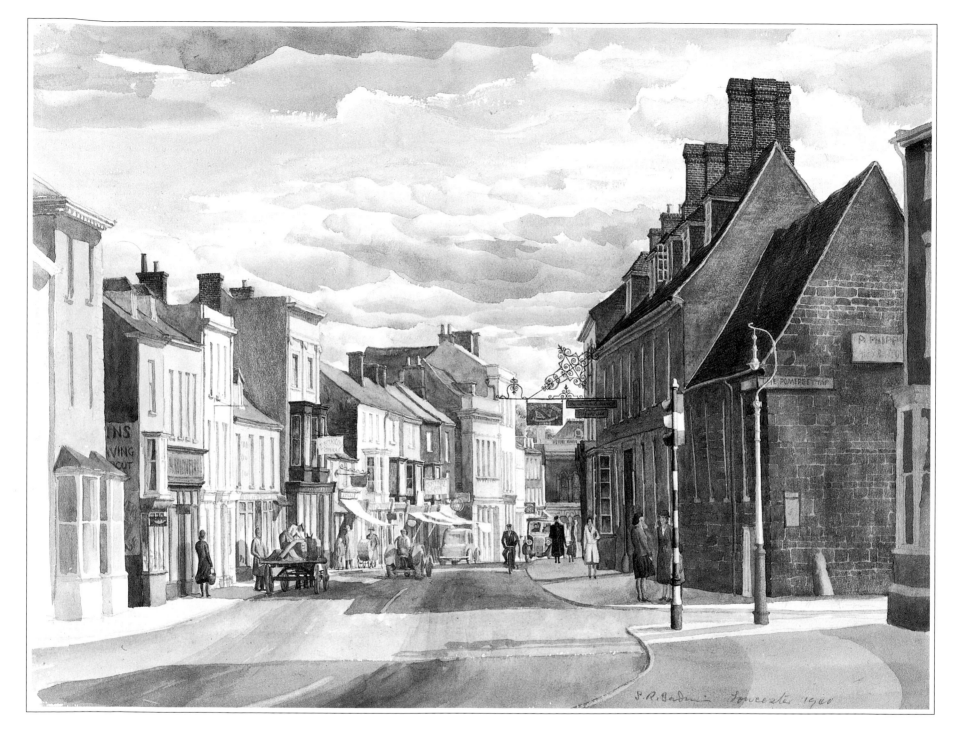

Stanley Roy Badmin (1906-1989)
Towcester High Street from the Pomfret Arms Corner, Northamptonshire, 1940

Boughton House is vividly described in guidebooks as 'A vision of Louis X1V's Versailles transported to England'. It is undoubtedly the most French-looking seventeenth-century building in England. The 1695 façade, concealing substantial remains of a fifteenth-century building, combines a number of French motifs: banded rustification on the ground floor, a mansard roof with dormer windows and a complete absence of ornament. The recessed nine-bay centre, flanked by projecting wings, is raised over an arched loggia.

The house was redesigned for the first Duke of Montagu who had been Ambassador in Paris 1669-72 and 1678-9; his London home Montagu House, where the British Museum now stands, was also, as John Evelyn described it, 'after the French pavilion way'. His taste for things French extended to the layout of the estate and the design of the formal gardens.

Today Boughton, with its outstanding art collections, is still owned by a descendant of the Montagu family, as it has been since 1528. In order to maintain the house and its collections intact, the present owner has opened it to the public, offering all the usual attractions – tea-room, gift shop, picnic area, exhibitions and art education courses.

Stanley Roy Badmin (1906-1989)
BOUGHTON HOUSE, NEAR KETTERING, NORTHANTS, 1940

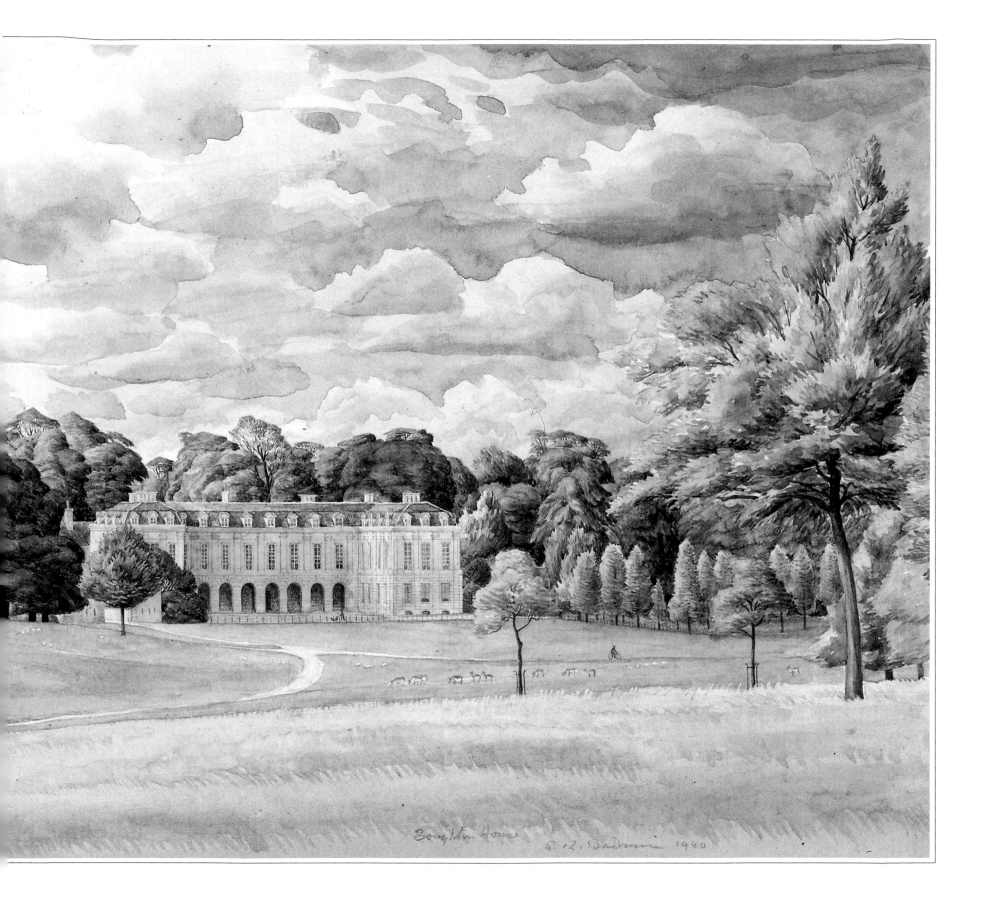

Boughton House

S. R. Badmin 1940

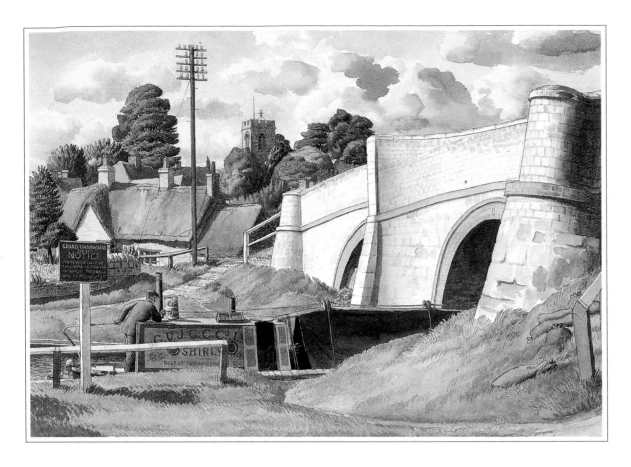

Stanley Roy Badmin (1906-1989)
STOKE BRUERNE, NORTHANTS, 1940

S toke Bruerne lies on what was once the Junction Canal, linking Cosgrove to Northampton. By 1940 this had been taken over by the Grand Union Canal Company, as both the towpath notice and the initials on the barge indicate. The village lies at the southern end of the Blisworth tunnel, a major feat of canal engineering opened in 1805. The handsome brick and stone canal bridge dates from around 1835-40 when the canal was widened and a series of locks built. Its aesthetic value was recognised by British Waterways when, in 1972, they strengthened it with a concrete core, leaving its robust outlines unchanged.

The canals were both a consequence of, and catalyst to, the changes in the country's economy that constituted the Industrial Revolution. In a fever of activity and investment lasting almost a hundred years 4,000 miles of canals were built, concentrated largely in the north-west and the Midlands. These new waterways moved raw materials, industrial products, agricultural produce and passengers with unprecedented speed and efficiency. The end of the canal was marked by the arrival of the railways, which were not only faster but covered a much greater area. Their traffic much reduced, canals ceased to be financially viable (though

there were late exceptions such as the Manchester Ship Canal, completed 1894) and were abandoned.

In recent years, a 'greener consciousness' has led to a reassessment of the canals and their conservational and energy-saving advantages. Canals have already begun to enjoy a resurgence as a leisure facility, with the narrow-boat holiday increasingly popular. Conservation volunteers are working to make new stretches of our inland waterways network navigable again after a century or more of neglect.

The original *raison d'etre* of the canal may have been lost but Stoke Bruerne retains its character as a canal village: in 1963 the British Waterways Board set up a canal museum there.

A nderson made several drawings of Thame, including the Bird Cage Inn, and houses on the Aylesbury – Oxford Road. The most fascinating, because the most lively and eventful, is this one showing the local livestock market.

Thame's importance as a market town since the thirteenth century has been governed by the shape of its long main street, in which the market was held. it is unusually wide and lined with a remarkable number of

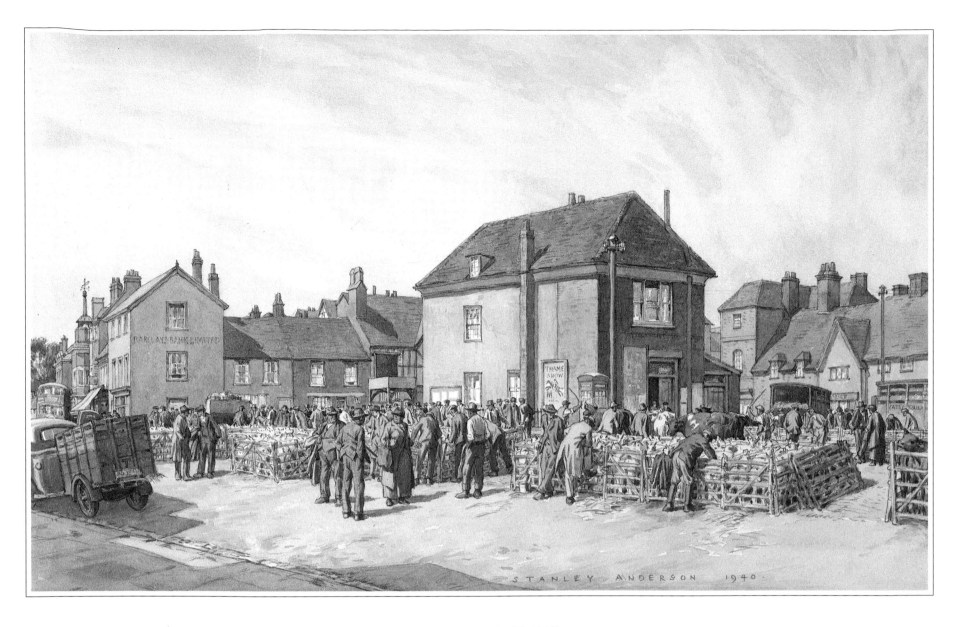

Stanley Anderson (1884-1966)
THE MARKET, THAME, OXFORDSHIRE, 1940

ancient inns and houses in a variety of styles and materials. Pevsner, in *Buildings of England* describes it as being 'picturesque in an unpretentious way'. The market was moved to a new site in 1950, fulfilling Anderson's prophecy as written on the drawing, 'Threatened by concrete and galvanised iron on the edge of town!' The centre of the High Street has since become, inevitably, a car park. Otherwise the street remains generally unspoilt.

Against the house in the centre of the picture is a red telephone kiosk, then an unremarkable sight, now a rarity since British Telecom's decision to replace Scott's elegant Soane-inspired design with the bland near-invisible new model. Only two thousand red boxes have been retained, after vigorous campaigning by amenity societies and conservation groups, in aesthetically sensitive areas.

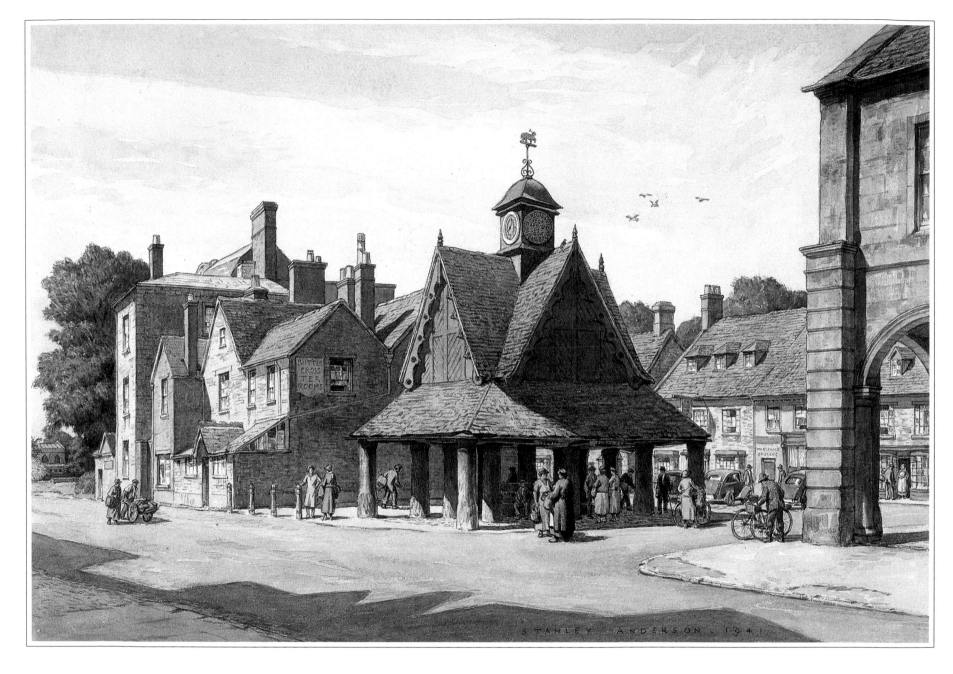

Stanley Anderson (1884-1966)
BUTTER CROSS, WITNEY, OXFORDSHIRE

Witney's situation gave rise to its chief industry and continuing prosperity. The sheep-rearing country of the Cotswolds lies to the north and north west; the river Windrush passes by Witney on its way to the Thames. These factors combined to make the town a centre for blanket-weaving, and it remains so today, despite the historic shift of textile industries to the north of England.

Anderson shows the bustling neighbourliness of the market place, centred on the sturdy Butter Cross, built around 1600. The plaque on the clock tower, 'Erected by Gulielmus Blake, Armiger de Coggs' (Coggs is a suburb of Witney), applies only to the tower and not to the cross itself. It is a handsome building, with its massive raftered roof supported on thirteen stout stone columns, designed to give seats and shelter to traders on market day. The arch on the right is a part of the loggia of the eighteenth-century town hall.

As with so many other Cotswold towns Witney was already showing signs of the tourist trade which was to reduce many of them to picture postcard subjects, their local stores and services replaced by the ubiquitous 'tea-shoppe' and antique galleries. Fossilised in an artificial picturesque past, such towns enjoy the preservation of their architectural integrity at the cost of social and economic stagnation.

Walter Bayes (1869-1956)
ENTRANCE TO THE BOTANICAL GARDEN, OXFORD, OXFORDSHIRE

Bayes alone was commissioned to represent the 'city of dreaming spires'. He produced seven drawings in all, which encompass Oxford's role as a university town and highlight its architectural splendours. His vision of Oxford is that of popular imagination, the *Brideshead Revisited* idyll of sun-dappled mellow stone and warm mauve shadows, the streets and the towpaths peopled by girls and boys in bright summer clothes.

The Botanical Garden is entered from the High Street. Today it is regarded by its visitors as a public park, a calm oasis in the centre of a busy city, but its origins (and its continuing function) are more strictly utilitarian. The first European botanical garden (for the scientific study of plants, specifically of their medicinal uses) had been laid out at Padua in 1545; the first such institution in Britain, founded on the initiative and the money of Henry Danvers, Earl of Danby, opened in Oxford in 1621.

The value accorded to the enterprise was marked by an attention to aesthetics and presentation: Danvers commissioned 'three gattes in to the phiseck garden' from the mason Nicholas Stone (1586-1647). The most magnificent of these (on the High Street frontage), a massive rusticated portal in the newly fashionable Italianate style, was erected in 1633, and stands unchanged today.

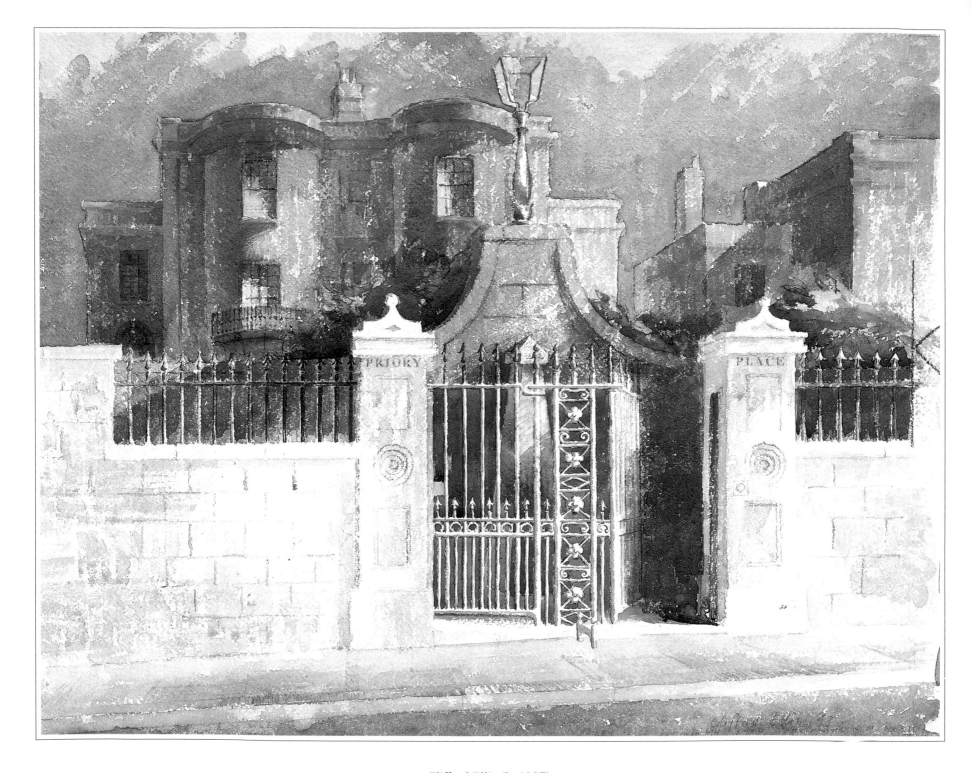

Clifford Ellis (b. 1907)
PRIORY PLACE, LYNCOMBE HILL, BATH, SOMERSET, 1943

The architectural excellencies of Bath had made it a favourite subject with artists and photographers, quite independent of the 'Recording Britain' initiative. The record was considered to be adequate until late in 1942, when a new and specific threat appeared to one of Bath's less conspicuous features, its abundance of decorative ironwork. Much of this was scheduled for removal by the Ministry of Works, to be used as scrap metal for making armaments. In response, a further ten drawings were produced in great haste by Clifford and Rosemary Ellis; Ellis himself was also instrumental in saving some of the finer examples, as he recorded:

> A brief schedule of ironwork-to-be-preserved had been made, but I discovered that this schedule was not being observed in the outlying districts. . . I managed to get work stopped for a day or two and made drawings in a great hurry, of ironwork not on the original schedule, not yet removed and which I proposed might be left as some compensation for what had already been taken 'in error': the Ministry of Works and Planning agreed to several of my proposed additions to the first schedule, and though some of these additions were in turn ignored, one or two were left.

The gates of Priory Place, dating from the early nineteenth century, were typical of what was lost; neither sufficiently distinguished to merit listing nor serving any essential function, but nevertheless adding greatly to the elegance and harmony of the frontage it adorned.

Lansdown was an elegant residential area on the outskirts of Bath, with large detached villas standing in extensive grounds. Most were fronted with fine decorative ironwork which complemented the restrained Georgian façades behind. Ellis described the ironwork as 'gay and light, profusely varied, and a wonderful foil, both in its form and in its colour (for ironwork must be painted) to Bath stone.'

Clifford Ellis and his wife Rosemary, who worked collaboratively on many commissions (including posters for Shell-Mex, and covers for Collins's *New Naturalist* series), recorded several examples of such decoration scheduled to be removed for scrap.

Clifford Ellis (b. 1907)
GATES AT THE HERMITAGE, LANSDOWN, BATH, SOMERSET, 1943

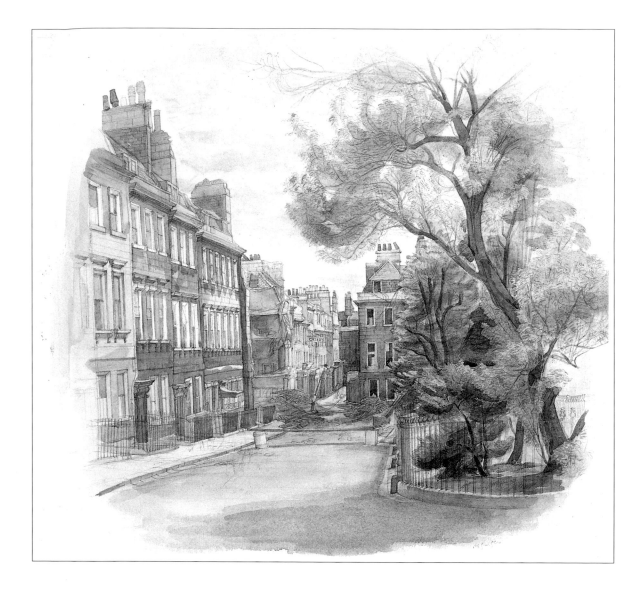

The oddly shaped chequered building is the Methodist chapel on Albion Street, built in 1819 with a façade dated 1854. The 'architect' was a Mr Perkins, the local school-master, which may explain its unusual form. Internally, however, it was well planned and sufficiently spacious to accommodate a congregation of two thousand. The surrounding cemetery, with its leaning tombstones and rampant weeds, provides a desolate contrast.

The bulbous brick structures seen beyond the wall are the bottle-ovens of a pottery; Hanley is one of the 'Five Towns' which make up the region known as the Potteries by virtue of its dominant industry (see page 134). The Stoke-on-Trent City Museum and Art Gallery (1954) now stands on the site of these ovens, a symbol of how the marketing of culture is replacing commerce, not just in Stoke, but in the economic life of the country as a whole.

Phyllis Ginger
CATHERINE PLACE, BATH, SOMERSET

Though inspired, in part, by the fear of imminent damage and destruction from German bombs, few of the 'Recording Britain' pictures make any overt reference to the effects of war, already evident in some cities by 1940. Phyllis Ginger's views of Catherine Place, Bath and the Council House, Bristol, are exceptions; both show scenes of bomb damage. Here a hole has been blasted through the elegant Georgian terrace during one of the 'Baedeker' raids, so-called because they targeted some of Britain's most beautiful cities – Bath, Exeter, Norwich, Canterbury and York. (*Baedeker* was the name of a series of standard tourist guide-books).

Phyllis Ginger's work, meticulous, delicate and overlaid with pale transparent washes, is very much in the tradition of the English school of topographical watercolour.

Louisa Puller (1884-c.1963)
BETHESDA METHODIST CHAPEL AND CHURCHYARD, HANLEY, STAFFORDSHIRE, 1943

STAFFORDSHIRE

Barbara Jones (1912-1978)
THE PAGODA, ALTON TOWERS, STAFFORDSHIRE, 1943

Alton Towers is the former estate of the Earl of Shrewsbury. The house and gardens were remodelled from 1814, at the instigation of the fifteenth Earl. Eight architects, including Pugin, worked on the house to produce the castellated fantasy that now perches precariously on the wooded bank. The terraces below are crammed with rock and rose gardens, exotic trees, woodland walks and an extraordinary variety of follies: towers, a bridge, a rotunda, a miniature abbreviated Stonehenge and other druidical monuments, temples and fountains. Most notable of these are the replica of the To-ho pagoda in Canton (serving as a fountain) and the Choragic Monument of Lysicrates, which contains a memorial to the fifteenth Earl, with the words 'He made the desert smile' (a reference to his transformation of the estate into a pleasure ground).

The site, covering five hundred acres, is now owned by a private company which has developed and promoted Alton as a theme park. It has become a kind of British equivalent to Disneyland. Described in its advertising as 'Britain's most outstanding tourist attraction' it boasts all the ingredients of the ultimate leisure experience – funfair rides, live shows, gardens, restaurants and shopping facilities. Such pleasures attract more than two million visitors annually.

Tunstall is one of the so-called 'Five Towns' that make up the Potteries. Amalgamated as Stoke-on-Trent in 1925, the place has been described as an 'urban tragedy'; five, really six, mean, ill-planned towns, each a haphazard accumulation of factories and slummy cottages. There is no centre to the whole and no focus to the individual towns.

A ceramics industry has existed here since the fourteenth century, giving rise to an 'architecture of ovens and chimneys' and an atmosphere in the town 'as black as its mud' (Arnold Bennett, *The Old Wives' Tale*). This is one of the few industrial landscapes in the 'Recording Britain' collection; grim as it is, it has a certain nostalgic charm, for the distinctive ovens and chimneys were already disappearing, as other methods and other markets rendered the traditional processes obsolete.

This panoramic view shows clearly the pervasiveness of the industry: the houses dwarfed by the factories and a church on the horizon almost indistinguishable from the chimneys in a sky obscured by smoke.

Alan Ian Ronald (b. 1899)
THE POTTERIES, TUNSTALL, STAFFORDSHIRE, 1937

STAFFORDSHIRE

Michael Rothenstein (b. 1908)
ALMSHOUSES, NEWCASTLE-UNDER-LYME, STAFFORDSHIRE, 1943

Rothenstein had contracted a disabling illness in 1926 which had left him unfit for military service. The 'Recording Britain' scheme had, as one of its avowed purposes, the aim of supporting such artists who had lost their livelihood as a result of the war, and Rothenstein recalls that the project 'was a bit of a life-raft. . . I could travel and be in the country and draw funny old buildings. . . and it gave me some kind of an excuse to draw' (Quoted in exhibition catalogue, Drumcoon Arts Centre, Wigan, 1983).

His 'Recording Britain' pictures invariably reflect his emotional response to the subject and he deliberately sought out scenes whose resonance echoes the spirit of the war years. This block of red-brick almshouses, built in 1743 to house twenty poor widows, has the blank anonymity and bleak prospect of a charitable institution. Compare it with the tree-framed gentility of the Geffrye almshouses, founded thirty years earlier in the rural environs of London (page 111). The Newcastle houses in their dull urban setting suggest enclosed and restricted lives marked by hardship and deprivation; the aspect is forbidding and prison-like, whilst the Geffrye resembles a modestly elegant country house.

This block has been demolished; generally speaking the private charity of almshouses has been replaced by the public provision of council housing.

Rothenstein has described his work as illustrating the 'sudden intrusions of the marvellous into the everyday'; his work of the early 1940s imparts a peculiar intensity to the commonplace. Subjects that in other hands would remain drab and uninspired – such as the interior of the iron structure of the Lower Market (built around 1790) – are transformed, lifted beyond literal transcription by imaginative insight and a visionary use of colour.

The subtle delicacy and brilliance of the washes he used in this picture confound our preconceptions of the subject. The most prosaic of buildings achieves an ethereal presence through the alchemy of the artist's imagination. It was this that was seen as differentiating 'Recording Britain' from contemporary documentary exercises that used photography (such as the Historic Buildings Record). As Thomas Hennell saw it, a photograph may convey more 'facts' but the camera was 'a pseudo-mechanistic enemy of the spiritual life and the imaginative faculty'.

The Lower Market, a very early example of the use of iron in buildings, has since been demolished; as Rothenstein noted on the back of his drawing, it was 'due to be pulled down immediately after the war'.

Michael Rothenstein (b. 1908)
LOWER MARKET, NEWCASTLE-UNDER-LYME, STAFFORDSHIRE, 1943

Badmin was much interested in recording seasonal changes and it is common to find a reference to weather conditions or the time of year in the titles to his pictures. Remarks such as 'A sprinkling of snow', 'Autumn', 'stooking before the rain' or 'Christmas weather' are appended to the topographical identification. Here he has illuminated his subject with the pencilled inscription 'Long Melford Green on a frosty morning.' A typical Badmin watercolour is tight and meticulous (compare for instance pages 91 or 123), this image in pencil and wash is paler and sketchier, suggesting the faint mistiness which accompanies a frost.

Like most of the medieval villages in Suffolk, Long Melford was built on the proceeds of the wool trade. When the industry moved north, the place continued to thrive in its role as a river port. As the name suggests it is a 'street' village which stretches for more than a mile. Unusually it also has a large green which forms an elongated triangle on a slight slope. At the top can be seen the imposing bulk of Holy Trinity, often acclaimed as the finest village church in England, and in front of it is sixteenth-century Kentwell Hall. Facing the church across the long expanse of green is the handsome red-brick Melford Hall (illustrated in Badmin's pen and ink drawing opposite), built around 1560 and now the property of the National Trust.

But Badmin's real subject in this sketch is the way in which the features of a village landscape cohere together in an organic whole. Centre stage is the group of massive elm trees which dominate the site, now lost to the depradations of 'Dutch elm disease'. The year after making this sketch Badmin began work on the illustrations for *Trees in Britain* (Puffin Picture Books, 1942), one of a series on aspects of the countryside which, as he recalled, 'were invaluable in the days of evacuation during the war when children were coming from the cities into the country and were asking questions about trees and other things.' In the same way, the images of 'Recording Britain' took the country to the city and offered a definition of the national character that was rooted in an agricultural economy.

S R Badmin (1906-1989)
MELFORD HALL, LONG MELFORD, SUFFOLK, 1940

S R Badmin (1906-1989)
LONG MELFORD, SUFFOLK, 1940

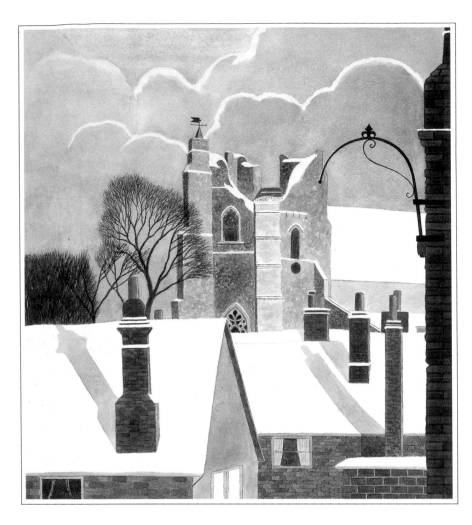

Jack L. Airy
ST BARTHOLOMEW'S CHURCH FROM THE SOUTH-WEST, ORFORD, SUFFOLK

Jack Airy appears, on the evidence of his style and the dearth of biographical information available, to have been a talented amateur. He contributed eight Suffolk pictures, of varying degrees of competence. This view of St Bartholomew's is one of the best, a sharp-focus close-up from an unusual angle. Schematic and highly coloured, it has the charms of a naïve unpretentious style. Though the perspective is unconvincing and the colours flat so that a sense of recession is deduced rather than demonstrated, it is nevertheless an accurate and evocative record of its subject.

Airy's snowy, mid-winter view of the ruined tower (it had suffered a partial collapse in 1829) complements Louisa Puller's more conventional view of the church taken from the fields in high summer. Such duplication was uncommon in the 'Recording Britain' collection, but was felt to be justified in this case because the two pictures were so very different in conception and in character.

A perfect expression of the English Picturesque, the picture demonstrates how village settlements expanded by gradual accretion, the cottages as much an organic growth as the landscape in which they are set. Surrounded by outhouses and lean-tos, these untidy cottages are the antithesis of the artificial neatness of the 'well-kept' village of commuters and weekenders.

Cowern's subject is the gardens with their rows of vegetables – onions, carrots, cabbages and runner beans. This is the true tradition of the cottage garden – a plot given over to fruit, vegetables and herbs, with flowers as an incidental splash of colour. The 'cottage garden' as it is now defined, with its crowded plantings of old-fashioned flowers – roses, lilies, pinks, honeysuckle – is really a creation of the wealthy; no labourer could afford the luxury of giving his plot over to such useless show.

Raymond Cowern (b. 1913)
COTTAGE GARDENS, DALHAM, SUFFOLK

The ochre-washed cottages form a compact group at the foot of the fourteenth-century church; the picture shows them in a dilapidated state, chimneys leaning, patches of plaster fallen away to expose the laths beneath and the thatch decayed. Cowern has added, after the title, the inscription 'Cottages recently saved from demolition', and his sketch of the subject is presented as an annotated diagram of the process of repair. The thatch is being applied in two distinct layers – the darker reed thatch is overlaid with golden straw. Both materials were readily available in East Anglia: straw from the abundant grain harvests, reeds from the fens. These thatched roofs are typical of the region, being steep with open gables, quite different from the low all-encircling kind found in the West Country.

Marking up the drawing to indicate the mount line, Cowern chose to exclude the telegraph pole, an intrusion of modern life impinging on the timeless picturesque of the cottage/church group. In doing so he falsified his subject, suggesting an isolation and independence from progress that simply was not true. Now, of course, national park authorities 'improve' picturesque villages, such as Otterton, Devon, by removing electricity and telephone wires; and residents in National Trust villages, such as Lacock in Wiltshire, are forbidden to erect intrusive anachronistic structures such as television satellite receiver dishes. Aesthetic values, imposed from outside, predominate over practicalities, as tourism replaces the traditional rural economy.

Raymond T Cowern (b. 1913)
THATCHING AT CAVENDISH, SUFFOLK, 1940

straw
thatching

weed
thatch

straw

May 1970 · R.J.C · thatching at Cavendish. Cottages recently saved from demolition.

Rowland Suddaby (1912-1973)
STOKE-BY-NAYLAND, SUFFOLK, 1942

The subject of Suddaby's inky sketch is a village in the Stour valley, on the border with Essex. Of no great significance in itself, it nevertheless has an iconic power as one of the handful of scenes in the locality studied repeatedly and obsessively by John Constable (1776-1837). Constable is, above all others, the painter we associate with the archetypal English landscape – a working, living landscape of cottages and churches, locks, mills, plough-teams and haymakers – and our vision of it is still mediated through his, as countless reproductions and endless imitations testify.

Suddaby is not concerned to describe the details of his subject, but rather to reinterpret the painted image, dulled by familiarity. Just as in Constable's work we find a tension between evocation and representation, so Suddaby's use of broad washes deny the fine detail we expect of topographical studies – the effect is similar to that achieved by Constable himself in his late sepia-wash sketches in which the subject is identified by its silhouette.

Stoke-by-Nayland is distinguished by the massive church tower rising above the water-meadows; for Constable it symbolised 'the remains only of former opulence and culture', a reference to its previous history as a cloth trade centre. Now, of course, Stoke has substituted tourism for trade, preserved by its fame as a Constable subject. Neglected and disparaged in his lifetime, Constable had been rediscovered by the turn of the century and 'the Constable Country' had become a place of pilgrimage. As early as 1893 Thomas Cook's added it to their list of tours; it was promoted by the Great Eastern Railway Company and popular guide books encouraged the visitor to compare the reality with the painted view.

Sacheverell Sitwell described this monument to Sir Robert Clayton (d. 1707) as 'one of the most entirely satisfying works of art in the whole Kingdom'. This is perhaps an exaggeration but it is undoubtedly a magnificent piece, the figures over-life size, superbly modelled and expressive, a fine example of the English baroque. Housed in St Mary's, an impressive Perpendicular church, it is signed by Richard Crucher and is his only known work.

Hooper's choice of the Clayton tomb illustrates one aspect of the nature of the 'Recording Britain' project, which set the unique and exceptional beside the simple, traditional and vernacular. This image belongs to the English passion for the past, the antiquarian spirit so strong in the English character. The study and preservation of the life and art of the past is manifested in the proliferation of local history and archaeological societies, the National Trust, and such specialist groups as the Church Monuments Society.

Churches and church art occupy a large part of the 'Recording Britain' canon. In a nation where now fewer than five million people are regular church-goers, the church is more an architectural curiosity or a work of art than a spiritual centre, losing its place as a focus of town or village life. Country churches are now frequently targets for thieves; silver and paintings are removed to safer keeping and the churches themselves kept locked between services, to the disappointment of the casual visitor. In many churches only non-portable art such as monuments and brasses remain to demonstrate the rich heritage of ecclesiastical craftsmanship and devotion.

George W. Hooper (b. 1910)
THE CLAYTON TOMB, BLETCHINGLY CHURCH, SURREY, 1942

A.C. Bown
BUTCHER'S SHOP, CORNER OF SLIPSHOE LANE, REIGATE, SURREY

The Surrey immortalised in 'Recording Britain' is a county of villages and market towns, which have now either been incorporated in the sprawl of London, as are Croydon and Richmond, or become commuter dormitories for the city. An attractive town with the North Downs as a backdrop, Reigate belongs to the second category; the kind of town to which Londoners were tempted by posters that exhorted them to 'Live in Surrey free from Worry' (Southern Railways, 1934).

Bown (an amateur contributor of subjects in Hampshire and Surrey) worked in a manner similar to that of Barbara Jones, and on similar subjects – individual buildings exhibiting some idiosyncrasy of style or decoration. This building, which houses Bellingham's butcher's shop, was formerly 'the Red Lyon', a pilgrim's inn advanta-geously situated on the main road south. It lost its trade when in 1763 a new main road was constructed to the east of this. The conversion to a shop occurred in 1775, and so it remained, at least until 1946. The shop front is typical of the later eighteenth century; the pillars, painted to represent marble, are actually made of wood.

Like other Surrey villages on the out-skirts of London, Richmond, with its famous hill and vast deer park, was favoured for its clean air and rural character. Even now, overwhelmed with traffic and heavily redeveloped, it maintains its central identity despite its proximity to the capital. The quiet gentility of old Richmond survives only in such residential enclaves as the Green; ringed with tall eighteenth-century houses, it is as quiet and self-contained as a cathedral close.

Walker lived for a while in Richmond and completed twelve drawings of its houses and antiquities. In this view the war is advertised by the scrubby neglected Green and the windows of the right-hand house, taped to minimise damage and injury from flying glass (a common hazard during air raids as windows were blown out by the blast of the bombs).

Edward Walker (b. 1879)
Nos 10, 11, and 12, Richmond Green,
Surrey, 1942

Sussex was one of the first counties to be recorded, in a total of ninety-four drawings. A former pupil of Frank Brangwyn (1867-1956), Hilder was already well known for his paintings of the Kentish landscape; he contributed eleven Sussex scenes to 'Recording Britain', five of which concentrate on the quiet reaches of the Cuckmere valley.

The Cuckmere is one of five rivers which cut their way through the South Downs, the hills which form the backbone of the county; it reaches the sea about four miles west of Beachy Head. Litlington itself (population 118 in 1949) is a pleasant, once peaceful, village now over-patronised by people visiting nearby Alfriston, the most popular tourist village in Sussex. Litlington's status is that of a convenient and attractive place to take tea. Its attractions are evident in Hilder's sketch of farm and church on a summer evening, with the trees and hedges casting deep shadows across the broad lane. Hilder's vision has come to represent the essence of Englishness, the kind of scene whose charms are labelled 'timeless' in a collective nostalgic fantasy for the 'real' countryside, which is now increasingly rare.

Like the Lake District and Snowdonia, the South Downs are victims of their success as tourist attractions, with overcrowding and environmental damage a direct consequence of their picturesque appeal. The villages of Kent and Sussex have suffered particularly from that twentieth-century phenomenon, the urban sightseer arriving by car; lanes and narrow streets are soon clogged with traffic, the ranks of parked cars obliterate historic sights and impede the locals. Still a relatively new activity in the 1930s and 1940s, the day-trip by car has become a favourite leisure pursuit, as every frustrated town-dweller seeks to sample the rural idyll, however brief and superficial that experience may be.

Rowland Hilder (b.1905)
THE CUCKMERE AT LITLINGTON, SUSSEX

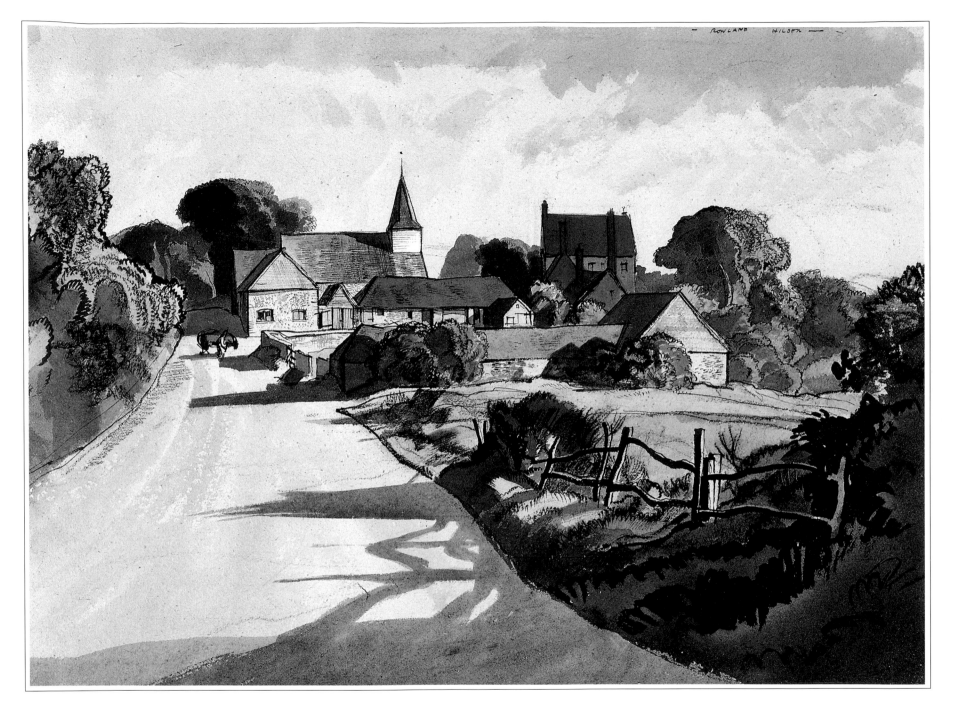

Rowland Hilder (b. 1905)
LITLINGTON IN THE CUCKMERE VALLEY, SUSSEX

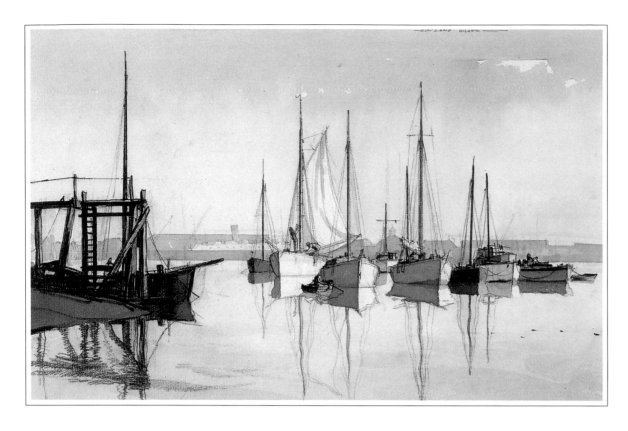

Rowland Hilder (b. 1905)
NEWHAVEN HARBOUR, SUSSEX

In making this record of Newhaven harbour, Hilder indulged in his love of boats: his earliest ambition had been to follow the example of W.L. Wyllie as a painter of marine subjects. Here, unless one counts the jetty, no land is to be seen at all, only a row of yachts at anchor, with a liner berthed beyond them. A similar view of Poole harbour, Dorset, was submitted by S.S. Langley.

Though technically outside the brief of 'Recording Britain', which was concerned with 'places and buildings of characteristic national interest', it is nevertheless a record of a significant part of British life. These pleasure boats serve as reminders of Britain's seafaring tradition as an island which had maintained its independence by virtue of its sea defences, and as a country whose wealth was established by sea-trade.

Rye was one of the Cinque ports, fortified in the thirteenth century, and the Ypres Tower (which now houses the local museum) was its chief bastion. Rye has now lost its function as a port, being separated from the sea by an expanse of marshland above which it rises as a pyramidal jumble of red-roofed houses. The town is small and intimate, the houses crowded together along steep cobbled lanes; the loss of its *raison d'etre* effectively ended its growth and it remains much as it was in the seventeenth century. This fossilisation has of course resulted in its reincarnation as a picture-postcard tourist town.

Access to the sea is still possible via the Rother, which is a tidal river; at high tide it merges with the surrounding plain, refloating the scattered boats that lie along the margins.

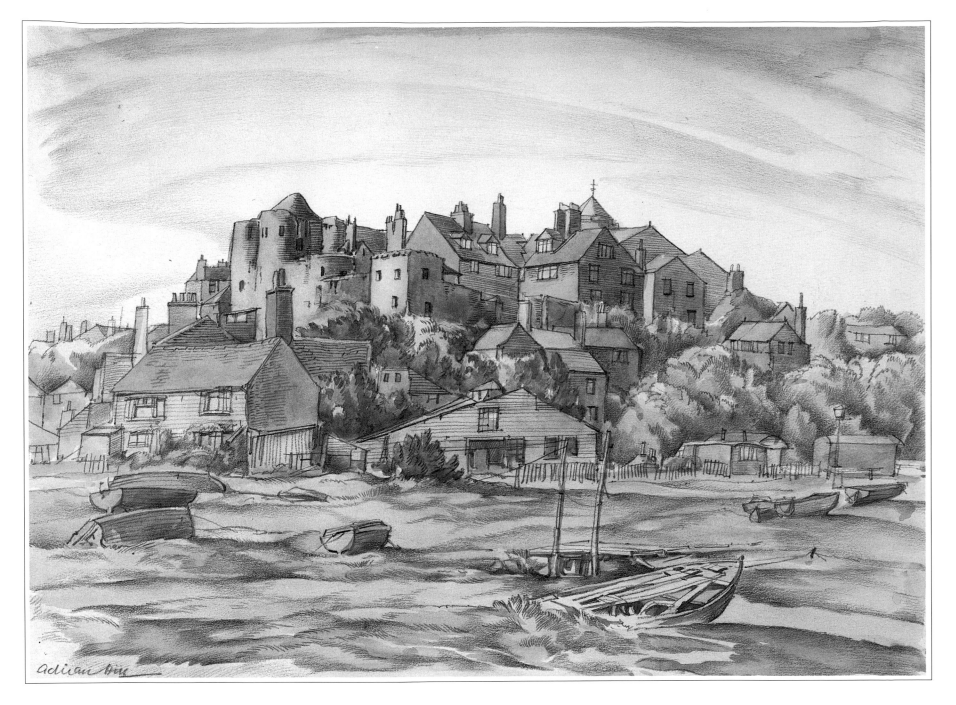

Adrian Hill (1895-1977)
YPRES TOWER, RYE, FROM THE RIVER ROTHER, SUSSEX

Adrian Hill (1895-1977)
BRANGWYN'S MILL, WINCHELSEA, SUSSEX

This was one of the oldest post mills (see page 68) in the country, built in 1760. By 1940 it was defunct, with both its sails gone; Hill chose to paint it as a famous landmark on the Downs beyond the hill village of Winchelsea. The windblown aspect of the place is emphasised by the bent and stunted trees.

Hill's contributions to 'Recording Britain' were limited to Kent and Sussex. Kent was his native county and he later lived for many years at Midhurst, Sussex (the subject of two pictures). He had served as an official war artist on the Western Front, 1917-18, and published several books, including *On Drawing and Painting Trees* (1936).

Knight's unfinished drawing demonstrates a continuity in English watercolour practice: he acknowledged a stylistic debt to Cotman, and here he has used 'Cox' paper (after David Cox who first used it), a rough cartridge paper which enhances the scumbled effect of dry pigment. By such means he has captured the textures of decay, of flaking plaster and weathered wood. The subject – an irregular medieval house – is an embodiment of the eighteenth-century idea of the picturesque.

Popularly known as Anne of Cleves' House, this was one of the properties made over by Henry VIII to his unwanted bride as the price of ridding himself of her. A fascinating subject for Knight, with his architectural training, it is a compendium of virtually all the local building materials. There are flints, enormous sandstone roofing slates, roof tiles and bricks, but basically, though very much restored, this is a timber-framed house of the 'Wealden' type. It is now a museum of crafts and local history situated on the outskirts of Lewes.

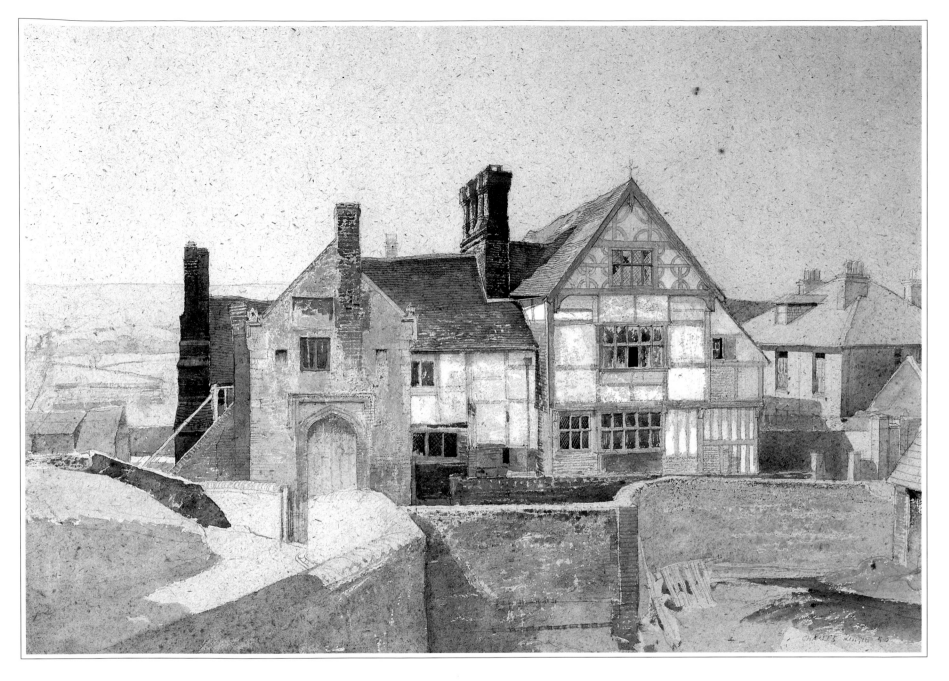

Charles Knight (b. 1901)
ANNE OF CLEVES' HOUSE (NORTH ELEVATION), DITCHLING, SUSSEX, 1940

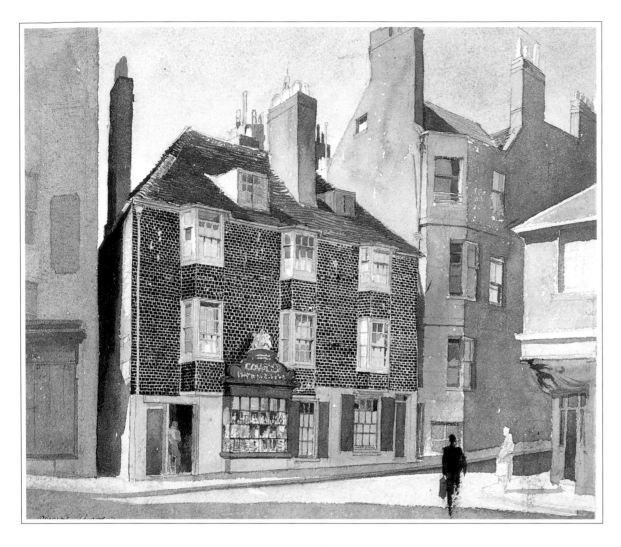

Knight worked for a local architects' firm J. L. Denman, detailing perspective drawings. This experience is evident in the confident accuracy of watercolours such as this. He chose the subject for its architectural interest; a note below the mount line refers to the 'black-glazed tiles'. These were a type of interlocking 'mathematical' tiles, common in Kent and Sussex, where they were employed as a facing to emulate the newly fashionable Flemish brickwork. The black-glazed tile was a variation found only in seaside towns, designed to protect the façade against the depredations of a salty atmosphere.

The building belongs to the earliest phase of Brighton's prosperity, before the attentions of the Prince Regent encouraged growth and development. Built in 1794 as a house, it was partly converted into a shop in 1856. It retains the original shop window, with the glazing bars intact, and the elaborate signboards of Mr Cowley, 'by authority, fancy bread and biscuit maker'.

Charles Knight (b. 1901)
HOUSE AND SHOP IN POOL VALLEY, BRIGHTON, SUSSEX, 1940

The coastal counties, from Dorset to Suffolk, were given priority when the first commissions went out, since they were the most vulnerable to invasion or to bombing raids. Brighton, on the south coast, was an obvious target for the German bombs and was consequently the subject of extensive coverage. Charles Knight produced forty exquisite watercolours in and around Brighton and Lewes, exceeding every other contributor for a single county, except Fairclough in Surrey. This sunbathed view of the Regency terraces captures perfectly the spirit of this elegant seaside resort, which owed its status to the attentions of George IV when Prince Regent, in the 1820s. In Knight's vivid palette and his use of flat planes of colour one may detect the influence of John Sell Cotman, one of the masters of English watercolour.

Knight's experience reminds us that the artists had a difficult task, in more ways than one. Rumours of German spies were rife and anyone seen sketching aroused immediate suspicion. Knight often had to work surreptitiously or in short bursts of activity, was threatened by local people and moved on by the police for his safety.

Charles Knight (b. 1901)
REGENCY BRIGHTON: HOUSES IN RUSSELL SQUARE, SUSSEX

Thomas Hennell (1903-1945)
THE SCYTHE-SMITHY, WEYBRIDGE, WORCESTERSHIRE, 1941

Hennell gives a fully detailed account of the process of scythe-making in his catalogue of disappearing country crafts, *The Countryman at Work* (1947). He was already concerned about the loss of traditional practices when enlisted for 'Recording Britain' and his subjects for this project often overlap with his earlier studies.

With the mechanisation of agriculture the scythe is now all but redundant, more familiar in museums of rural life than in use in the fields, but in the 1940s the implement was still in demand at home and abroad. There were two distinct types, made in different regions: the 'riveted-back' scythe was made chiefly in the Sheffield area; the crown scythe was made at Belbroughton and several adjoining villages in Worcestershire. The latter kind was more expensive, but also more effective.

Hennell's sketch shows the gloomy interior of the scythe forge, with various stages of production in progress. The tilt-hammer in the centre (which, used in conjunction with an anvil, shapes and welds the blade) is driven by water power.

Woollas Hall, standing on the north side of Bredon Hill, is a handsome high-gabled stone house with an irregular façade, dating from 1611. It is of no great historic significance; what is perhaps most remarkable about the house is its well-preserved state, and the fact that it has remained in private hands as a family home. Many other houses of this kind only survive by conversion to hotels, offices, schools or time-share holiday homes. Often the continuation of family ownership is achieved only by the expedient of opening the house to a fee-paying public, the treasures in the public rooms shrouded, encased, roped off, whilst the family removes to a modernised wing or a self-contained flat.

Generally speaking, the later twentieth century has been a time of crisis for the country house, with many owners finally defeated by the financial burdens of repair and maintenence. Between 1945 and 1974 more than two hundred and fifty houses of architectural and historic importance were demolished; there are now less than a thousand remaining in private ownership. Around a hundred of the most significant examples – the country house as work of art, exhibiting a unity of building, contents and garden – were acquired by the National Trust in the 1950s and 60s. This was a new area of responsibility for the Trust, which had previously been almost exclusively concerned with safeguarding unspoiled landscapes. Recently this policy has been reversed; the Trust will not accept or seek to acquire a house unless sufficient endowment funds are available to maintain it and the acquisition of land, particularly of coastal areas, is again the priority.

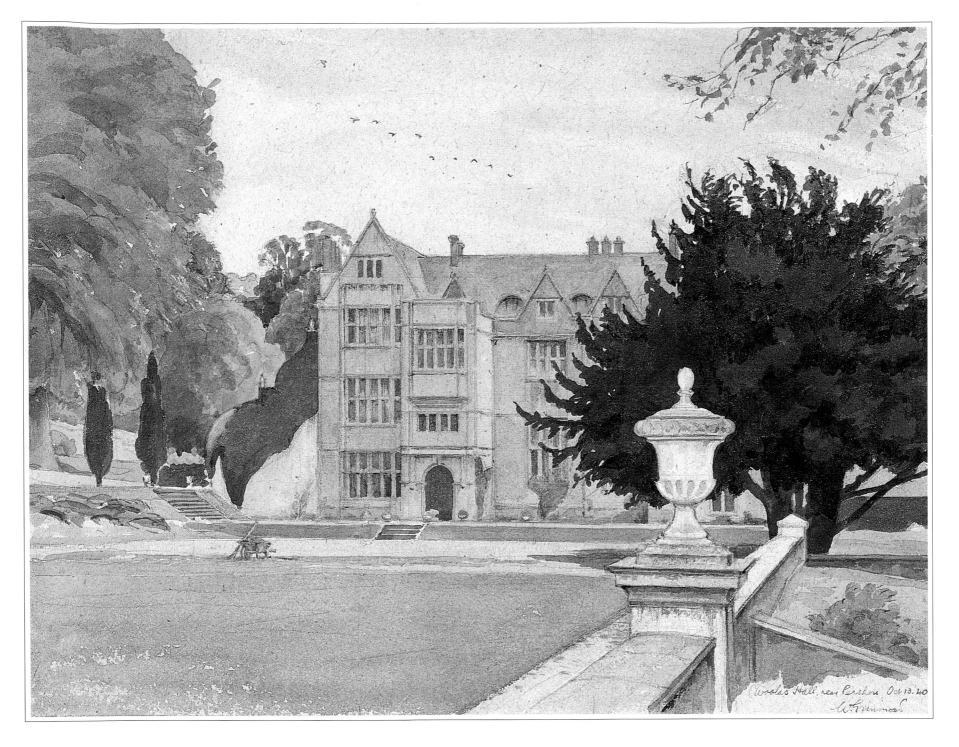

William Grimmond (1884-?)
WOOLLAS HALL, NEAR PERSHORE, WORCESTERSHIRE, 1940

Raymond T. Cowern (b. 1913)
REPAINTING THE GUILDHALL, WORCESTER, WORCESTERSHIRE, 1940

Worcester's eighteenth-century town hall is a magnificently aggressive example of municipal pride. Built of red brick with stone dressings the front is embellished with an excessive variety of exuberant ornamentation, including a statue of Justice and monuments to Charles I and II and Queen Anne. It was erected in 1721-3, presumably to designs by Thomas White (d. 1738), pupil and assistant to Wren, who submitted a scheme in 1718 and signed the carved pediment.

As if parallelling the work in progress, Cowern's sketch is unfinished; the scaffolding across the façade gives the effect of a drawing squared for transfer. The subject is an unusual one for the time for, with the outbreak of war, work on the repair of buildings virtually ceased; able-bodied labour was needed more urgently elsewhere and materials were in short supply.

Generally speaking 'Recording Britain' eschewed scenes and subjects already well represented in the existing topographical record. Instead it concentrated its limited resources on the lesser known. The ruined monastic abbeys of Yorkshire – Fountains, Bolton, Kirkstall, Rievaulx – had been extensively documented in the Romantic topography of Girtin and Turner, but Guisborough, though magnificent, was relatively obscure.

An Augustinian priory, it was founded by Robert de Brus about 1120. A fire destroyed the original church in 1289; work on rebuilding must have begun immediately for the one substantial fragment remaining is certainly pre-1300. This is the turreted and buttressed east wall of the chancel, one of the most important surviving examples of early Gothic architecture. The great windows have lost their intricate tracery; the scaffolding provides a temporary geometric substitute, the poles and planks appearing slight against the massive masonry.

Like the other great abbey remains Guisborough is now open to the public.

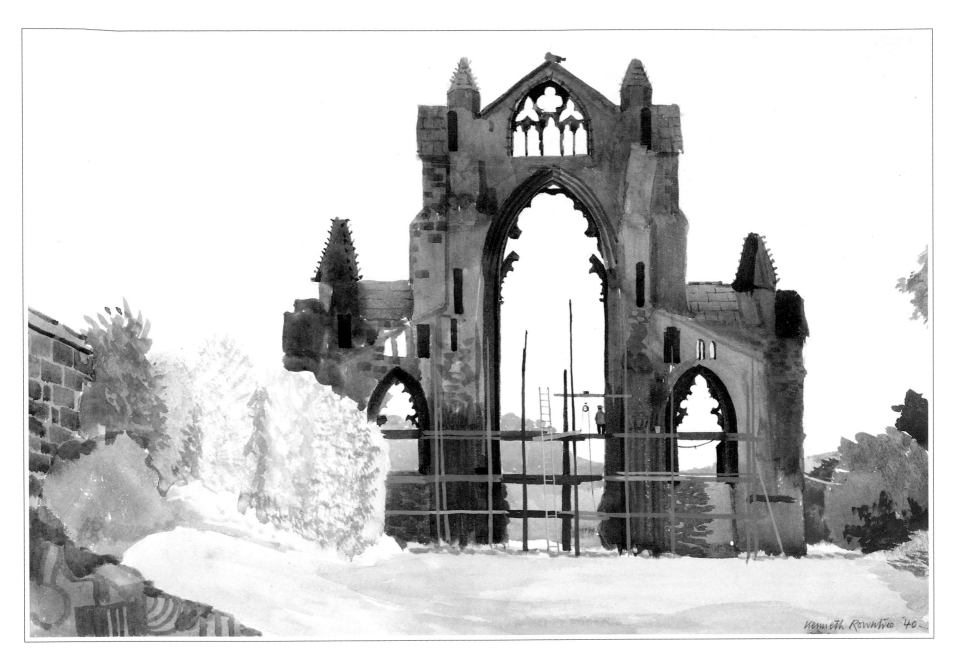

Kenneth Rowntree (b. 1915)
GUISBOROUGH PRIORY, YORKSHIRE, 1940

Index

Index limited to artists, place names, official bodies and important individuals. Page numbers in **bold** type indicate illustration.

Abergynolwyn, Slate Fences **118**
Acts of Parliament 7, 9, 29
Airy, J.L. **140**
Aldington Church 94-**5**
allotments **102**
Alton Towers, Pagoda **134**
Anderson, Stanley **42-3**, 72-**3**, **126-9**
Arts Council of Great Britain 21
Ashdale, Underbank Farm 17, **63**
Ashopton: Ashopton Inn 29-30, **60**; Wesleyan Methodist Chapel **62**
Atlee, Clement 22

Badmin, S.R. 12; paintings 44, **45-7**, 90-**1**, **103**, **123-6**, **138-9**
Barnston, Livermore Tombs 17, 68-**9**
Bath 30; Catherine Place **132**; Priory Place **130**-1; The Hermitage **131**
Bayes, Walter 14, 18, 33; paintings **67**, **104-6**, **116**, **119**, **129**
Bell, Graham 16, **72**
Belowda Beacon, China-clay Works **55**
Blackburn, 'Old Bull'/Darwin Street **6**
Blandford, Eastbury Park near **35**
Bletchingley, Clayton Tomb **145**
Blue Coat School, Westminster 29, 108-**9**
Bow Brickhill 44-**5**; Village Choir **44**
Bown, A.C. **146**
Brentford, White Hart Inn **119**
breweries 21, 22
Bridgend, Old Bridge **72**
Brighton: Pool Valley **154**; Russell Square **155**
Britain and the Beast (C. Williams-Ellis) 12
British Institute for Adult Education (BIAE) 19, 20
Buxton, The Crescent **61**
Byland Abbey, Yorkshire **8**

Central Institute of Art and Design (CIAD) 7, 9, 21, 22
Central Register 9
Cheltenham, The Promenade **78**
Chichester Channel, Birdham Mill **13**
Chieveley, The Hop Castle **41**
Clark Jane 16
Clark, Kenneth 9-11 *passim*, 16, 21; quoted 9, 19, 20
Colchester, Gaumont Hippodrome (*formerly* Old Grand Theatre) **67**
Committee for the Employment of Artists in Wartime 9, 11, 21
Commons Preservation Society 7
conservationists 25-7 *passim*
Conway Castle, Coracle and 54-**5**
Council for the Encouragement of Music and the Arts (CEMA) 19, 20
Council for the Preservation of Rural England (CPRE; *latterly* Council for the Protection of Rural England) 7, 9, 29
Cowen, Raymond 140, **141-3**, **158**

Dalham, Cottage Gardens 140-**1**
Dawson, Byron **97-100**
Dimond, Phyllis 33, **107-11**
Ditchling 11; Anne of Cleves' House 12, 152-**3**
Doric Arch 25-6, **112**
Downham, Clitheroe near 98-**9**
Dunstable, Priory Church 38-**9**

Eldridge, Mildred 14, 16, 33, **59**, **118**
Ellis, Clifford 30, **130-2**
Emanuel, Frank **6**
English Popular and Traditional Art (Enid Marx) 18
executioner, benevolent 26
exhibitions 18-20

Fairclough, Wilfred **2**, **6**, 10, 11, 33
Farleigh, John 31-2
Fennemore, T.E. 7
Finchingfield, Post Mill **68**
Fingest, St Bartholomew's **42**
Folkestone, Martello Tower **92-3**

Garn Dolbenmaen 52-**3**
Ginger, Phyllis **78**, **113**, **132**
Godmanstone, Sheep-shearing **33-4**
Great Coxwell, Tithe Barn 19, 31, **40**
'green belt' 7
Grimmond, William **157**
Guisborough Priory 16, 158 **9**

Ham Common, Ormeley Lodge **2**
Hanley, Methodist Chapel 132-**3**
Harkness, Edward 9
Harrietsham, Chegworth Mill 90-**1**
Hartrick, A.S. 14, 15, 33, **74-5**
Hennell, Thomas 13-15 *passim*,

31-4 *passim*; quoted 18; paintings 64-**5**, 76-**7**, **86**, **156**
'heritage' 7, 27
Hilder, Rowland **148-50**
Hill, Adrian **92-3**, **151-2**
Hinton-in-the-Hedges, Tombstones 17, **122**
Hooper, G.W. **87-8**, **145**

Jones, Barbara 15, 18, 25, 34-5; paintings **41**, **57**, **65-6**, **96**, **112**, **120-1**, **134**
Jones, Gwyn 33, 55
Jones, Tom 9, 10, 20
Jordans, Stone Dean 42-**3**

Kettering, Boughton House near **124-5**
King's Lynn: Fairground **120**; Savage's Yard 18, **121**
Kirk, Eve 31
Knight, Charles 11, 12-14, 15, 30; paintings **12**, **152**, **153-5**

Lasham, Beech Avenue **86**
Lee, Constance L. **114**
Lincoln, Drury Lane **6**
Lines, Vincent 14, 15
Litlington **149**; River Cuckmere at **148**
Little Saling, Church of SS Peter and Paul 17, **71**, **171**
Litton Cheney, Old Rectory 27
Llanrwst, Gwydir Uchaf Chapel **50-1**
Local, The (Maurice Gorham) 22
London **103-17**; Bedford Square, Shelter **108**; Blue Coat School 108-**9**; Clapham Common, Holy Trinity Church **103**; Covent Garden Market **106**; Crouch End Cottages **114**; Euston Station, Doric Arch 25-6, **112**; Geffrye Museum **110-11**; Gray's Inn, Raymond Buildings **31**; Hampstead Heath, Fair Ground **116**; Kinnerton Street **107**; Park Village East **113**; Regent's Park Zoological Gardens **105**; St John's Wood, Knight of St John Tavern **115**; Stepney, Regent's Canal Docks **104**; Strand Lane, Watch House **117**
Londoner's England, The (Alan Bott) 21-2
Long Melford 138-**9**; Melford Hall **138**
Lower Tocknells, Tocknells Court 78, **79**
Lulworth Cove 31, **64**

Macmillan, Harold 26
Manchester, The Old Shambles 100-**1**
Marx, Enid 18, **115**
Ministry of Labour 7, 9, 21
Moore, Mona 20

National Buildings Record (NBR) 19, 30
National Gallery 10
National Heritage Memorial Fund 28
National Land Fund 28
National Park 7
National Trust 7, 27, 28
Nature Conservancy 28
Nature Reserve Investigation Committee 36
new topography/topographer 15, 18, 22
Newcastle-under-Lyme: Alms-houses **136**; Lower Market 136-**7**
Newhaven Harbour **150**
Norby, Terrace 16

'Old English' 14, 18
Olney, Flooded Meadows 46-**7**
Orford, St Bartholomew's Church **140**
Ostrowska, Wanda 31
Oxford, Botanical Garden **129**

Painswick, Bus Stop **73**
Palmer, Arnold 10-**11**, 12, 21, 22, 102; book by 14; quoted 27, 28, 30, 33-4
Palmer, Samuel 14, **94**
Pershore, Woollas Hall near 156-**7**
Pile, Albert 100-**1**
Pilgrim Trust 8-9 *passim*, 19, 20
Piper, John 9, 14-16, 31, 32; paintings **40-1**, **48-9**, **82-3**, **122**
'Popular Art' 16-18
Portmadoc, Tan-yr-Allt 17-18
Powys, A.R. 28
Preston **100**; Clifton Mill near **97**
Puller, Louisa 30, 84-**5**, **133**

Ramblers Association 7
Read, Herbert 7, 13
Record of Historic Buildings 19
'Recording Britain' scheme: background 7-8; exhibitions/tours 18-20; history/outline 7-22; publication of book 9, 20-2
Reigate, Butcher's Shop **146**
Richmond Green, Nos 10/11/12 **147**
River: Ceiriog, Baptism 16, **59**; Cuckmere **117**
Ronald, A.I. 32, **135**
Rothenstein, Michael 8, 14; paintings **16**, **68**, **78-81**, **136-7**
Rowntree, Kenneth 9, 14, 15, 16-18, 29-30; paintings 38-**9**, **51**, **54-5**, **60-3**, **69-70**, **159**
Royal Fine Art Commission 26
Royal Watercolour Society (RWS) 10, 14
Russell Flint, W. **13**, 14, 21
Rye, Ypres Tower 150-**1**

St Agnes, Disused Tin Mine 56-**7**

Saturday Book 18
'Scheme for Recording Changing Aspects of England' 9-10, 11
Seddon, Richard 30
Shoreham, Landscape with Barn **94**
Shrewsbury, Milk Street **29**
Society for the Protection of Ancient Buildings 7, 26, 28
Society of Architectural Historians 26
Southwark, Signwriter's Shop 18, 21
Spear, Ruskin 55, **58-9**
Stanton Low, St Peter's Church **49**
Stoke Bruerne **126**
Stoke-by-Nayland **144**
Stone, Reynolds 27
Stonor, White Pond Farm **6**
Stowe, Temple of British Worthies **82-3**
Suddaby, Rowland **144**
Sudeley Castle 80-**1**
Sydenham, Crystal Palace Gardens **96**

Tetbury Railway Station **85**
Thame Market **127**
tours 18-20
Towcester High Street 122-**3**
Tresayes, Great Wheal Prosper **58**
Tresham, Breast Plough at **75**
Trevelyan, Julian 25
Tubbs, Ralph 19
Tunbridge Wells: Music Gallery **88**; Regency House **87**
Tunstall, The Potteries 32, **134-5**
Tyringham, Bridge at **48-9**

United States Federal Arts Project 9, 13

Veryan, Round House **57**
'Vision of Britain' (exhibition 1989) 26

Walker, Edward 29, **117**, **147**
War Artists Advisory Committee (WAAC) 17
Wareham, 'Black Bear' **65**
Waterfield, Aubrey **89**, **94-5**
Webster, Thomas **44**
Weybridge, Scythe-smithy **156**
White, Ethelbert 33
Wickhambreux Mill **89**
Wimbourne, Cottages **66**
Winchcombe Pottery **77**
Winchelsea, Brangwyn's Mill **152**
Windsor Castle drawings 14
Witney, Butter Cross **128-9**
Worcester, Guildhall Repainting **158**
Workers' Educational Association (WEA) 19
World War II (1939-45) 9, 22, 30

Young, R.L. 52-**3**